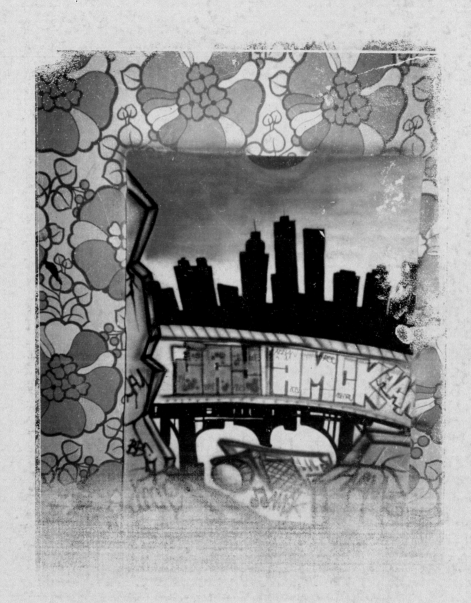

POET

A PARADISE – ON THE EVOLUTION OF TRAIN BOMBING IN BERLIN

Berlin, the capital of Germany, is a city with a long tradition of graffiti. Before the Berlin Wall came down in 1989, West Berlin had been a walled-in island while the eastern part was the capital of the GDR. The divided city was the centre of the cold war and had the world's best-guarded border. Why do I even mention this? Because these circumstances left their mark on the city's mentality, its inhabitants and its sprayers on both sides of the Wall. The first appearance of graffiti in West Berlin, defined as New York subway Writing, dates back to about 1982 while politically motivated graffiti (mainly class struggle slogans) first appeared in the early 60s. But I will focus on the time just before the Wall came down, the late 80s. This was when a new type of graffiti, subway Writing, finally made its way onto West Berlin trains.

But West Berlin wasn't the only city where young people began to mimic their New York idols. In other European metropolitan areas, such as Paris or Amsterdam, like-minded youngsters, too, began to spray. And although the odd piece made its way onto public transport before this trend had reached West Berlin, the European Writer movement of the 80s was still dominated by wall pieces.

Despite all efforts by isolated sprayers in some European cities, the quality of New York subway images remains uncontested in its quantity. Only now, 20 years later, has the European movement acquired its own identity and visual quality independent of the train images.

We have moved out of the Americans' shadow and their interpretation of graffiti. But it was their ideas and foundations that we packaged into new concepts and relied on to push forward our own evolution. But I've said enough about the present. Let's go back to the beginnings, back to West Berlin in the 80s when any self-respecting sprayer or, more accurately, Writer proved his spraying skills and style on the Berlin Wall. West Berlin Writers always had a penchant for style. This is the small but decisive element that has left its mark on all of Berlin and has given the city its own status in the aerosol universe. You can either write your name or style it. At the same time, this was also an era of experimentation and of spreading ideas on any available surface. Some just did it, others would have liked to do it and another bunch just talked about it. Especially about West Berlin trains. But then a number of fortunate circumstances came together. Before 1987, very few pieces existed on West Berlin trains.

And, better put, only rumours about these pieces actually existed because there was usually no documentary evidence of them. After 1987, if any Writer even thought about bombing a train, he or she did it on a carriage of the local "S-Bahn" or city train. By the end of the 80s there were only three S-Bahn lines in West Berlin and sprayers first went to the lay-up in Zehlendorf or the Wannsee yard in the southern part of the city on the S1. SHARK from Dortmund, for example, did Berlin's first S-Bahn whole car.

In 1988, AMOK and KAOS ONE immortalised themselves in Zehlendorf as did MAXIM, SHEK, BAS 2, KAGE and SICK, who was later known as WESP and co-founded the GHS crew. The northern part of the city sported three other suitable lay-ups for spraying: Gesundbrunnen, Waidmannslust and Schönholz. It was there that Writers such as SOK, ARENA and ACON, who was later known as MORE and also founded the AGS crew, had developed an interest in S-Bahns during that same year.

So, in 1988, the odd train got bombed in both the southern and northern parts of West Berlin, but not more than a handful over all. By the end of 1988, all districts in West Berlin had been tagged.

AMŎK

WRITING WAS LIKE BMX OR FOOTBALL

Any mention of early Berlin Writing will feature the name Amok in broad, conspicuous letters. Quite a few rumours and legends are associated with your name. When I was little, I always thought, "This guy has to be at least seven feet tall." Only later did I realise that one can also use a ladder for spraying. So, you are not excessively tall and the beginnings of Berlin Writing were probably also quite unspectacular…

It was in 83 – 84 that Writing slowly started to take off in Berlin. At the same time, the media was giving the subject enormous coverage. Germany's main public TV channel ARD, for example, screened "Style Wars" although they wrongly translated it as something like "Subway Pictures, Crazy Legs". They still didn't quite know how to deal with this phenomenon. Then my sister inspired me to get involved. She had drawn little bubble styles on her schoolbooks for physics or math. Together with a few friends, I kept spotting tags written in marker all over the city. This was before people had discovered spray paint. It all started in the districts of Steglitz and Friedenau in southern Berlin. A crew called "Saints" were leaving their throw-ups and tags all across town. Then the bomb really hit with the book "Subway Art". All of a sudden most of our questions, such as how to work on a wall or if outlines come first and then the fill-in, were answered. This book showed it all right. From this moment on, it all spread like wildfire.

Early Berlin styles contain many elements from Amsterdam and Munich…

Kane, a friend of mine, really enjoyed travelling. He often went to Paris and Amsterdam. In Paris, Writing had evolved at the speed of light and exceeded anything we had seen before. This is where he saw the first images done by BBC, the Bad Boys Crew. They, as we found out later, were a lot older than we were and in close contact with New York.

In Amsterdam, Kane also met the very influential Writer Shoe. Writers from Munich only ever came up to Berlin to embellish the "famous" Berlin Wall. Still, their technical standards turned out to be a true enrichment for Berlin. By chance we bumped into a French soldier at a disco, who was stationed in Berlin and wearing a backpiece by Jay One. He got us in touch with the BBC. That's how things got rolling and the styles evolved. I'm now talking about 1988.

You seem very well adjusted. This is not something to be expected from someone called Amok. And your styles aren't exactly peaceful, either…

The name resulted from a game that I played with Kane. For hours we'd sit around at night trying to think up ideal monikers until smoke was coming out of our ears from the exertion. Names that meant something deep, names with a shocking impact, letters with an ideal flow that could be read back to front and vice versa. That's how I found my name and that's the whole story.

What kind of relationship do you have with your work?

My letters are my work. I've developed them like I have my personality. What I'm trying to say is, my letters are not only part of my life, but also an expression of my personality. They reflect it.

A lot has changed in Writing…

In those days, Writing was like BMX or football. At some point I got too good at BMXing and it started to bore me. I always needed new challenges and was constantly on the lookout for them. In Writing, I finally found what I was searching for – a task I couldn't just put aside that easily. It asserted such a claim on me that I even left my girlfriend because of it.

There is a lot of performance pressure in Writing now that didn't exist in my own, personal development. The benchmarks have shifted. The quality of other people's images used to spur you on to get better. It was a game with fixed rules, which was centred on your own development. These days, it is almost impossible to create a personal style because almost everything has been done before. Today, the 3D styles of the 80s, robot styles, etc. are continuously recycled in videos, magazines and books around the world. Their execution might vary, but does that make the work original?

You have seen many developments and followed many biographies. What are your thoughts on the future of Writing?

Regardless of the politics that control our cities, tags will always mark their streets. Writing is an essential urban phenomenon. Of course, the selection of tools has changed and expanded and, with it, the possibilities of expression. Keyboard and mouse have joined the spray can. But the fundamental idea behind Writing will continue to exist. The thrill of illegality remains a vital part of it.

As a father of three you probably don't spend too much time in subway tunnels any more. What are you currently working on?

Yes, the fridge needs to be filled. I earn my daily bread with graphic design and interface programming. A number of politicians and the Ministry of Sports are amongst my clients. For me, that's no break in what I have been doing. My Writing experiences flow directly into my current work.

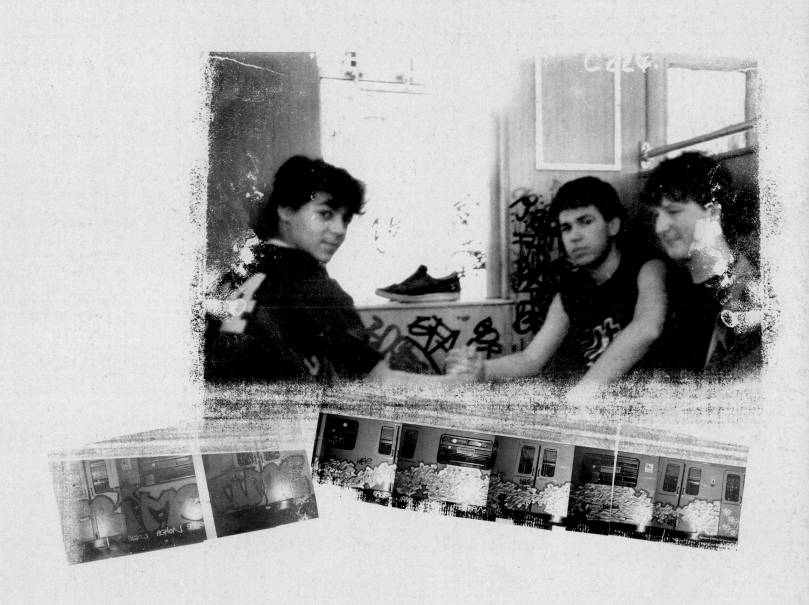

In Schöneberg, Kreuzberg and Wilmersdorf alone, hundreds of young people got into tagging because a new tag wave that had hit at the end of 1987 had spread to high schools all over West Berlin by 1988. Increased activity by a rising number of Writers generated a few contacts and the first, separate meeting points by independent Writer gangs were established at the end of 1987. But most exchanges took place at discos around 1988-89. The first real Berlin Writers' corner, where different generations of Writers met, was established in front of the Society on Ku-Damm (West Berlin's prime shopping street). MAXIM deserves a special mention. He could always be found where the action was and, in 1988, the Ku-Damm was also the assembly point for a wild bunch of younger Writers. While the old school was happy to use the Berlin Wall for their styles, younger exponents were far more interested in illegal actions in the streets and subway stations.

That's where I met a few Writers from the district of Wedding, amongst them SOE, KOBOLT (R.I.P.), BECKS, SICK, Dj CRASH, SKANER (R.I.P.) as well as KASIM, BAS 2 and his partner ASEK, who were both still with the AC crew at the time. Most of the time we went on weekend tagging tours, but only a small number of us did real pieces.

In addition to the corner by the Society, which was exclusively a meeting point for Writers, there was the Riverboat disco in Wilmersdorf. On weekends this is where you would meet the entire West Berlin hip-hop scene. Breakdance, fat laces, name belts and backpieces were on display by the end of the 80s. I did one of my first pieces after a night out there with MIGEL's partner DEMO (R.I.P.), AZAD's little brother SCAN and KANT (R.I.P.) in MIGEL's old hall of fame in the Lützow tunnel.

Although the hall of fame wasn't legal, MIGEL always made sure that no strangers sprayed there without his permission. We painted with DEMO so we knew it wouldn't be a problem, and I knew him anyway. Until I changed schools, I had been in the same grade as MIGEL, DEKO and ROK, AMOK's younger brother, for two years. At the new school I met ZONE and we started to hang out. MIGEL's partner was a famous Berlin Writer called NEAR, and his tags were amongst the best in town. During school breaks he gave us hints on how to really style tags, and he also started to call me SEAR, which I later wrote in all possible variations. You could probably say that he was something of a mentor to me. At the same time a few guys hung out at my neighbour's, who called himself AERO. Amongst them was STONE, who later joined the T2B crew. We met regularly to compare our sketches and founded a crew called BANDITZ. It went on like that until January 1989 when ZONE met SHEK and KAGE.

At that time SHEK was already one of Berlin's best Writers. KAGE was experimenting a lot. He was in the same class as KAOS ONE and BAS2. In a way he was a blatant thief, who would always procure stuff for people at half price. He was a mad guy, a visionary, who from the start had very precise ideas about his art. He didn't put them into words but simply painted them.

One Saturday night in February 1989 ZONE told me that he had just seen pictures of a subway action with BAS 2, ASEK, KAGE and SHEK. This news got me thinking. Before that, I had known nothing about the New York underground culture and their sprayed trains. I considered the subway action in Berlin more of a dare although - or maybe because - that kind of thing hardly ever happened here. But the thought wouldn't leave my mind. I kept asking NEAR about it until he told me everything he knew. I was shocked to hear that allegedly all subway trains in New York were painted. What I didn't know was that this era was coming to an end in New York at precisely the moment when ours started in Berlin.

I managed to persuade KAGE and SHEK to take me along to the next bombing session. But there was a small problem. Until that day I had only used a can once or twice and I was still unskilled. I was more of a tag fanatic, a lover of the broad felt tip and my tags were on many train stations. So I thought I'd simply spray huge tags on the subway. But when I heard of the others' plans for end to ends and top to bottoms, i.e. very large pieces, I, too, wanted to paint under any circumstances. A week before we set off, SCAN, my homeboy KINO and I broke into a paint shop at night and I decided to go for pink and light blue.

I had no idea how much I would need and took 4 cans for the outlines and 5 for the fill-in of the letters. Of course that was way too much for four letters, especially because you need much less on steel than you would on a wall. But, as I should find out later, it was the right decision. On the night of March 15, 1989 it was finally time to go.

We had thought of a few locations and then decided on the subway stop "Berliner Straße" because it seemed to have a fairly quiet lay-up. There were four of us: SHEK, NECO, KAGE and me. After about 10 minutes I was finished. Metal is simply not like concrete. It all went very quickly and I was a little disappointed when I realised that the others would need another hour or so. I spent the rest of the time spraying two further panels. I had brought the right amount of paint after all. I painted with the standard caps on the cans. We painted all through the night to catch the train in the morning before it was cleaned.

SHEK and I waited on the platform and, when we finally took our pictures, we just about saw the faces of the policemen who rode past in another carriage but didn't realise what was going on right in front of their eyes. That night I sensed that KAGE was as hungry for action and adrenaline as I was. The next night around 9pm we went back to Berliner Straße. We did a few quicks on a train to satisfy our new hunger. From that moment there was only one type of graffiti for the two of us. In most of Berlin's subway lay-ups we could be sure to be the first Writers to leave our mark. Most of the time we simply ran from the station into the tunnel and waited inside the parked trains until the station was locked. After the last trains left, we took our time to scout out the emergency exits in the shafts.

In those days, unlike today, there was a conductor who stayed over night at every station and it was important to find out his schedule. I remember when I first tried real outlines with the red Crime Time piece, but for some reason I couldn't quite get it right. I was very hectic and KAGE just said, "Why don't you take a break. Sit down for a while, take a deep breath and continue with this cap in 10 minutes." He gave me a skinny cap, but this didn't really help. On top of that, because of the darkness, I forgot about the outline of the second star. The shaft was badly lit by a single bulb. During the following April of 1989 we stepped up our bombing regime. Whilst in the beginning we only did weekends, we soon started to go out midweek at night.

Sometimes during this April ZONE would come along, but for some reason he lost interest after a while. The only other Writers who knew about our springtime exploits were MAXIM, SHEK, NEAR and BAS 2. The others heard the odd rumour about our regular subway spraying, but some of them didn't really believe it. Somehow I could understand their disbelief because we were so young and inexperienced. It was something expected of older Writers, but we made quick progress.

During 1989 we didn't just bomb trains but painted every single hour we could spare. In daytime we bombed the walls of the S-Bahn line S1, at night we tagged the subway stations or something else. We already did much more than what was expected of Writers considered bombers in Berlin. In the beginning nobody else had seen our trains besides MAXIM.

We always ran into him sometime between 5 and 6am and we told him about our actions if he wasn't around for the actual bombing. Usually he'd then wait around to take a look at the images on their way to the buff. No one saw more subway pieces driving by than MAXIM. The other Writers at the corner could later see our photos, which caused quite a stir because every self-respecting bomber now wanted to do the subways, too. But soon most of them realised that it wasn't as simple as it seemed and we obviously wouldn't divulge any information about the locations. How we proceeded was another secret. This was something everyone was meant to find out for himself or herself. So even in May and June of 1989 it was down to a small gang of Writers to bomb the subway system after ZONE had stopped coming along: us and BAS 2, SICK and MAXIM.

One of them would occasionally join us - in the beginning having more than four people was still taboo. In May 1989 we started to do whole cars. The InterFameExpress was the first real subway whole car in Berlin. We had planned the entire event really well with about 50 spray cans. I painted in the Breitenbachplatz tunnel together with MAXIM and ASEK, spending more than three hours on the car. The InterFameExpress even rode around for a day before it was cleaned and it was spotted by quite a few Writers, proving that it was possible to see a sprayed subway whole car on the tracks.

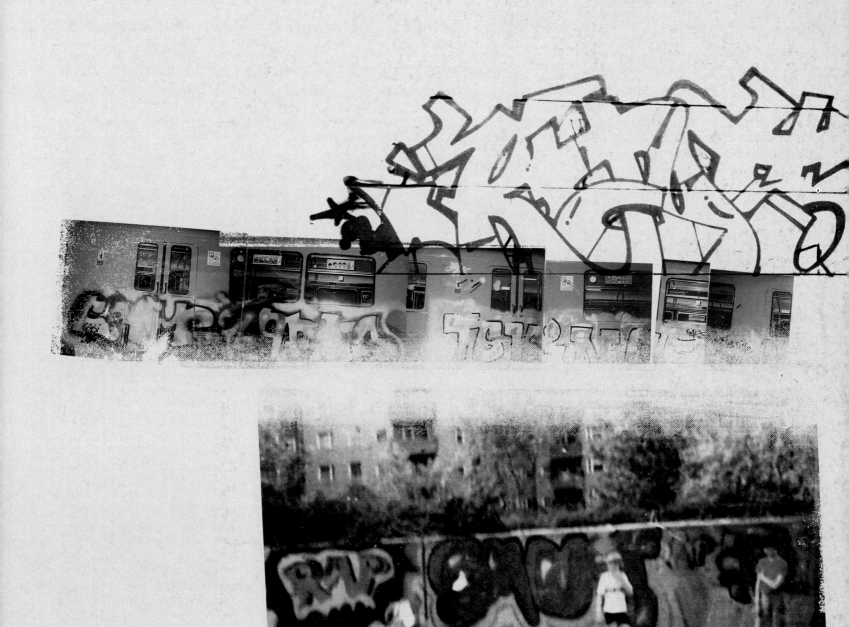

Four days later the first one man cars that KAGE and I had done followed at the lay-by "Platz der Luftbrücke" on the U6 line, directly beneath the Berlin police headquarters.

KAGE painted a coloured Stop Toys on his train, which came up behind a black skyline, while I did a SEAR blockbuster in silver accompanied by a vivid Ice Cold.

In June/July of 1989 we met more and more Writers who told us about their successful first attempts at spraying subways. But while the others did their first trains in the tunnels, KAGE, for example, had long been doing his famous end to ends without using any letters, just colours and designs. Although the actual idea wasn't KAGE's, he painted at least 14 end to ends in this style at a time when pretty much everyone in Berlin only cared about their own letters and style. In the summer of 1989 KAGE joined the GFA crew from Wedding. I followed a little later after a little battle with them on the walls of the S1 between Schöneberg and Yorkstraße. We started to do stuff with the crew, e.g. doing a carriage on both sides with character and all the trimmings at the subway stop at Hallesches Tor. We also did a whole car.

There was a girl called GINA in the GFA crew who also sprayed for a girl-only crew called CL, short for Crime Ladys or Comic Luzies. In early August 1989 GINA asked me to take her, LARI and SHERIN along to paint a subway. We agreed and on August 5, 1989 we went to the tunnel of Platz der Luftbrücke. The girls were too excited to do a proper piece. They were constantly asking for help and, in the end, they had me agreeing to do a Crime Ladys for them after I had completed half an end to end myself. After that night I really thought about whom I would take along and whom I wouldn't. But already the next day NECO called me from Kreuzberg and told me about a TV crew who were interested in filming us. We agreed to meet them two days later and, on the night of August 8, 1989, NECO, MIGEL, ROK, KAGE and I met up with three guys from the channel Sat1 at the tunnel of the U8 at Gesundbrunnen.

We decided that two of us should get locked in and later open the shaft on the street side for the rest of the gang. The shaft was very narrow and some of the TV crew had trouble getting their equipment through. But we had to have a serious talk with them when they decided to switch on massive lights for their shoot. I did a colourful TGKings for NECO's crew of which I also was a member.

I wanted to try something new and used the same colour for fill-in and background. To get the impact just right, I only hinted at the outlines. They featured the story a week later on Sat1's breakfast show introducing train bombing as the kids' brand new hobby. It was especially districts in the south of West Berlin such as Alt-Mariendorf, where the subway line U6 ended, and Lichtenrade, the end of the S2 line, which spawned a lot of young, talented Writers in the summer of 1989. These included BUS 126, BISAZ, SOR6, DEKOR, SNOR and BORN. And the same thing happened in the north of West Berlin. Up there the groups of Writers were so large that a number of Writers' corners were soon initiated. Different crews had their own stations at which to meet. Humboldthain station, for example, was the GFA crew's meeting point while the T5B met up at the next stop, Gesundbrunnen. Members of the AGS crew, on the other hand, had chosen Wittenau. These were all stops on the old S2 line. In the summer of 1989 you could sometimes meet 30 Writers or more in one spot.

Most of them were simply youngsters who thought spreading their name in the S-Bahn and their neighbourhood was a great game or adventure.

Somehow it all made sense. They were living in a big city, in an infamous district like Kreuzberg or Wedding, where street gangs had sprung up after they had watched the movie "Colors" in 1988. With the gangs came the urge to get a new identity and pseudonym. Only a few of them were any good at doing real pieces.

But there were also a few young people in West Berlin who put a lot of effort in developing their personal style, paving the way for future generations. A role in that was definitely played by excellent pieces by some old schoolers on the Berlin Wall, which ran alongside a number of subway stations and parallel to the S2 line. Word soon spread that something was happening up north on the S2. It was also at Gesundbrunnen that I first saw a train that remained in its painted state for a few days. It was an end to end by BOSE from the Märkische Viertel district with "It's bombing time" emblazoned across it. At only 14 he was one of the youngest train bombers. Soon after followed trains by SHANE, MORE, DAES, SOK, MOSH and many more. There was a real boom on the S2 by the end of 1989. It had all started in the summer with the first outside tags on S-Bahn trains.

By now everyone had gotten more self-confident and Writers from all districts went on a pilgrimage to the corners of the S2 to see the trains go past. There was so much interest that the corners would move from station to station, sometimes within the space of a few hours. In the end it was decided to use the checkpoint station Friedrichstraße as a fixed meeting point. The conductors there obviously noticed the whole commotion and the trains didn't really look like they used to either.

Trains, carriages and stations on the S1 and S2 were now smothered in tags, sometimes even real pieces. By West Berlin standards this was already a lot because now even the public took notice, while subway bombing carried on underground. But as mentioned above, in those days a number of fortunate circumstances joined forces. One of the main reasons why the trains continued to look like they did until the end of 1990 was the choice of Friedrichstraße station, which was also a border crossing checkpoint between the eastern and western parts of the city. It was definitely a smart choice to use a station situated in the eastern part of town, the so-called zone, under GDR rule and therefore not subject to western prosecution. The border guards at the station simply didn't care what we did to the trains. They differentiated between the station, which belonged to the GDR, and the trains, which were the property of West Germany.

So for quite some time we could simply draw throw-ups onto the carriages in clear view of everyone who disembarked at Friedrichstraße station. It was only forbidden to take photographs, and every once in a while we'd have to listen to some stupid sermons, but otherwise we were free to do what we wanted. Unfortunately, these heavenly conditions for sprayers only lasted for a few months. The fall of the Berlin Wall in late 1989 marked the symbolic ending of the first big phase of train bombing in Berlin. But just a year later, in 1990, Germany's reunification and the opening up of East Berlin's huge S-Bahn system provided new challenges for Writers and kicked off a new rush of train bombing to outshine anything done before. But that's a different story.

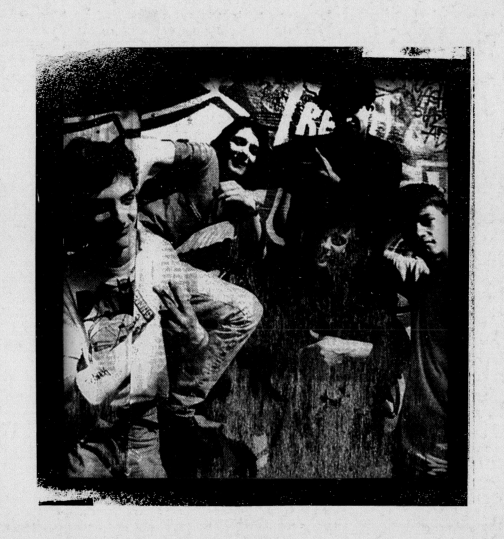

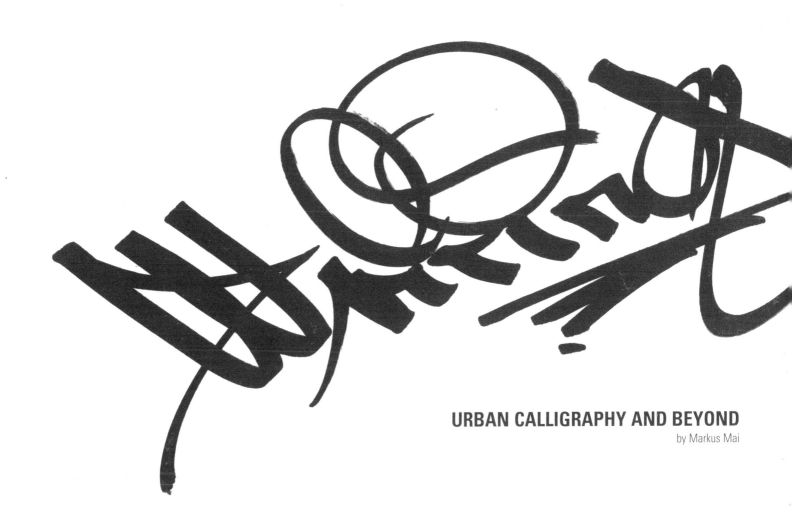

URBAN CALLIGRAPHY AND BEYOND

by Markus Mai

CONTENT

Writing is culture. It's an integral part of hip-hop culture, an essential part of modern urban culture. Graffiti. Tags, throw-ups and pieces. Names, statements, logos. Written illegally or sprayed to order. Messages in the city and to the city. Omnipresent.

From its beginnings in New York in the 1970s Writing has become a modern form of representation whose historical interpretations have gone from cave paintings to the political slogans of the 1960s. It has quickly influenced and captivated youth all over the world. Whether they're sending a signal, being different, being provocative, spreading their fame, creating, thrilling in illegality or finding and expressing their identity, Writers are leaving their mark.

In a way, the development of Writing can be compared to the history of jazz - a "visual jazz" as it were. Like in jazz, there are affectations in Writing. There are also many rules that should be obeyed and, therefore, room to deviate from them and to improvise. In both disciplines it is absolutely imperative for one to master technique before one can develop a personal style.

The Writer develops his or her personal style out of a clearly defined canon of forms, which stem from the Latin alphabet. He or she then improvises with further forms and surfaces. It's not unusual for Writers to spend years fine-tuning their styles with markers before they trust themselves to spray paint a wall. Progression is made through the combination of personal development, local elements of style and international influences. European Writing is different from its American and Asian counterparts, but the roots are the same.

In the past, countless books, films, movies, TV programmes and magazine articles have helped to develop Writing's mythology. In the process, they have documented it for the Writing scene beyond the allegation of selling out. And they have made it comprehensible for a general public beyond the allegation of vandalism.

Nowadays, tags are so ubiquitous that they have become practically invisible in an urban camouflage. The public is jaded. Property owners and public transportation companies have mechanised their reactions to graffiti. The graffiti is now removed from subway cars more quickly than it can be created. Graffiti's style and illegal allure have been co-opted into our daily lives and consumer culture for quite some time. Today, Writing is used in advertisements for Coca Cola and Nike while gaming consoles such as the "Jetset Radio" have even introduced it into children's rooms. On the one hand, Calvin Klein's fashion empire is making money with the work of Writing icons Delta, Futura 2000 and Reas that it has emblazoned on its perfume flacons. On the other hand, Agnes B., another fashion label, is opening the door for Writers to the international art market with its "Galerie du Jour". The Writers of the 1980s and 90s have become art directors, DJs, fashion executives, professional athletes, journalists and artists. They are still Writers and will always remain so. The strength to continue evolving lies in the exchanges that are taking place between these worlds.

This book takes up this very subject matter because, if there's excitement to be found, it exists in the aesthetics of Writing, the quality of the ideas, the energy of those involved, the personal forms of expression, the reactions and the opposing concepts - in other words, in the continual development of the Writer's character systems and original tactics.

When one looks at the phenomenon of Writing today, one sees a multifaceted picture. Those involved divide themselves into fundamentalists, followers, sceptics, adversaries and the avant-garde. All of them are similarly incorrigible. One group wants to perpetuate Writing's origins, the other wants to earn money, yet another just wants to participate or master a problem. The people who interest us the most in this book and who increasingly impressed us belong to group with very different roots. They form a group, which has made the aesthetics of Writing its own and has developed them further until they have not only reached their boundaries, but have also exceeded them.

FOREWORD

That is why the book's subtitle is "Urban Calligraphy and Beyond". In this perspective we have included Writers, who work on the details of letters, words and alphabets. Others are included, who have moved beyond the two dimensional sketchbook and wall to develop three dimensional objects or motion graphics. And yet others are included who, with a graphic design or art background, interact with Writing elements in a surprising or even playful way. The last chapter "Urban :: Art :: Activism" features artists, who use Writing's approaches, but whose messages do not have much to do with written calligraphy. They infiltrate a (public) space, leave a message there and then withdraw themselves quickly without being recognised. We call these methods "urban tactics".

Because we find this variety inspiring, we have done broad research. We have consciously sought out contrasts, have tried to be provocative and have concentrated on an aesthetic debate instead of a social one. The foundation for a culture's continuity is established where things are still brewing, where change, improvement, intensification and renewal are taking place.

In this sense, this book can neither be a historical documentation of the graffiti scene, nor does it want to be. This is because this history is based on a multitude of its protagonists' very personal stories. If it would be possible to present it at all, Writing's historical development as whole would have to be presented in an encyclopaedic textbook. This book makes no claim to offer an exhaustive listing of all graffiti protagonists. Rather, it concentrates on the aspect of Writing, which represents an important sector of the graffiti scene. By revealing Writing's aesthetic rules, it also tries to be an objective approach to this subject. The "historical" part is meant to be exemplary. These subjective stories represent only two of the many personal experiences of those who wrote graffiti's history. As such, we have clearly separated them from the rest of the book. This book is structured so that both an insider and an interested outsider are given the possibility to access the subject of Writing step by step. That is why the book begins with ubiquitous tags and then breaks these down systematically into alphabets. Next, the book traces the foundation of Writing's inspirations and its canon of forms, points out the multiple influences on Writing from related disciplines and then develops the principles of further expression for the future.

One could summarize our structure with this formula:

What?: What is Writing?
How?: How do Writers do it?
Why?: Why does Writing look the way it does?
Where?: Where are Writing's boundaries?
Whereto?: Whereto will Writing develop in the future?

This book presents aspects of Writing's development in the following chapters:

- Foreword and History
- Tag / Throw-Up
- Letter / Word
- 2D-3D
- Analogy
- Object
- Graphics
- Urban :: Art :: Activism

In addition to the authors' objective chapter introductions, we have included direct quotes from various Writers, which illustrate their personal perspectives. Unpolished, antithetical and direct, they should serve as inspiration or as reason for debate.

Robert Klanten
with Sven Ehmann and Markus Mai
May 2003

TAG / THROW-UP

The tag is a Writer's signature. It should be both readable and original. The tag's fundamental attribute is that it not only attempts to convey information, but also to organize a surface concisely. In determining a tag's content, the definition of the surface(s) and the intended expression are strongly interconnected. Almost every tag contains an element that seeks to take possession of a space. Similar to a pack of wolves spraying their scent, street gangs originally used tags to mark their territory. In order to serve this purpose, they needed to be unique and clearly readable. This also explains attempts to take over a space with a tag by making it look self-assured, wide or fat.

A tag defines a site, an area or a viewpoint and claims it as its own. As this visual language becomes more pervasive, however, individual style has come to characterize tags more than readability. Writers now identify and define themselves through the creation of these expressive emblems. As in Asian calligraphy, the Writer's movements and the tools that he or she uses are both decisive to the form that a tag takes. In addition to industrially produced markers, custom-made markers of various thickness and material are used. The amplification of the tag is the throw-up. This is not necessarily a Writer's signature, but it often contains small details, which paint a picture of the author for those in the know.

● **Phos 4** :: Berlin :: 2003

● **Bas Two** :: Berlin :: 2000

● **Kaos** :: Berlin :: 1988

● **Maxim** :: Berlin :: 2003

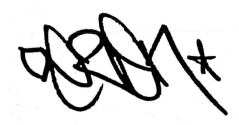

● **Dezon** :: Berlin :: 1989

● **Delta** :: Amsterdam :: 2002

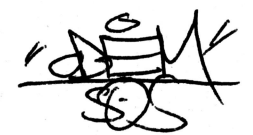

● **Odem** :: Berlin :: 1991

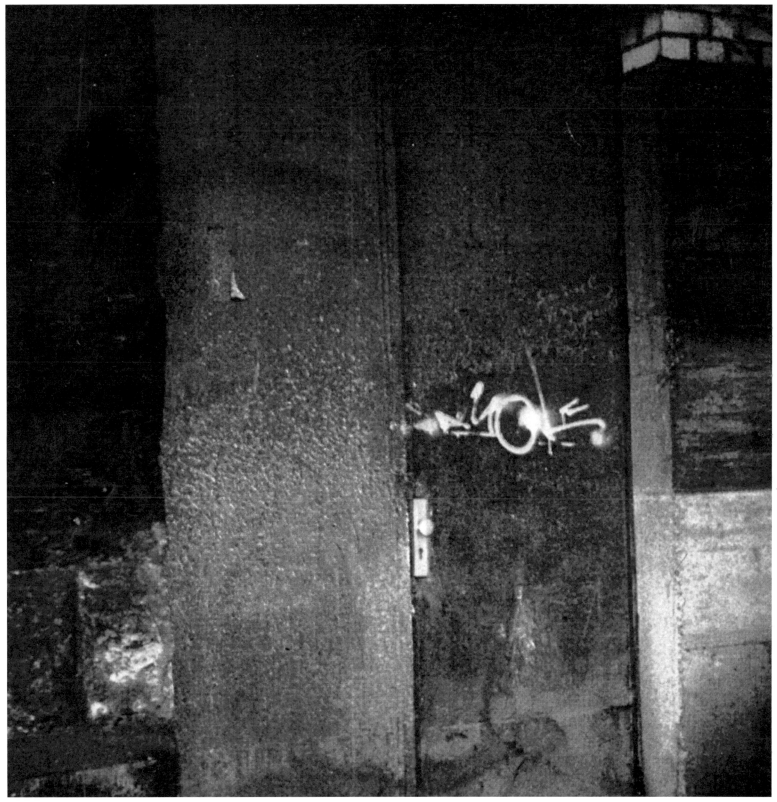

● **Amok** :: Berlin :: 1991

Various Writers :: 1987 - 2003

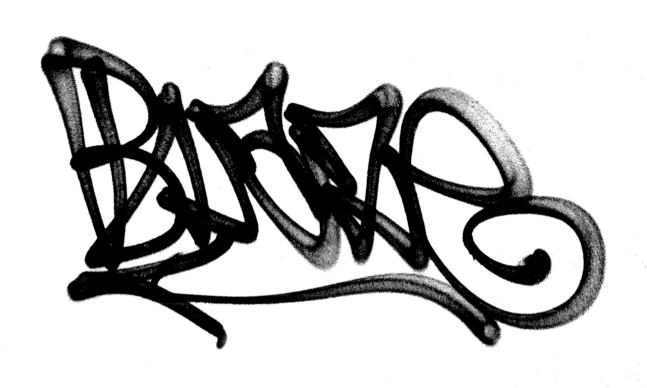

● **Blaze** :: Berlin :: 2002

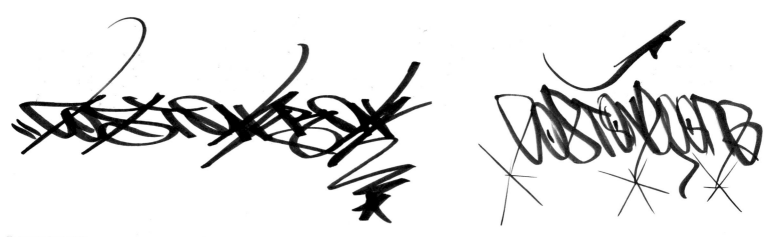

● **Tagnoe** :: Berlin :: 2003

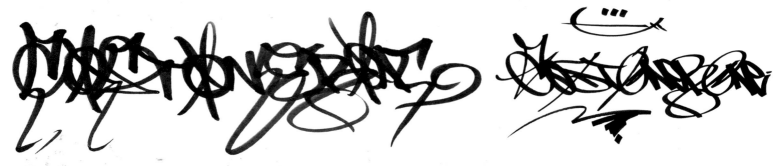

● **Tagnoe** :: Berlin :: 2003

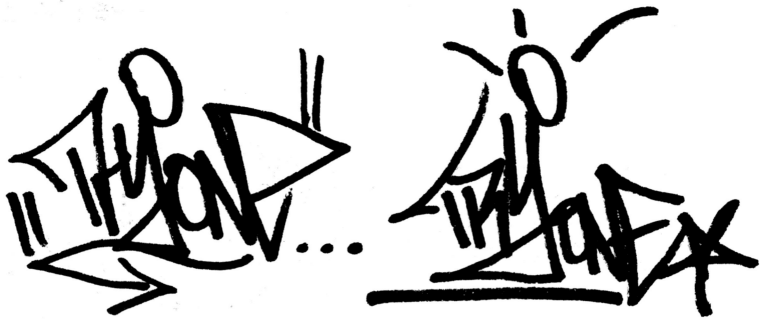

● **Try One** :: Berlin :: 2003

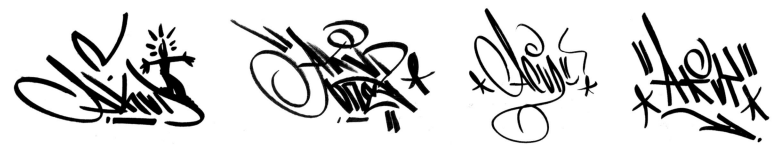

● **Akud** :: Berlin :: 2001

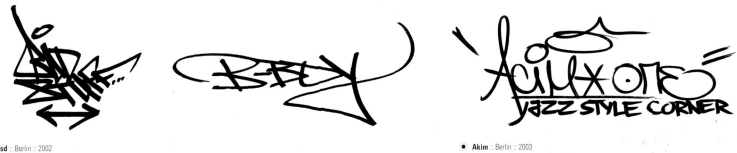

● **Zasd** :: Berlin :: 2002

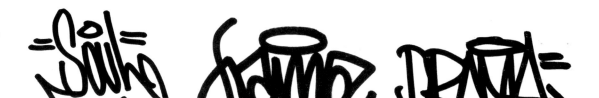

● **Akim** :: Berlin :: 2003

● **Drama** :: Berlin :: 2003

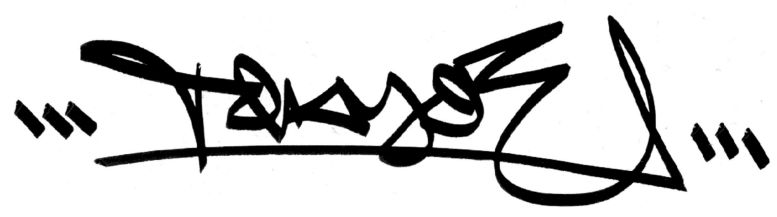

● **Tokioe** :: Berlin :: 2003

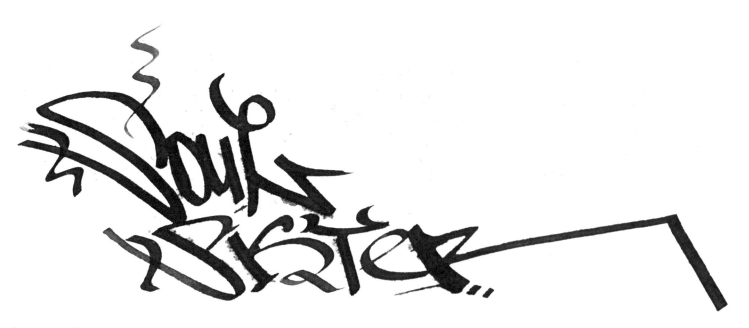

● **Zasd** :: Berlin :: 2003

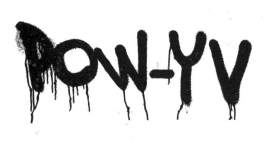

● **Masa** :: Caracas Venezuela :: 2003

● **Raza** :: Caracas Venezuela :: 2003

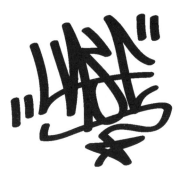

● **Hase** :: Caracas Venezuela :: 2003

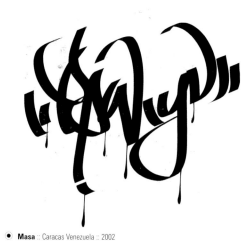

● **Masa** :: Caracas Venezuela :: 2002

● **Masa** :: Caracas Venezuela :: 2002

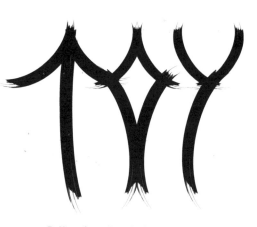

● **Masa** :: Caracas Venezuela :: 2003

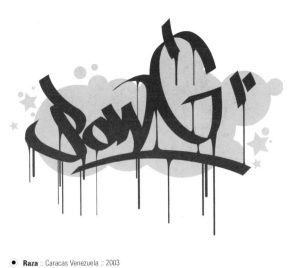

● **Raza** :: Caracas Venezuela :: 2003

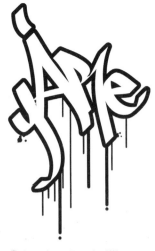

● **Raza** :: Caracas Venezuela :: 2003

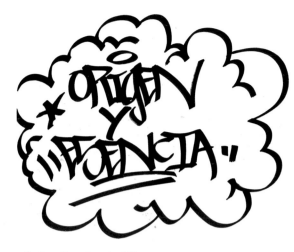

● **Masa** :: Caracas Venezuela :: 2000

● **Gel** :: Berlin :: 2003

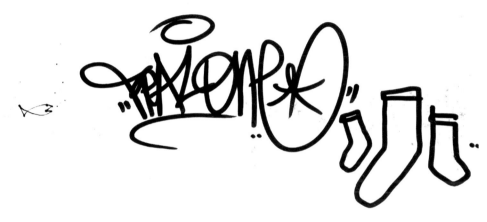

● **Reaz One** :: Germany :: 2003

● **Seak Punk** :: Berlin :: 2003

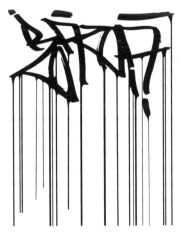

● **Raza** :: Caracas Venezuela :: 2003

● **Metra** :: Caracas Venezuela :: 1999

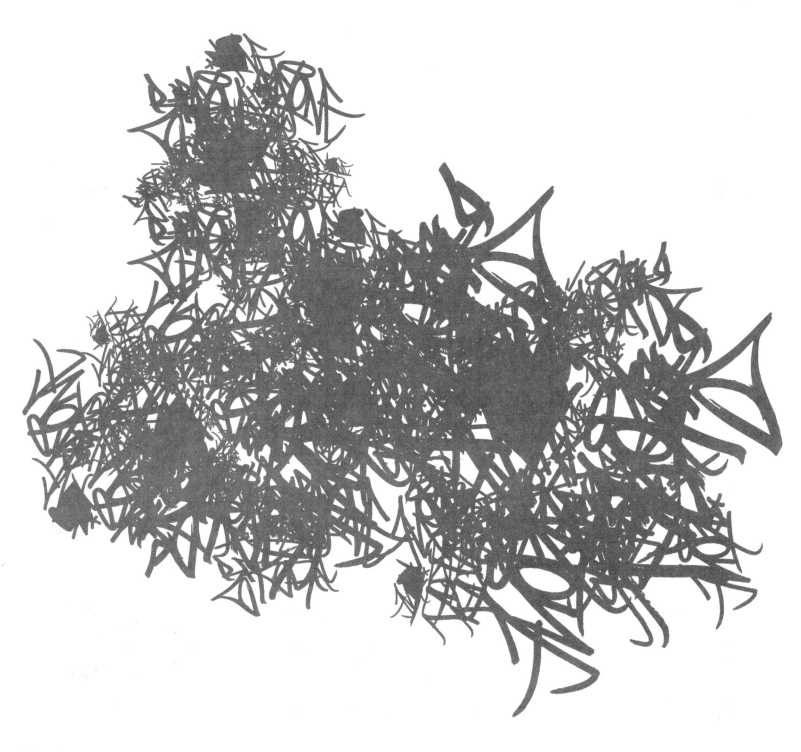

Masa :: Caracas Venezuela :: 2003

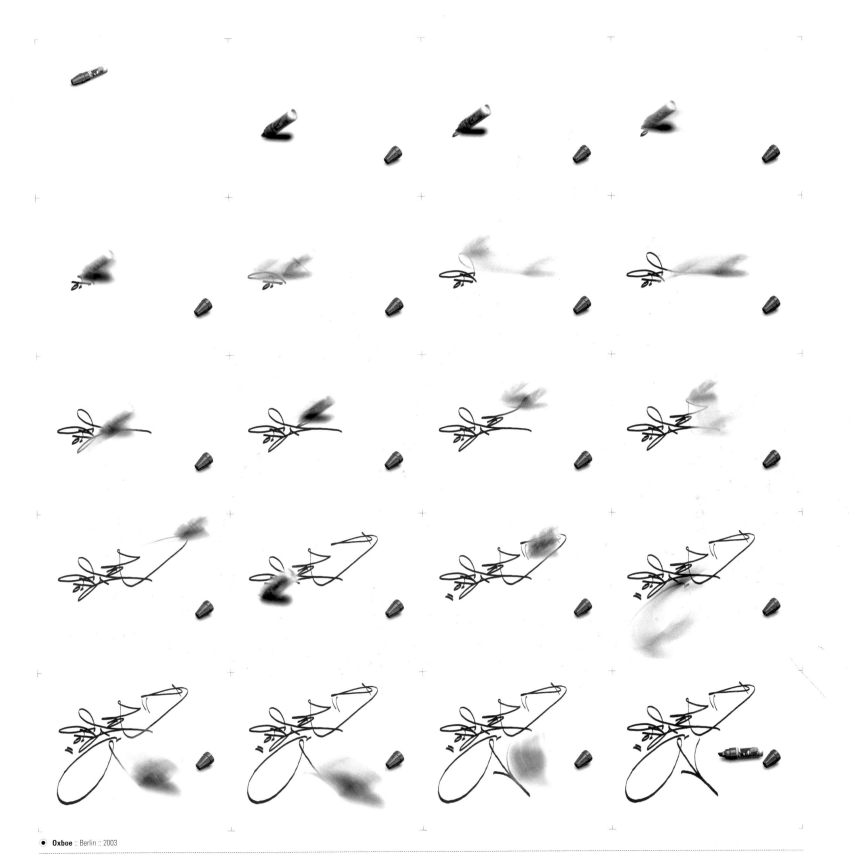

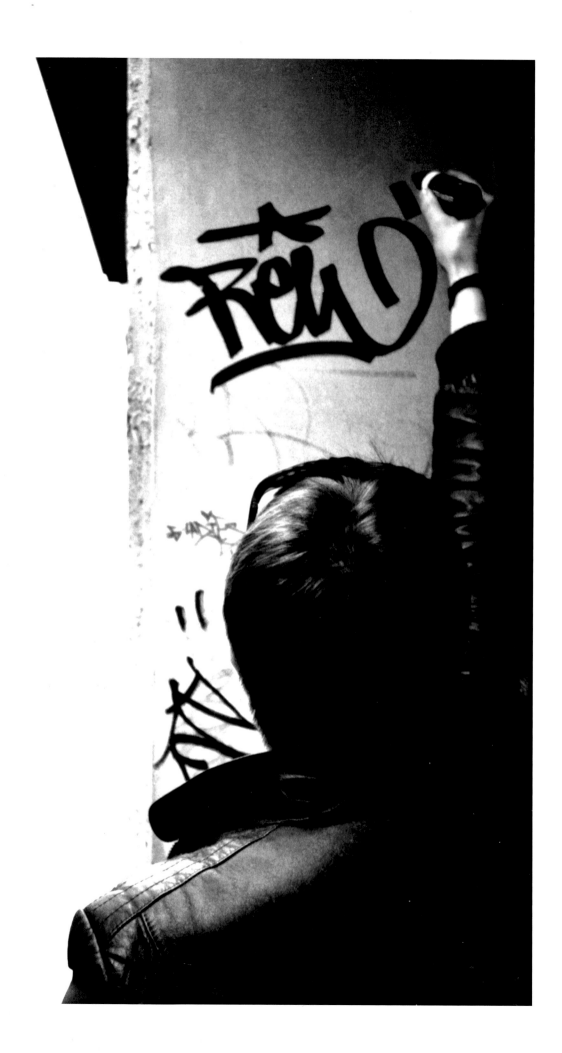

REW
THE INDIVIDUALITY AND BEAUTY OF THE TAG

Who or what's behind it? This is a question many Writers ask themselves when they flip through one of the many Writers' magazines or walk down the street. Once they see a tag they like or one that means something to them, they want to know who and what story is behind it. The point is: "...one they like or one that means something to them..." - because to the majority of people, who hardly ever think about this aspect or simply don't understand it, the shapes and histories of tags mean absolutely nothing, least of all appeal to them. "I enjoy those large, vivid images! But I don't see the point of the small, black scribbles on the wall. Those are ugly!" Sound familiar? Maybe it's even something that you've said yourself in an unguarded moment...

And maybe, without thinking, you also find the disabled, smelly or poorly dressed person in the subway entrance off-putting. And this without ever having considered his possibly extraordinary, fascinating history, his potential beauty and how this person - who or whatever he might be - might even be able to show you hitherto unknown worlds and views that might change a part of you or even your entire life. The same applies to a tag. Because it, too, is governed by a universal rule, which, unfortunately, most people decide to disregard: "Never judge a book by its cover!" Wear a suit and you're good, wear something that deviates from the norm and you become suspicious. I should point out that there will always be people who, even if they are familiar with the subject of tags, simply don't like their aesthetics and would rather see a pristine wall. These people get extremely upset when it becomes "soiled" again. This is a topic that should be considered in a different discussion on property and personal values. I would like to talk about the tag itself instead, its form and its essence. I'd like to talk about the fact that a tag is very different from banal "smears" such as a few random brushstrokes in a room that's about to be repainted anyway. Tags are the result of very specific needs that have accompanied humanity for thousands of years. Tags are about spreading a message, about drawing attention to something. For example, in a corridor you might see a number of tags. Because you are seeing them together in one place, they tell you that the names of these Writers belong to a specific crew. Then you might remember that this group of Writers hails from a very different part of town. You deduct that there might have been a party in this house that was attended by these Writers. Maybe you then ask yourself if one of them or which one of them might even live in the building. This is just one example of a tag communicating something and telling its very own story.

No matter if 74,000 posters all over the city shout out that a new Volvo is finally available, or if Peter lets Maria know that he has fallen for her on the wall that's on her way to school, or if a Writer leaves his tag at representative locations - the parallels are obvious. Especially when it comes to Writing, there are a number of different reasons for tagging. The most obvious one is fame and recognition from simply generating as many tags as possible at many conspicuous locations in different parts of a city or district. Another big motivation for tagging, and this is an aspect I'd like to emphasise here, is working with many different styles!

In addition to spreading their own name, there are some Writers who place a lot of importance on the form and the individual style of a tag. This might be about how an "R" or an "S" should be shaped, what the ideal proportions are, if it would look better broad and long or slim and tall, if a certain line of a letter should be long or short, if it should be round and curved or straight and angular, if the transition between the letters should be gradual or distinctly separate, or which, if any, further elements or other ornaments should appear next to the tag. Such criteria and viewpoints are used to define and measure the quality of your own tags and those of other Writers.

Based on this, it is easy to see and understand that not each and every one, but a large number of the tags we encounter in the streets (and fortunately every once in a while still on trains) possess individuality and beauty as defined by the studied commitment to the task and the constant evolution of an individual, stylish tag honed by years of practice. And this is comparable to a well-respected artistic discipline - calligraphy. Many people around the world involve themselves with this type of character design and they, too, have a passion for the medium. They study it and, through constant practice, they also undergo the process of improving their own style and, in the end, submerge themselves in the work they have come to love. Reflecting on this thought, especially when once again you catch yourself thinking of tags as a public nuisance and pollution not unlike indiscriminately discarding bulky rubbish impairing the so-called "standard of living" or when you simply pass an uninterested, superficial glance over it, reflecting this might make it easier to understand why tags exist and why they are much more than the senseless product of a thoughtless spur of the moment decision.

The New York writer DASH once told me that in New York, unlike in Europe most of the time, kids who started Writing often only did tags and throw-ups for ten years or so before they started on their first detailed, elaborate and worked out piece or even drew a sketch of it. Then he asked me, "When one of those kids, after many years, has reached the point where he wants to give his tags a little more shape and style and thereby more expressiveness, and he starts to do his first sketches and to spray his first pieces - can you imagine, considering the long schooling he's had, what kind of swing his hand already possesses at that point?"

After he had told me this, a lot of the extremely dynamic tags and masterpieces from New York came back to mind which, when I first saw them, had simply triggered a "Wow! Those tags and pieces are damn fresh!" They really stuck in my head and didn't just play a major part in making Writing something that will be with me for a long time, maybe my entire life, but also proved to me that tags have the power to trigger very distinct moods and feelings. I sense incredible joy when I see an extraordinarily good tag or one by a foreign Writer, which shows me that he's been in town recently.

Tags tell me their stories and, in doing so, make me a part of an invisible network in this city. This reinforces a feeling of affiliation with the people who share my love and passion for the cause. It unites me to them in a special way without having to have them around me all the time. It offers me a foothold. I am not alone... There are people in this world who are more comfortable in neighbourhoods where the streets are decorated with thousands of tags, throw-ups, rooftops, silver pieces, stickers and posters than in a squeaky clean "everything looks the same" prefab suburb with gaudy family homes surrounded by same-size gardens. You'd better be prepared for it...

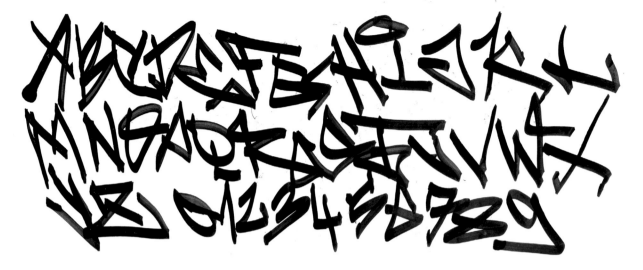

● **Keor** :: Berlin :: 2003

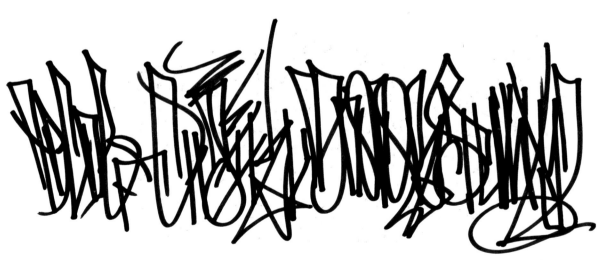

● **Phos 4** :: Berlin :: 2003

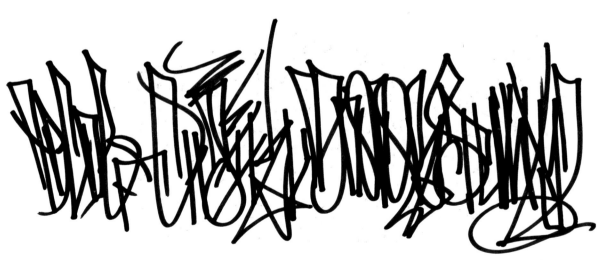

● **Tagnoe** :: Berlin :: 2003

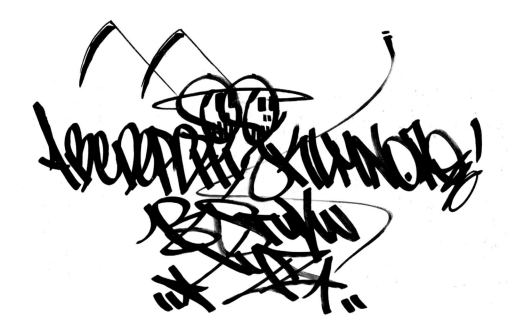

● **Tagnoe** :: Berlin :: 2003

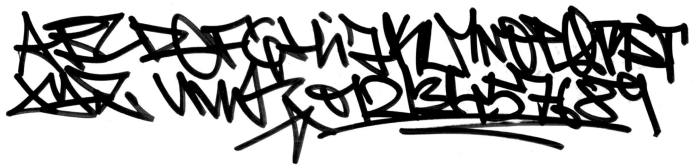

● **Rider** :: Berlin :: 2003

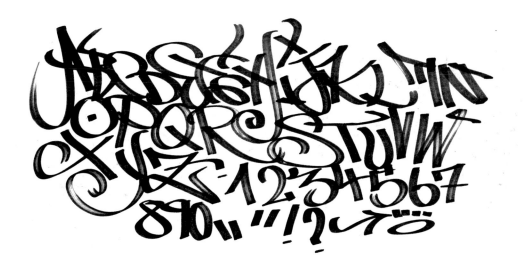

● **Zasd** :: Berlin :: 2003

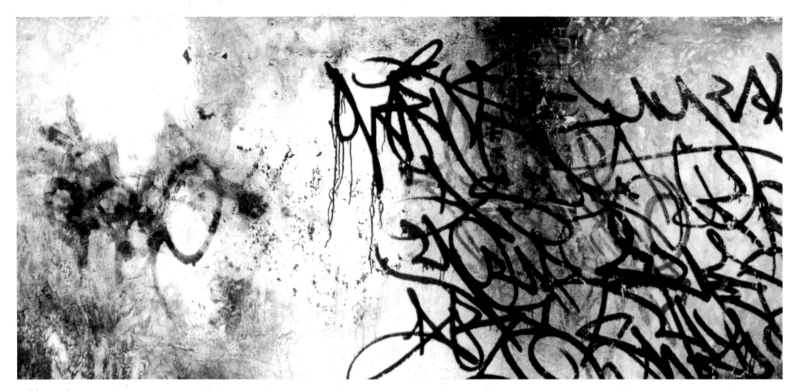

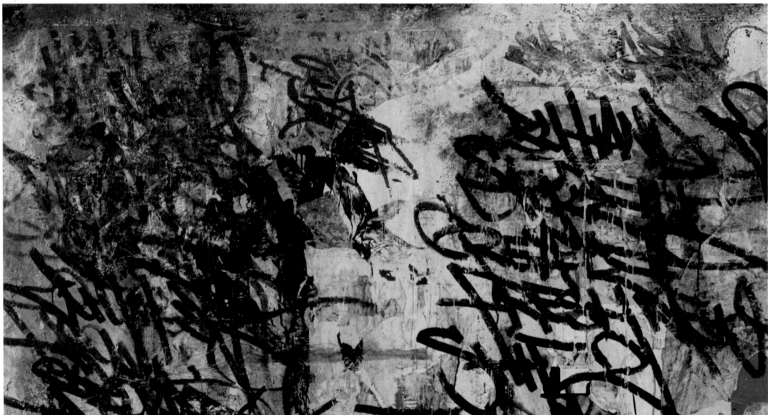

● **Ease** :: New York :: 2002

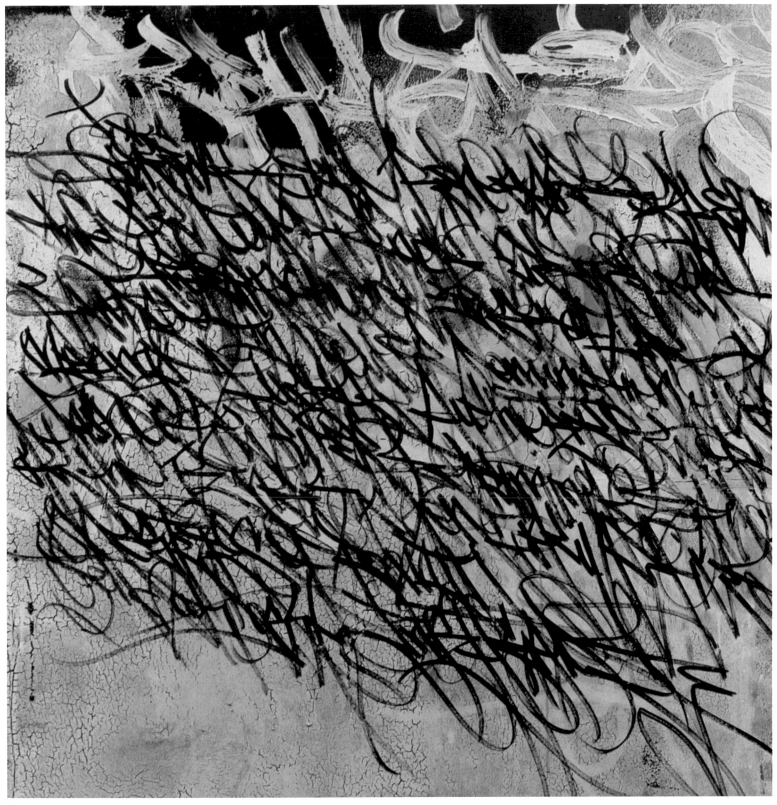

● **Ease** :: New York :: 2002

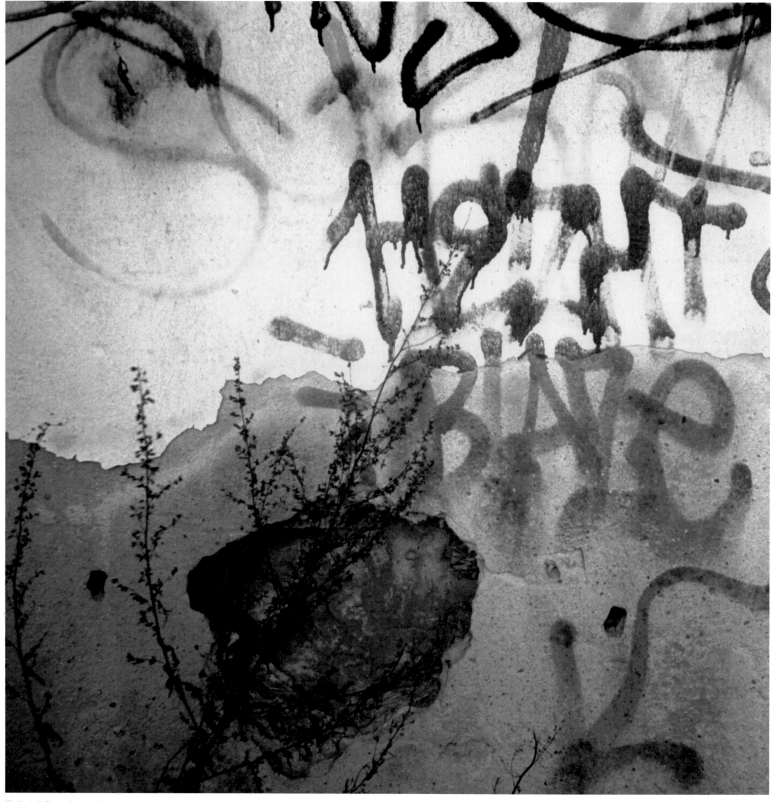

Hesht & Blaze :: Berlin :: 2003

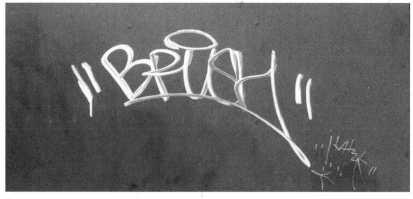

● **Brush** :: Amsterdam :: 2002

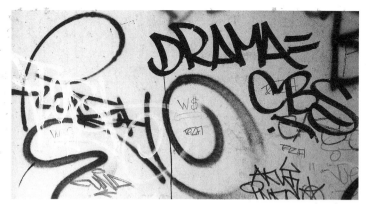

● **Flash** :: Berlin :: 1997

● **Zec Oner** :: Paris :: 2002

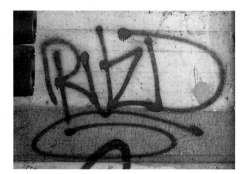

● **Ruzd** :: Berlin :: 2002

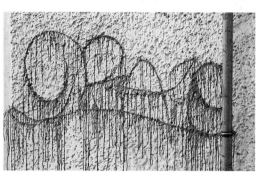

● **Grace** :: Berlin :: 2002

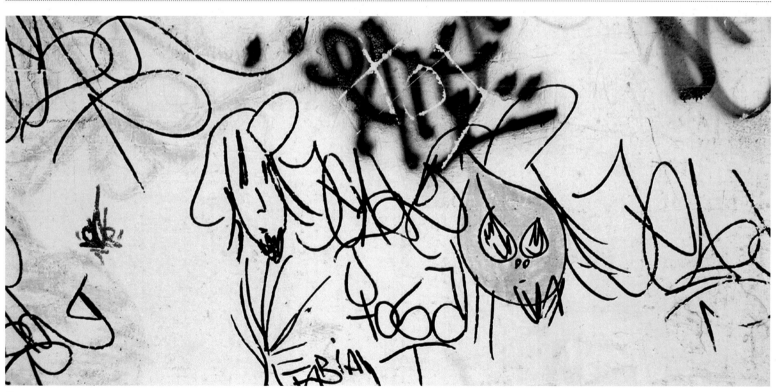

● **Flavio B** :: Santiago de Chile :: 2003

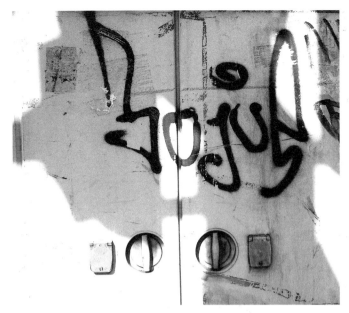

● **Bojus** :: Berlin :: 1987

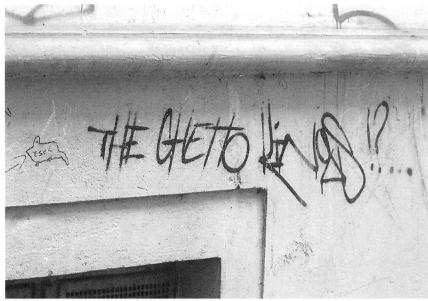

● **Neco** :: Berlin :: 1989

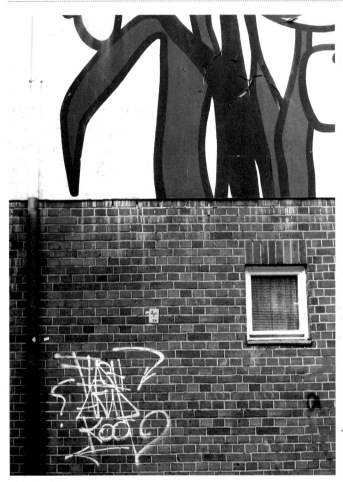

● **Flash** :: Berlin :: 2002

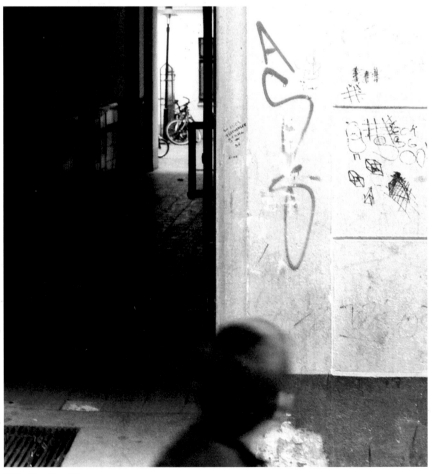

● **Kool Q** :: Berlin :: 1995

● **Akim** :: Berlin :: 2003

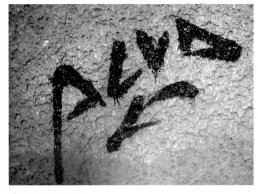

● **Acud** :: Berlin :: 2002

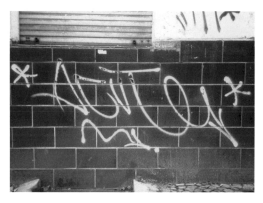

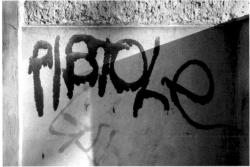

● **Pistole** :: Berlin :: 2003

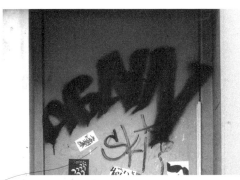

● **Again** :: Amsterdam :: 2002

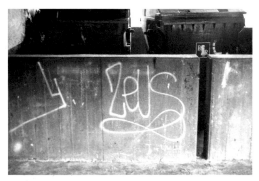

● **Zeus** :: Berlin :: 1999

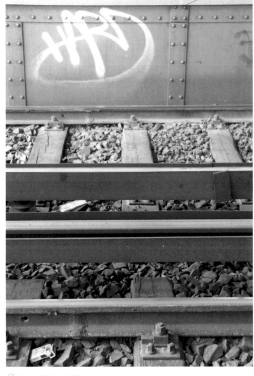
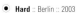

● **Hard** :: Berlin :: 2003

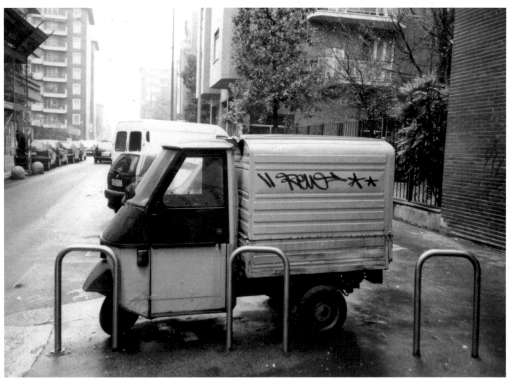

● **Rew** :: Italy :: 2001

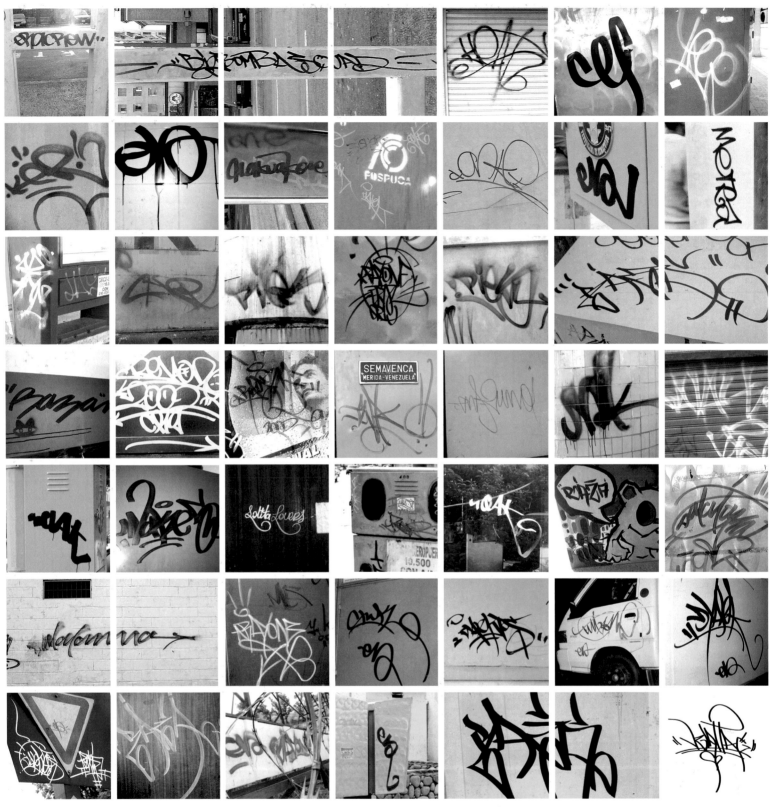

● **Various Writers** :: Caracas Venezuela :: 2003

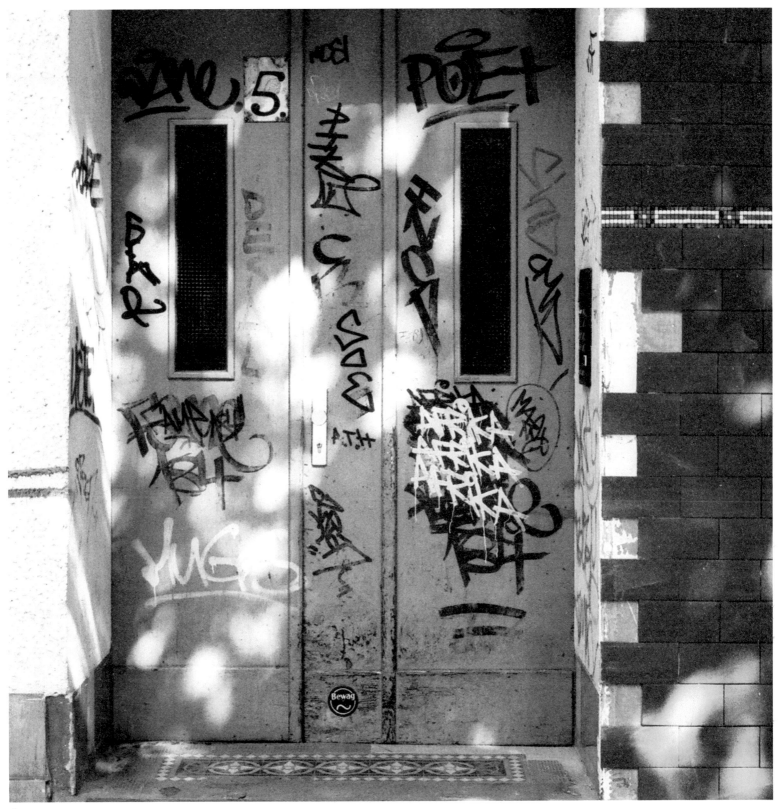

● **Dane** :: **Poet** :: **Inca** :: **Fame 184** :: **Hugs** :: Berlin :: 2000

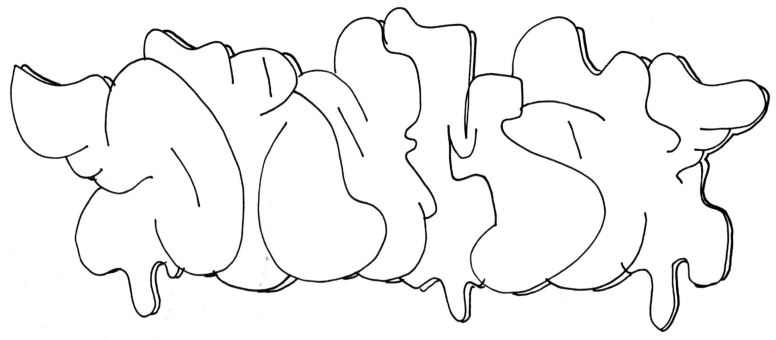

● **Drama** :: Berlin :: 2003

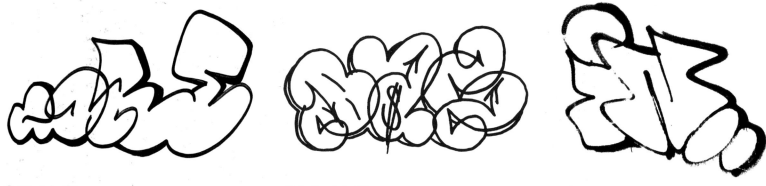

● **Milk** :: Berlin :: 2003 ● **Bas Two** :: Berlin :: 2000 ● **Inca** :: Berlin :: 1997

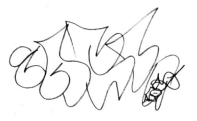 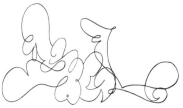 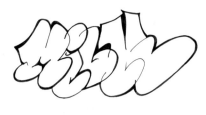

● **Bas Two** :: Berlin :: 2000 ● **Yok One** :: Berlin :: 2001 ● **Milk** :: Berlin :: 2003

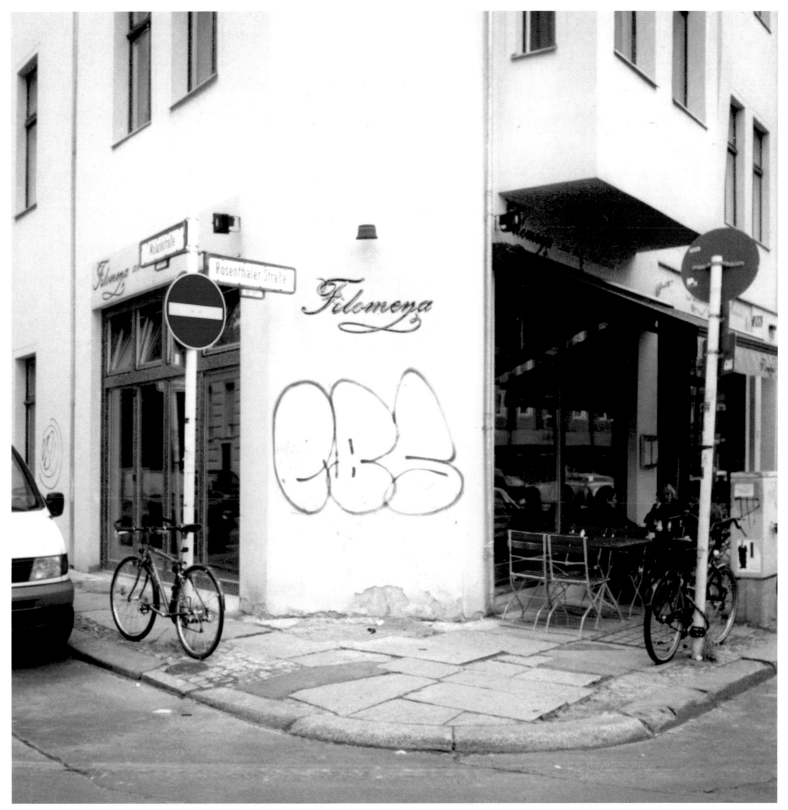

● **Drama** :: Berlin :: 2001

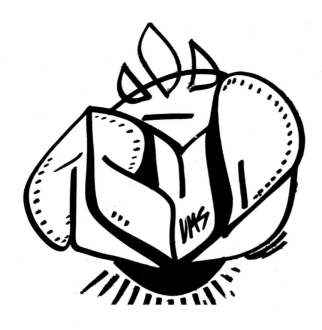

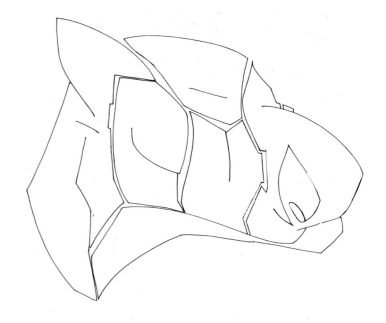

● **Acud** :: Berlin :: 2002

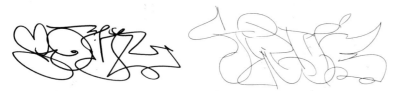

● **Zasd** :: Berlin :: 2003
● **Akim** :: Berlin :: 2003

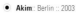

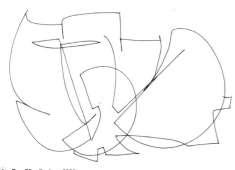

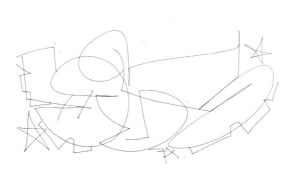

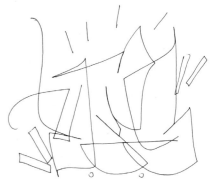

● **Dez 78** :: Berlin :: 2003

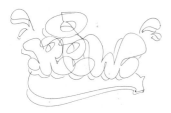

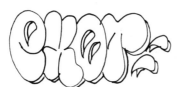

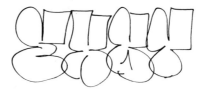

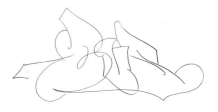

● **Rew** :: Berlin :: 2003
● **Exot** :: Berlin :: 2003
● **Bus 126** :: Berlin :: 2002

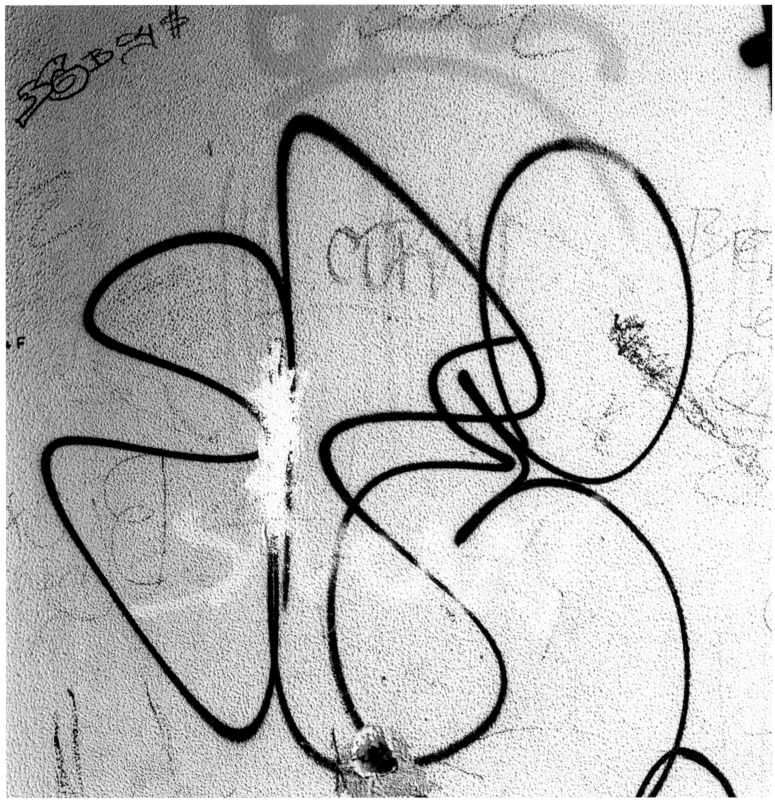

● **Neco** :: Berlin :: 1989

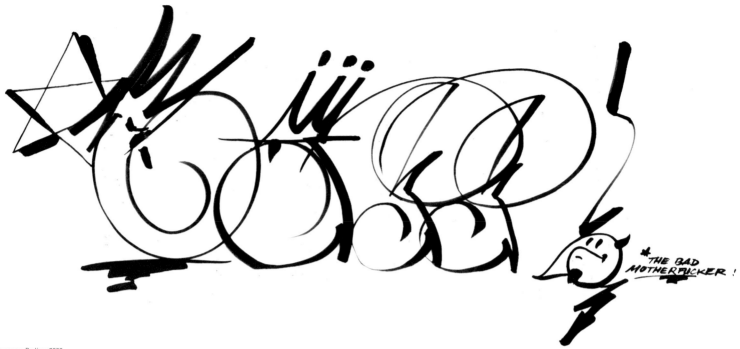

The BAD MOTHERFUCKER!

● **Tagnoe** :: Berlin :: 2003

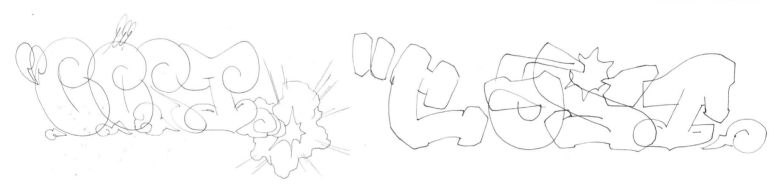

● **Tagnoe** :: Berlin :: 2003

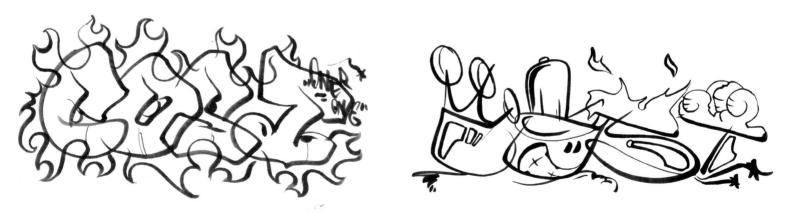

● **Tagnoe** :: Berlin :: 2003

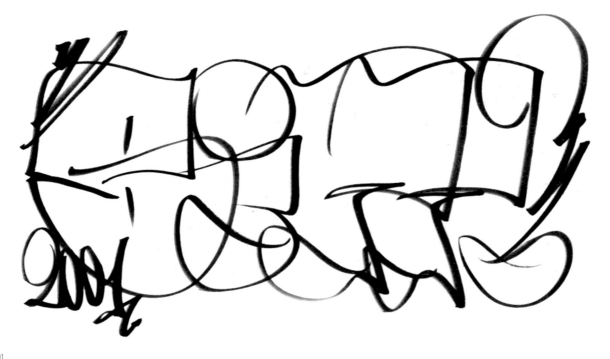

● **Tagnoe** :: Berlin :: 2001

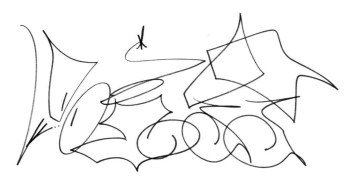

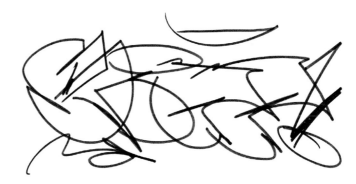

● **Tagnoe** :: Berlin :: 2001

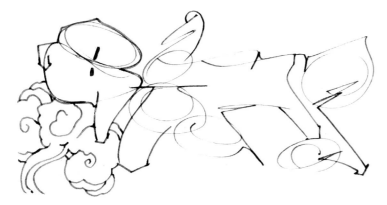

● **Tagnoe** :: Berlin :: 2001

DRAMA
THEY ARE EVERYWHERE

I look at pictures of New York, Berlin, Amsterdam, Copenhagen and Paris. They are images of street scenes, pulsating with life. Mothers pushing through tags with their shopping while alcoholics seem to guard the throw-ups. Worldwide, throw-ups have become an integral part of the streets and graffiti scenes. They have left their indelible mark on every big city. Like wild animals they may hide in the smallest corner, tower on walls like large monsters or start an aimless, antlike crawl across any surface imaginable. They are like a plague, but with one important difference - they don't paralyse cities, but enliven them.

Throw-ups reflect the mentality of their cities. Rough and raw, in New York they seem intent on intimidation, as if they want to put her in her place. In Sao Paolo, on the other hand, they are like flowers spreading happiness with their lovable richness of detail. Throw-ups have only begun to cast their spell over European cities within the last few years. Quite possibly, this is because, as a very extreme type of bombing, their originality wasn't recognised for a long time. The appeal of a throw-up lies in its pure shape and simplicity, but also in its unadulterated honesty. A throw-up, as a spontaneous creation, reflects the skill of its Writer. It acts as a snapshot of every one of his or her emotions. For most Writers, throw-ups and tags have become part of their everyday routines, almost like brushing their teeth. It can take years to develop a personal style and that's why throw-ups are so difficult to copy.

But what is the essence of a throw-up? It is lines, often just one, which, in a single draught, shape letters to become a word. Throw-ups play with the line, which is undoubtedly drawing's most important building block after the dot. Many Writers unconsciously include them in the background or positioning of a composition, creating the throw-up's message, which cannot be corrupted. From the depths of subway shafts up to the streets and even the roofs, they are everywhere. Another message contained in the throw-up is the free use of letters. There are no rules about proportion or authenticity. The style of lines is as diverse as the people who play with it. There can be no good or bad graffiti, only respect or the lack of it - and that's what it's all about in the game of fame and style.

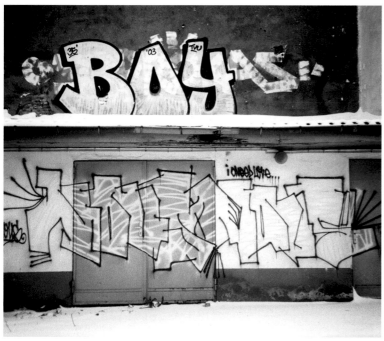

● **Boy & Nous** :: Berlin :: 2003

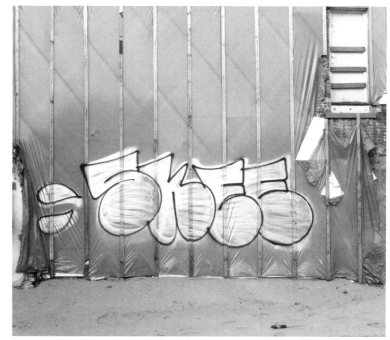

● **Skee** :: Amsterdam :: 2002

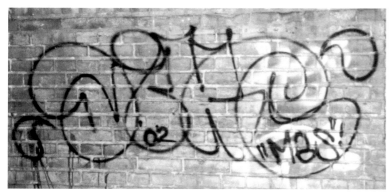

● **Dike** :: Berlin :: 2002

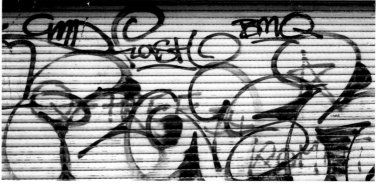

● **Flash** :: Berlin :: 1997

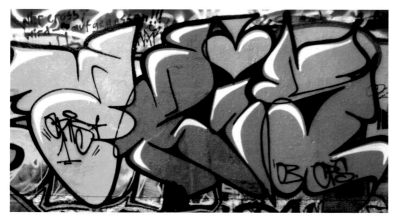

● **Aris** :: Berlin :: 2003

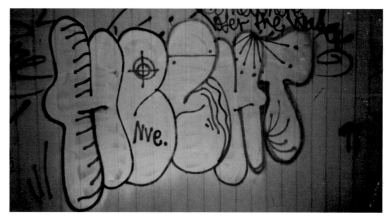

● **Hesht** :: Berlin :: 2003

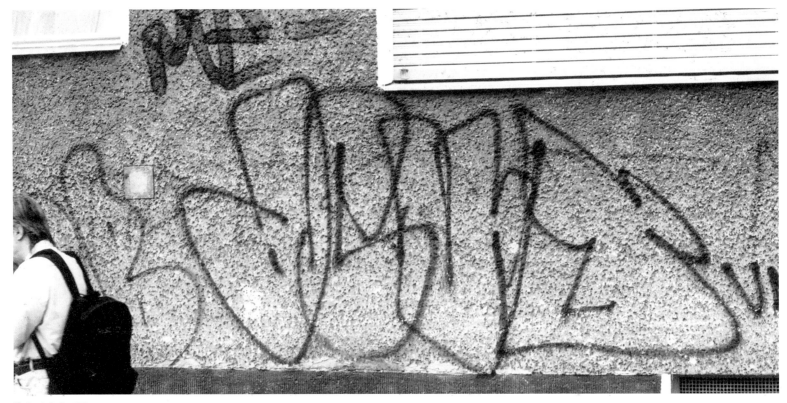

● **Acud** :: Berlin :: 2002

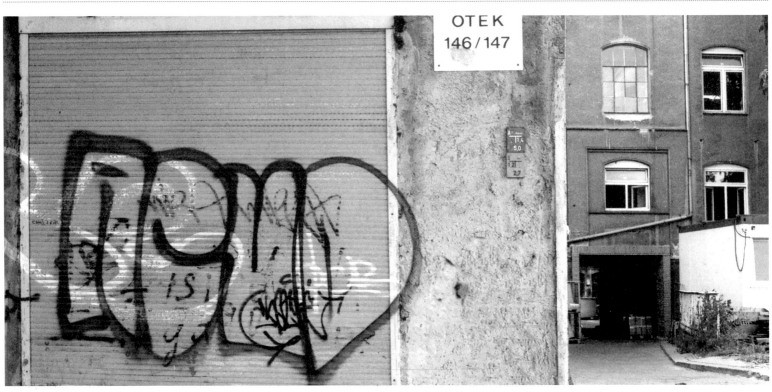

● **Acud** :: Berlin :: 2002

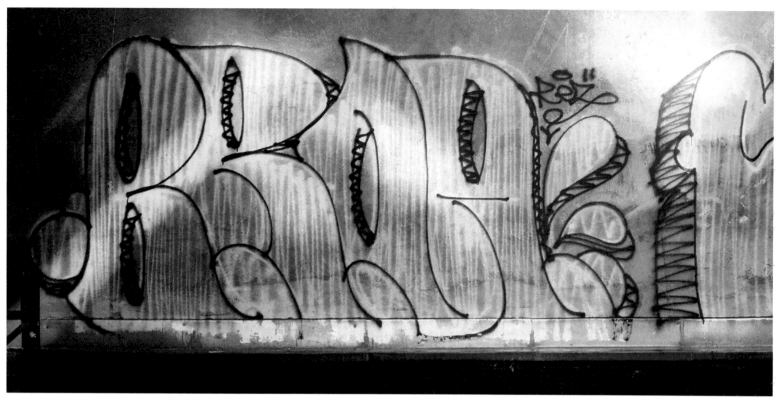

● **Broa** :: Berlin :: 2002

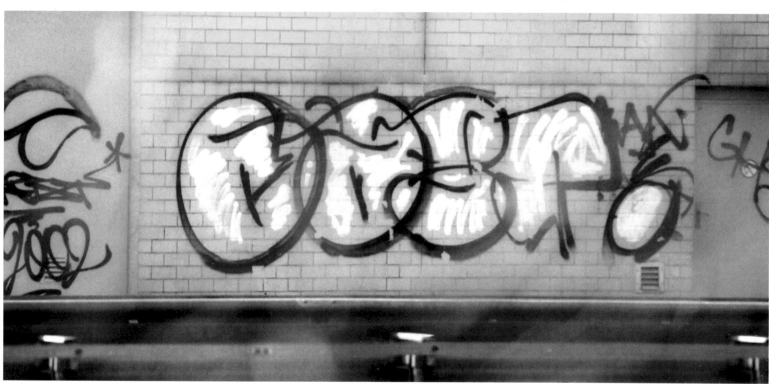

● **Cost** :: Berlin :: 2002

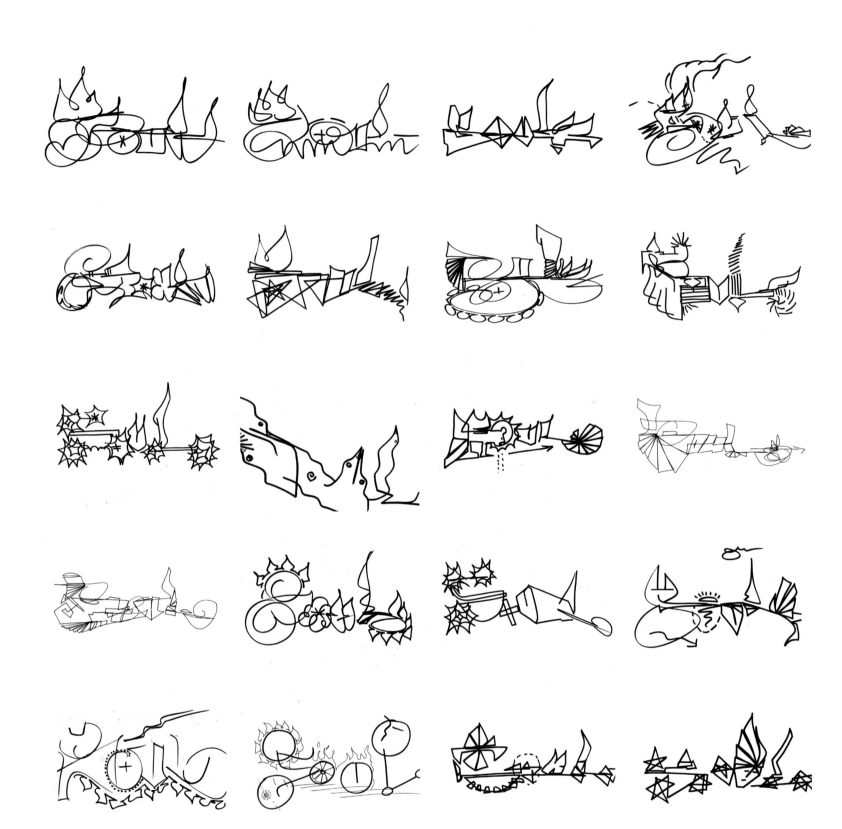

● **Akim** :: **Soul Series** :: Jazzstyle Corner at Glaswerk :: Berlin :: 2002

... every sketch was drawn in less than 15 seconds

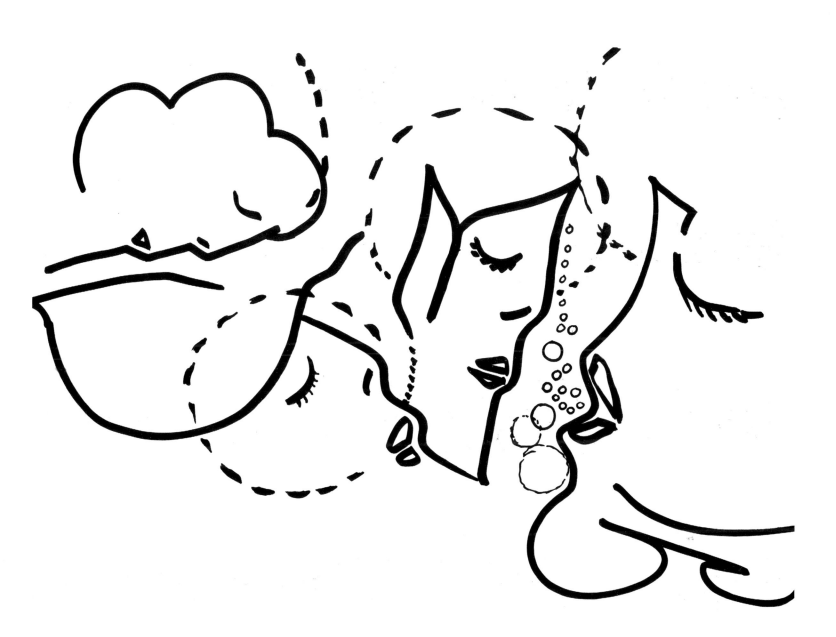

Akim :: **Soul Series** :: Jazzstyle Corner at Glaswerk :: Berlin :: 2002

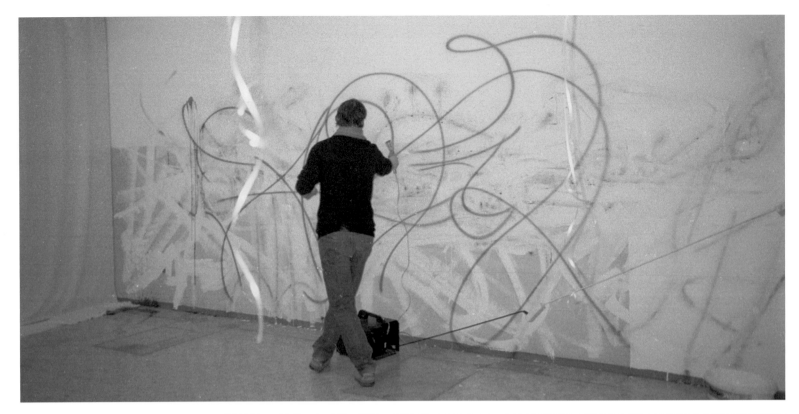

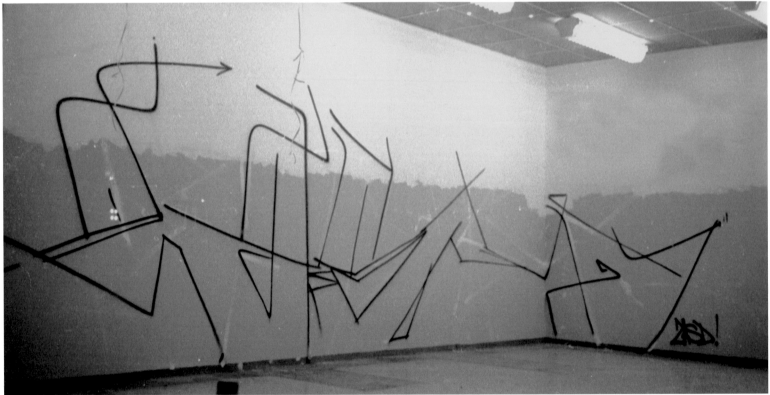

● **Zasd** :: Hip Hop Sommerschule :: Berlin :: 2001

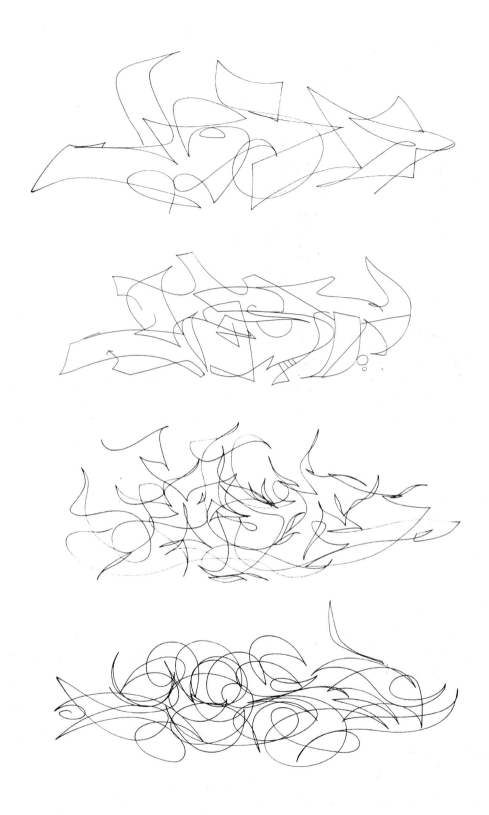

● **Zasd** :: **Onelines and Jazzstyles** :: Berlin :: 2001

LETTER / WORD

The letter is the central element in Writing. From individual letters to complex letter combinations, the alphabet determines the written cosmos. The Latin letter serves as the atom of western civilization's information. In forming word molecules, it becomes content. And in order to be understood, this content must be readable. The letters and alphabets shown here, however, do not aspire to be text in a newspaper. While simple forms expedite the flow of information and while readability is important, these are not the only demands placed on the letters in Writing.

Originality, distinctiveness and a clear profile that sets one letter apart from others are becoming more and more important to visual codes.

In Writing, the letter becomes an individually defined form. The letter is not only a stylised image depicting emotions, but it is also raised to the level of a personality. This chapter dissects the canon established with tags and throw-ups into single letters. It will become apparent that each Writer works within specific, aesthetic ground rules. In the first place, these serve to create the optimal presentation of one's own name. They are then applied to an entire alphabet. The obvious creative expression is not only far from arbitrary, but also obeys these clear rules.

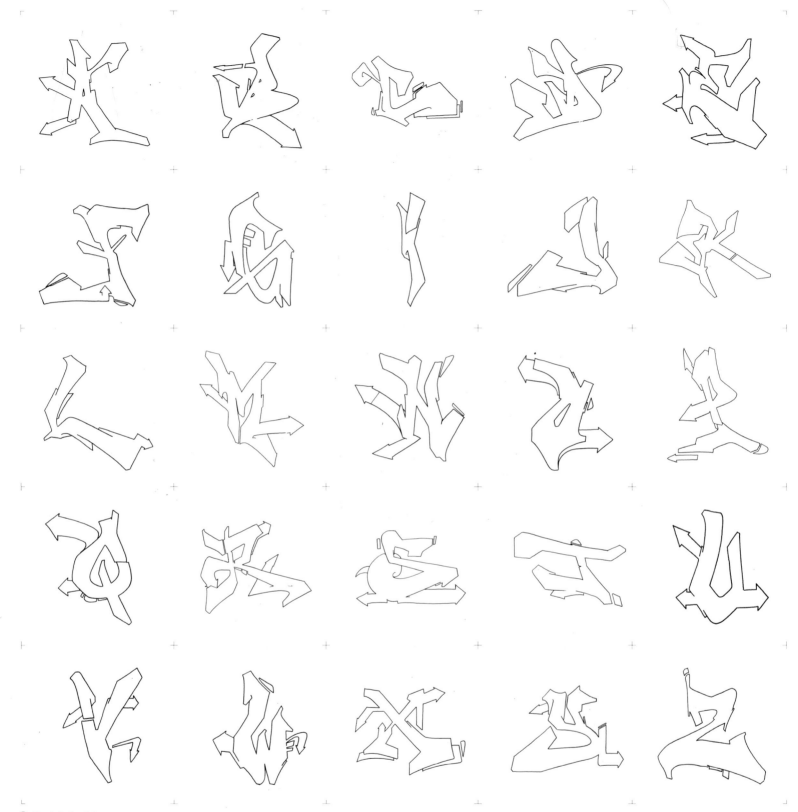

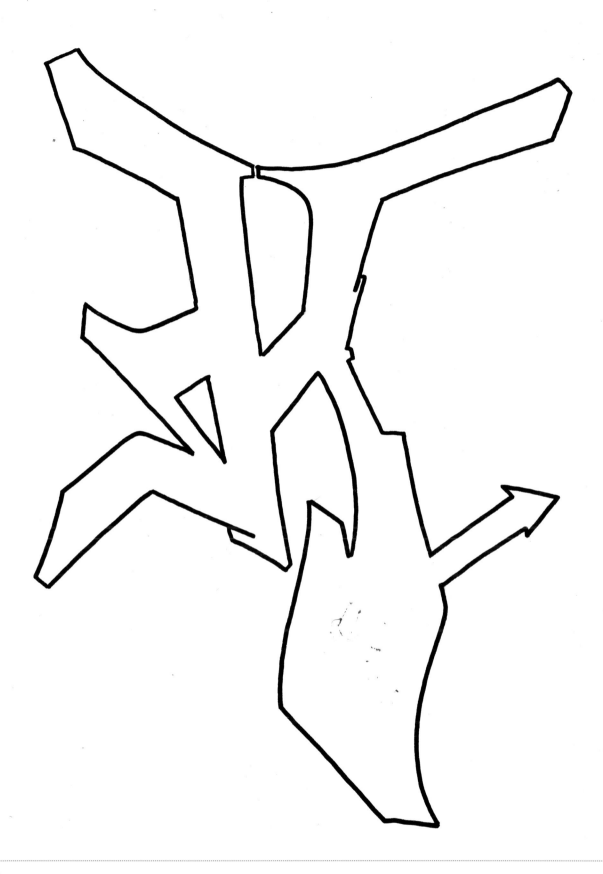

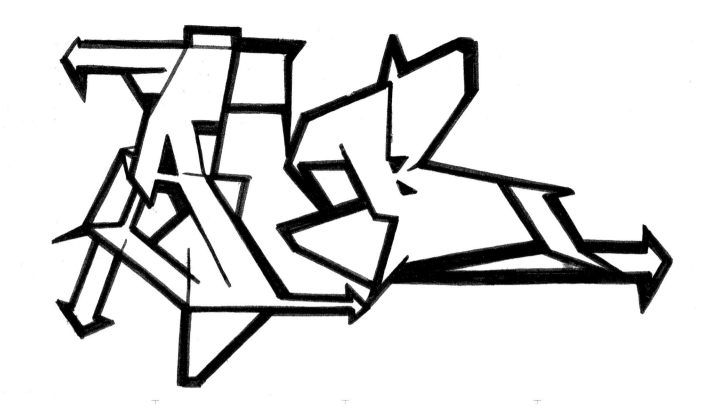

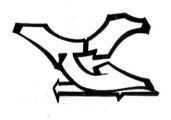 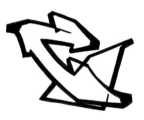 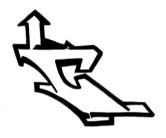 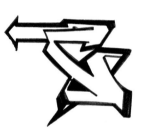

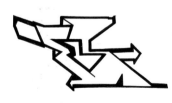 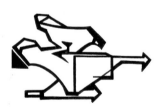 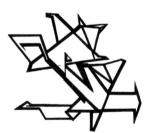 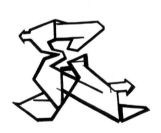

● **Try One** :: Berlin :: 2002

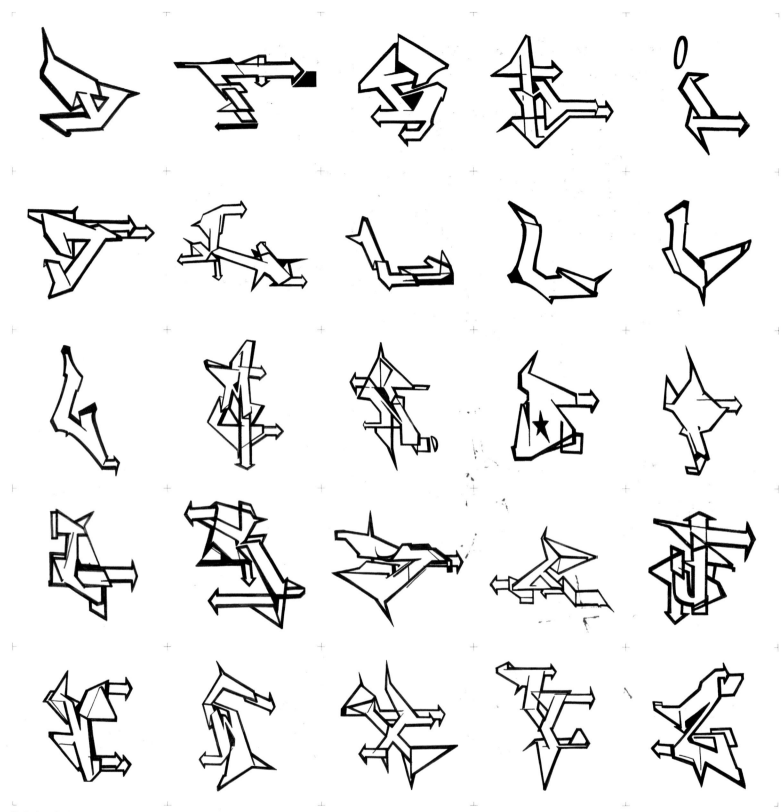

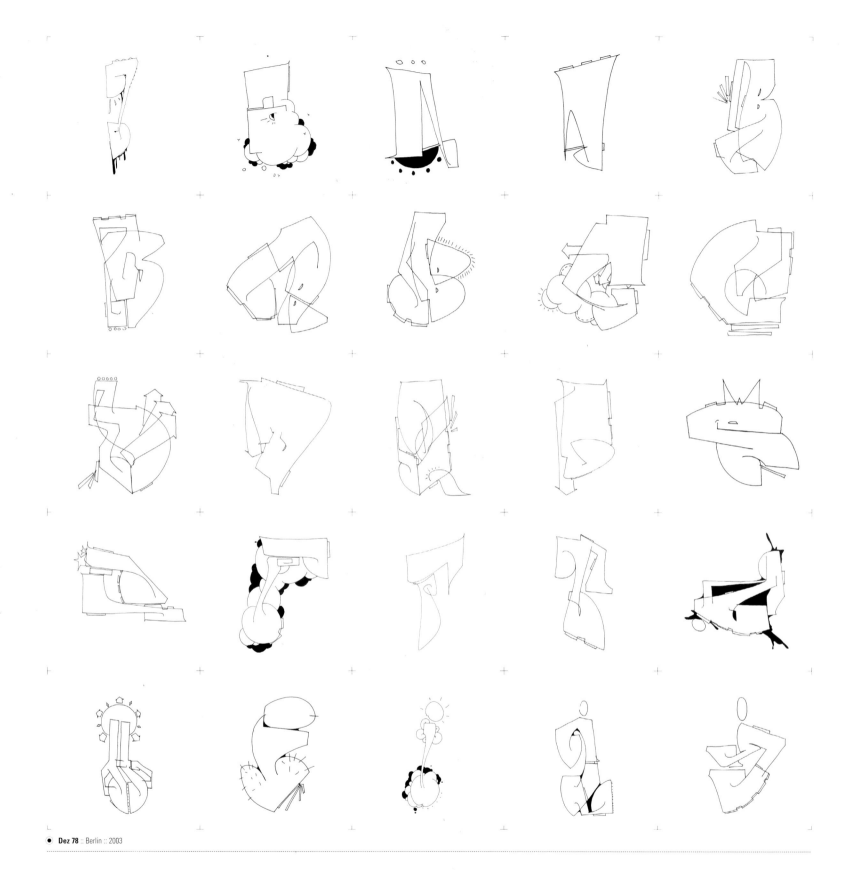

● **Dez 78** :: Berlin :: 2003

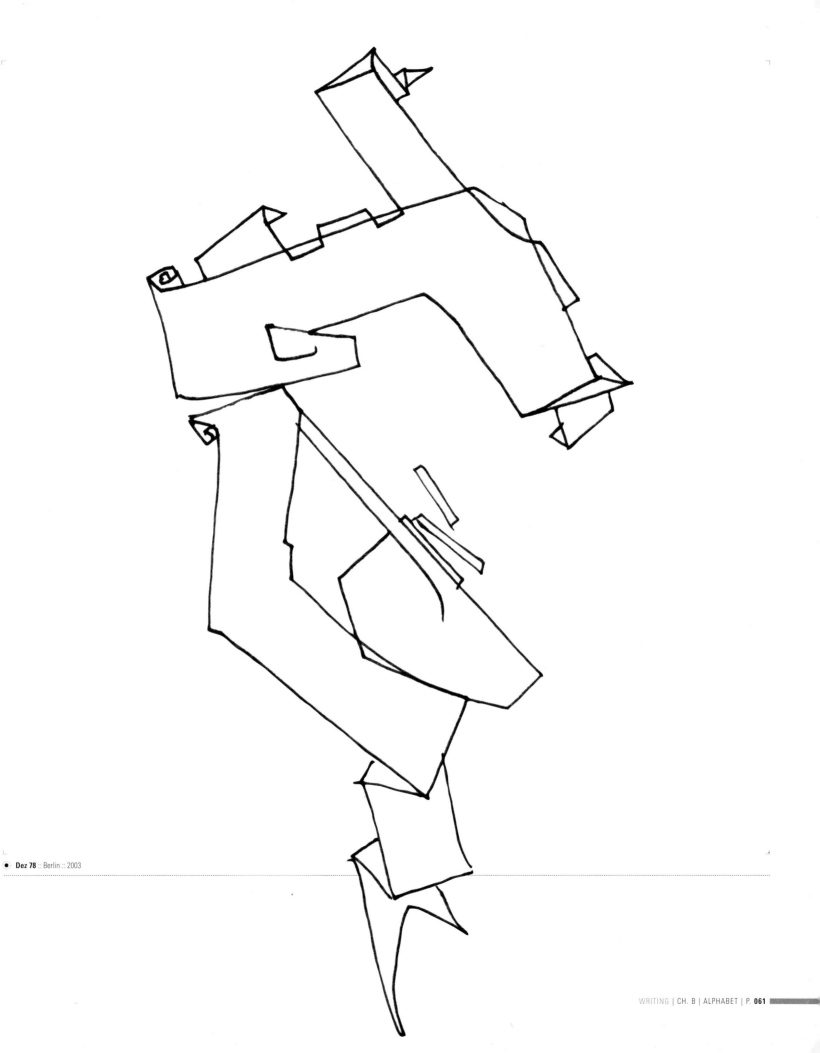

● **Dez 78** :: Berlin :: 2003

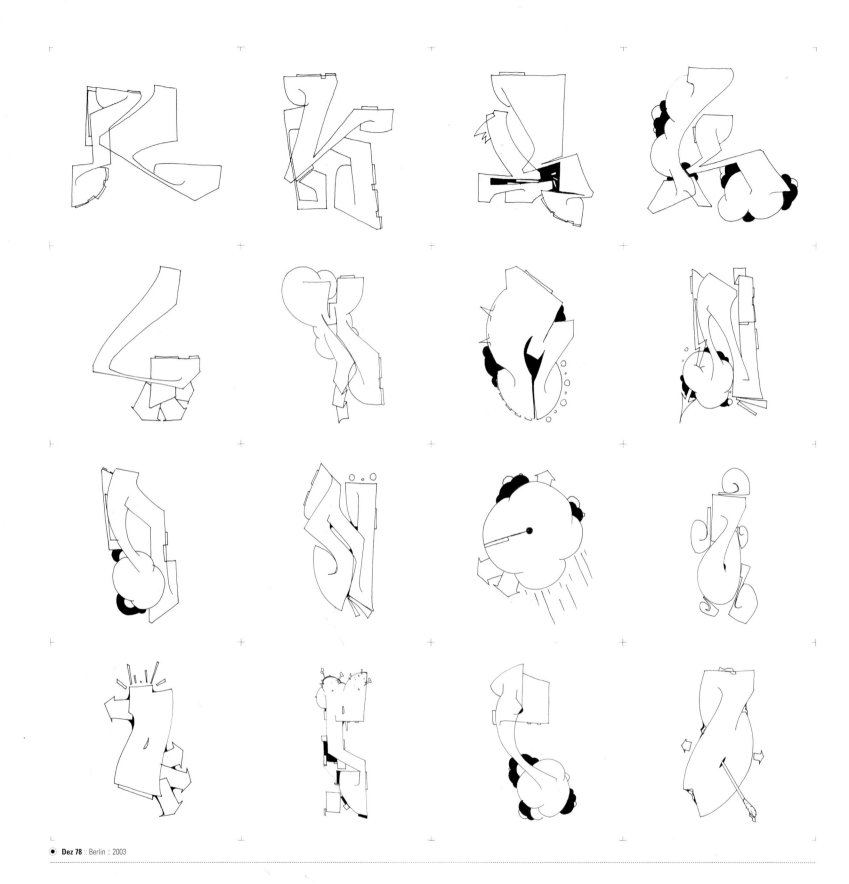

● **Dez 78** :: Berlin :: 2003

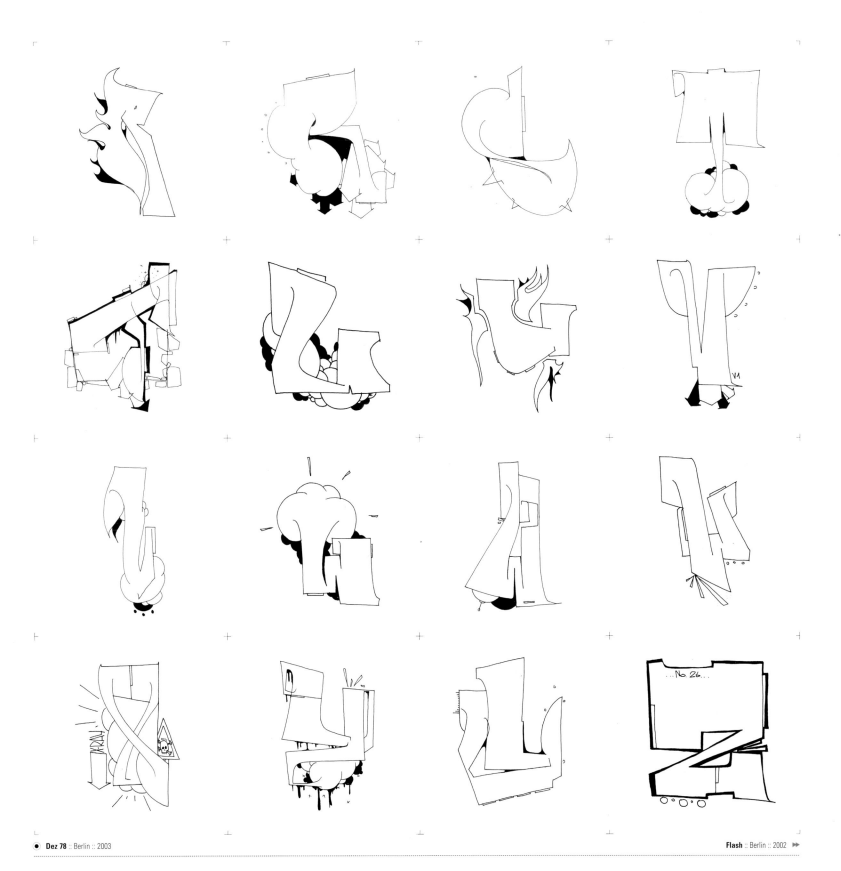

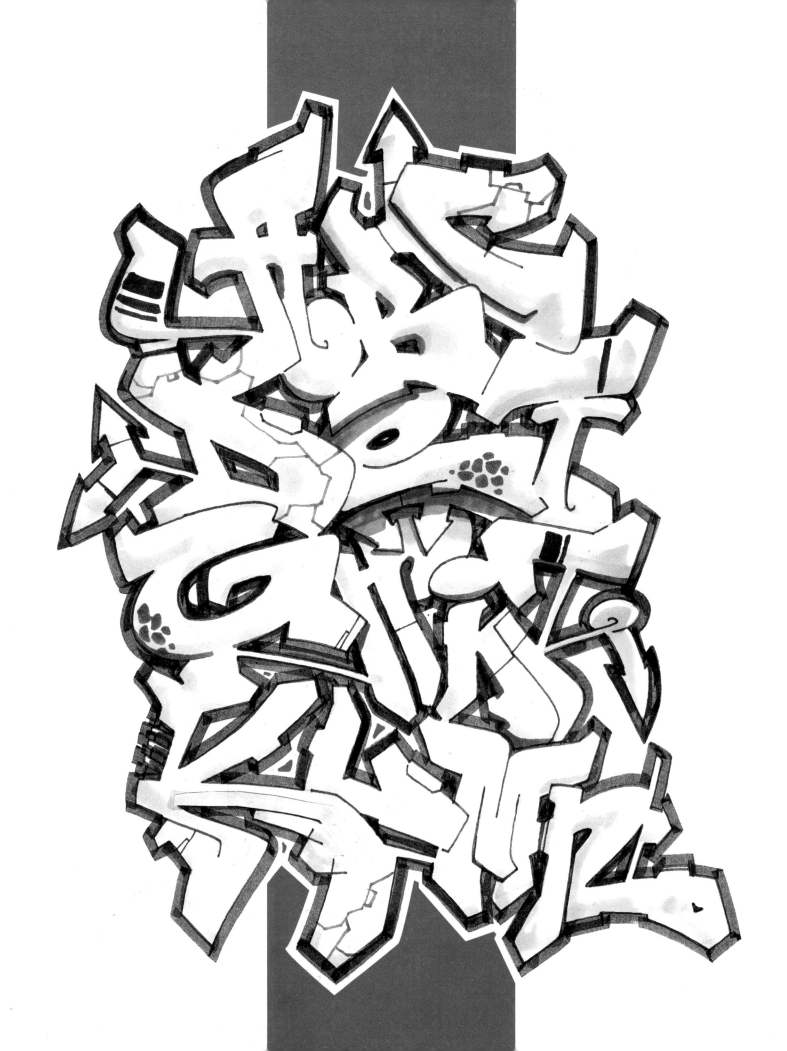

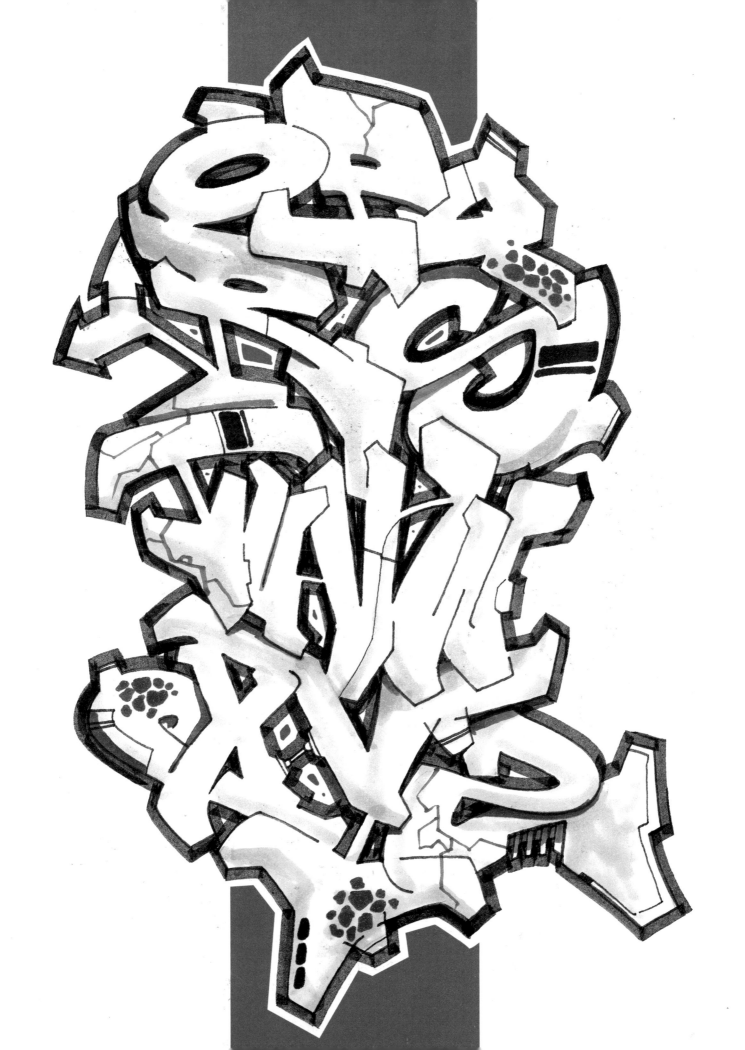

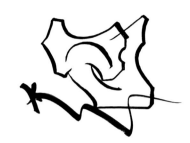
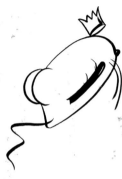
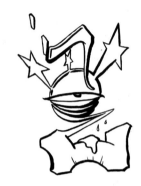
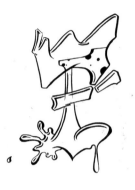
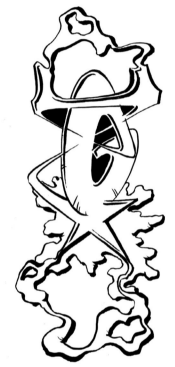

● **Tagnoe** :: Berlin :: 2003

TAGNOE

On January 15, 2003, Tagnoe wrote down an excerpt from the film "Le Mystère Picasso" by Georges-Henry Clouzot. He did this to point out the similarities between his own world, which obeys the anatomy of letters, and the artist's world, which presupposes knowledge of the human anatomy. Because the letter is the abstraction of the phonetic, it appears as if something that is already abstract is itself again abstracted. This is the point where the greatest misunderstandings arise because the Writing is not just about the word, but also about the total recapture and extreme evolution of a resurrected symbol. The letter returns to its inception and divulges some-

thing about its creator insofar as his masterful hand has managed to reveal something of the evolutionary processes' fire, to let it live on in the embers of the finished result's ashes. Precondition for understanding these processes is a precise analysis of letters and the evolution of New York graffiti up to the late 80s.

When I look at my style, I see the interaction of living things. It took me a long time to detach it from the beautiful surface and to look at the naked truth hidden underneath the fabric. Now they stand in front of me, looking at each other, simultaneously majestic and ugly, torn apart and welded together, drawn to embody the unspeakable.

... he runs, he glides in balance...
across the taut tightrope.
A curve to the right,...
a dab to the left.
If he should lose his balance, all will fall apart.
All is lost.

Tagnoe :: Berlin :: 2003

Akim :: Berlin :: 2003

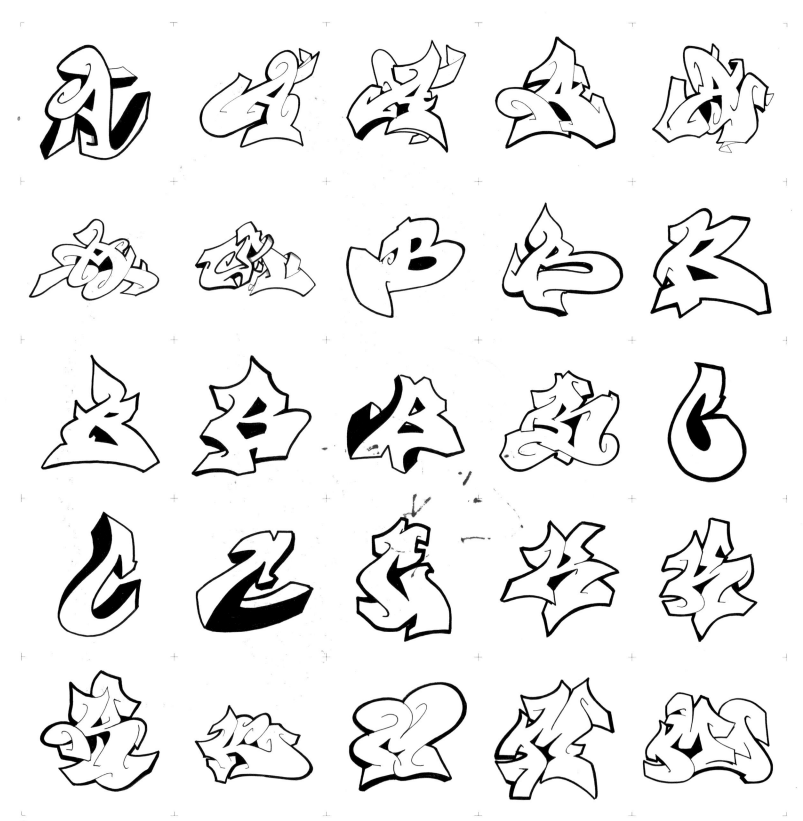

● **Milk** :: Berlin :: 2003

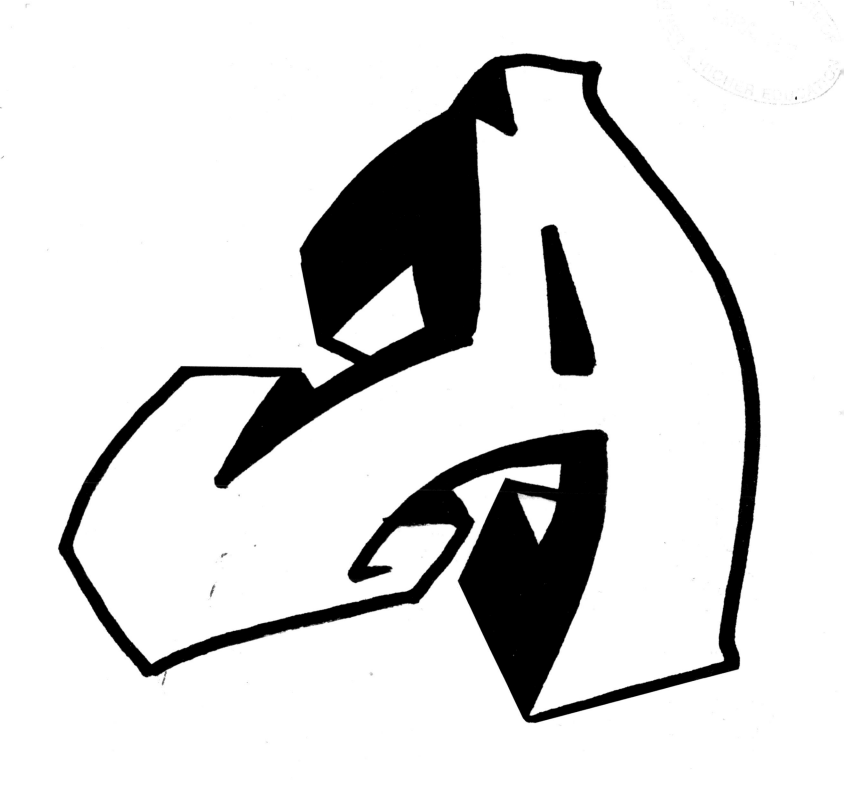

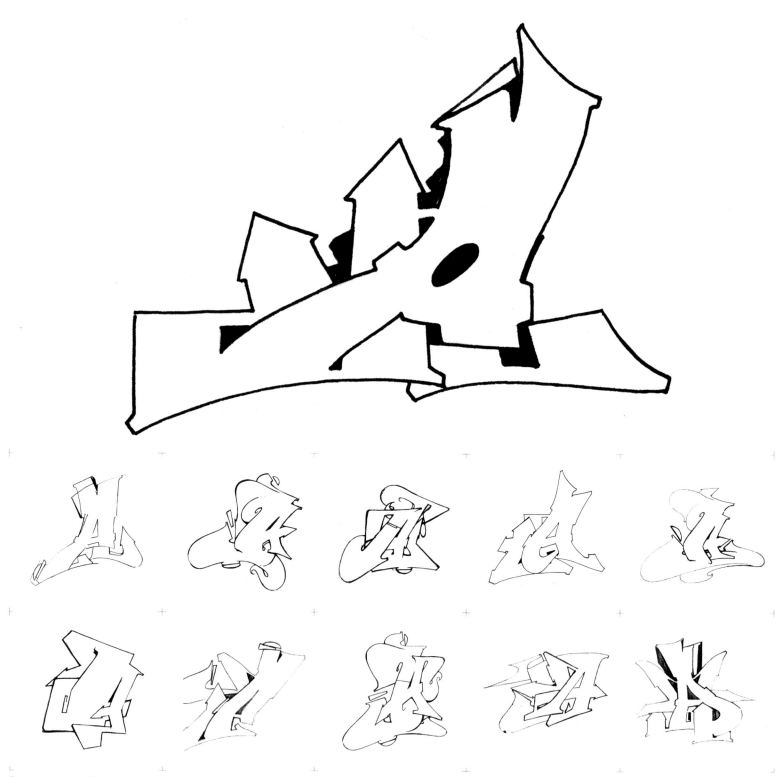

● **Amok** :: Berlin :: 1990-1992

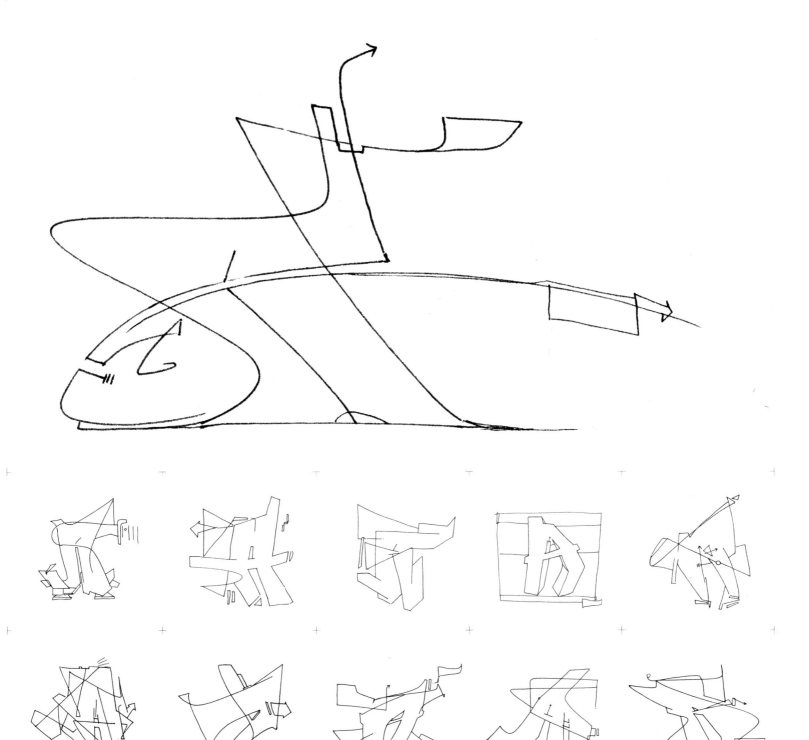

● **Zasd** :: Berlin :: 2001 - 2002

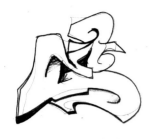 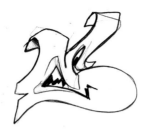 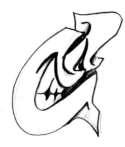

● **Milk** :: Berlin :: 2003

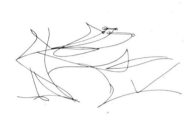 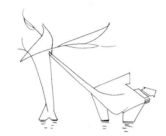 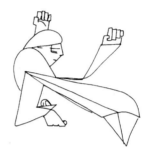 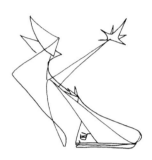

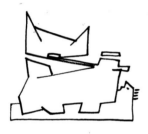 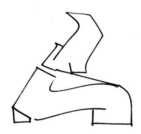

● **Zasd** :: Berlin :: 2001 - 2002

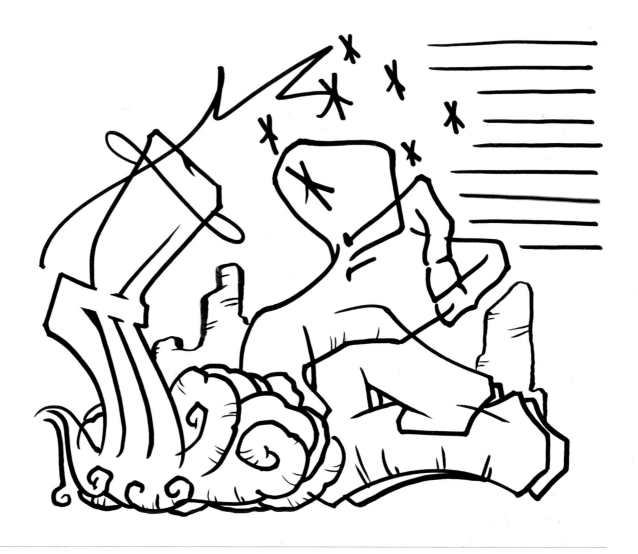

Tagnoe :: **Warwinners** :: Berlin :: 2003

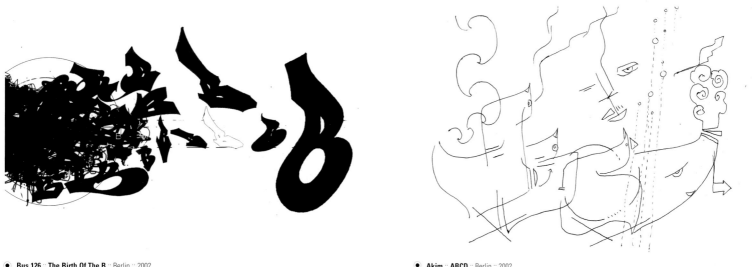

Bus 126 :: **The Birth Of The B** :: Berlin :: 2002

Akim :: **ABCD** :: Berlin :: 2002

POET
EXPANDED REALITY

Art is comprised of an infinite number of views and the philosophical realms to which they belong. Each of these is influenced by its various circumstances and purposes as well by individuals and the particular expressions that they use. They co-exist in universal harmony, connected by a creative energy, which flows unfettered. In these realms, style acts as a spiritual medium. Human beings can only seize, interpret, influence, perfect or broaden this style.

Culture springs from the efforts of its brightest minds, which try to explore and interpret its deeper meaning. As this will inevitably involve an analysis of other, preceding cultures, the process always results in an attempt at synthesis, a pooling of different features to discover a clear common denominator or even a similar origin. Each person has his or her own style, but we differentiate, we select, we judge and criticise (both positively and negatively) based on actual occurrences. Complex sequences acquire an order while experiences change and develop. We press for realisation. When the soul investigates the symbol, a level of perception is reached to which the mind has no access. Each partial insight, each naming and description of a trait shapes a new attitude, leading to an increase in changes, decision-making and constant redefinition.

The art of Writing has triumphed worldwide. More than anything else, it has contributed to shaping our understanding and views of art in public, urban spaces over the past few years. No previous type of graffiti has ever attained such dominance and proved so resistant to outside influences. Many might question the reason for a fundamental analysis of Writing, a term defined by the New York City subway Writer and found in graffiti's family tree. I would reply that, if we pay attention to this category, we might, one day, be able to deal with the consequences of its existence. This is because a conscious confrontation would have an immediate impact on design and encourage us to spot similarities and exploit connections.

The essence and characteristics of New York subway Writing and its visual interpretations outside of N.Y.C. should not be judged in the same way as pre-1965 graffiti. Indisputable facts and a worldwide network of activists underline this. There are undoubtedly a number of examples of artistic graffiti in the history of mankind, but none of these ever showed a sign of aesthetic or stylistic evolution. The evolution of subway Writing during the last 35 years, on the other hand, was kicked off and influenced by a quick, impulsive exchange, not only between the active Writers' different philosophies, but also between the painters and society itself.

The Writers' urge to reinterpret an old idea, the art of Writing, and to expand new visions of shape and colour in the context of letters was considered a threat by some parts of society. Society holds intractable prejudices against graffiti for reasons including the lack of access codes to appreciate the vibrant Writing. Style Writing is usually reduced to figures and colourful images, which in turn can deprive the essence of this art of its universal power. Writers use letters only as a medium for their art and devise concepts for a visual language built around their Writing. Subway graffiti or Writing was often completely misunderstood and wrongly denounced as blunt vandalism. Or it underwent a distorted, mutilated and rationally watered down interpretation. Society often reduced the Writers' movement to a curious collection of crazies or employed a questionable social approach for a superficial analysis and categorisation.

This often meant that Writers who had to rely on the acceptance of society were forced to distance themselves from the movement or at least from the term graffiti. Naturally, not all images were of high quality. On the contrary, more than 90 percent of all pieces only serve to document the learning phase. A superimposed order, a guiding principle or clarity as to why a letter had been designed in this and no other way should be discernible. Writing should strive for a deeper meaning. To me, this means that it should obey a certain order and that its elements be configured so that everything has its place in the Writing. Or in other words, intention and shape are closely related. And it is this property, which accounts for the unfettered strength, survival and flexibility of this discipline. Its spirit can be hard to pin down because boundaries are not fixed but floating, lending this art form a multitude of faces, which are constantly on the move and redefined almost daily with every new modulation.

Initially the tag (hit) was a signature. It then became larger and gaudier and, by the end of the 60s, it had acquired a contour. The signature image or "piece" was born. It in turn opened up an infinite number of creative possibilities with which everyone could - and still can - realise their very own visions and ideas. Individual interpretations of styles followed, and they still remain one, if not the, most important driving force in this movement's continuous evolution. Style helps the painters to live up to their artistic claim. Those in the movement who excelled at combining quality and quantity in their images received the most acclaim.

Urban art is an umbrella term for art in urban environments. According to my personal definition, urban art encompasses any project, be it legal or illegal, conscious or unconscious, which shows a rudiment of art. So if we want to take a more realistic look at the young, so-called urban art movement and its relationship with Writing (as in New York City subway Writing), we have to say that Writing is related to urban art. The Writers' highest aim is to infiltrate urban space through the mass production of art works. Given this, it is only natural for Writers to adopt a recurring name or signature for recognition value, which acts as a logo or product brand and reflects their true artistic claim. In other words, it's not just about "bombing" your name across town, but also about designing your name or logo.

The teachings of Writing have inspired and influenced many people in their perception of art. The assessment of urban art and Writing nevertheless remains in the eye of the beholder and more or less depends on his or her personal interpretation. In a way, this could make art just another play on words for people to fall back on when they want themselves and their actions to be understood as the expression of an individual. Because who could seriously claim to be an artist simply by making their own thoughts public?

The realm of so-called illegal art is usually situated in urban environments. The fact that the intensity of interests is often amplified in highly populated areas explains why this art is often divided into tolerated and not-tolerated categories. Locations or objects open to the public (like the public transport system) come replete with a set of rules aimed to ensure public order. Any art considered illegal oversteps these rules and can trigger real controversies. Society is challenged and forced to rethink its evaluation on what is art and what isn't. What remains is an idea, which needs to be redefined. European artists are in the process of reinterpreting the idea of American graffiti to shape their own identity. But almost everyone knows that both are part of the same pedigree.

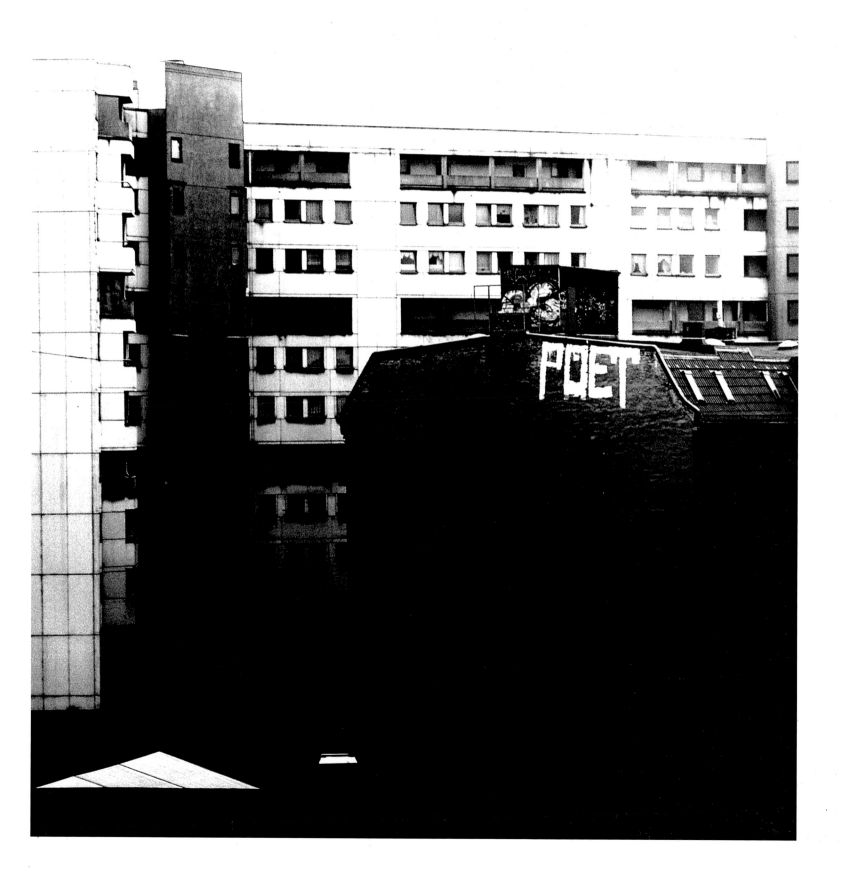

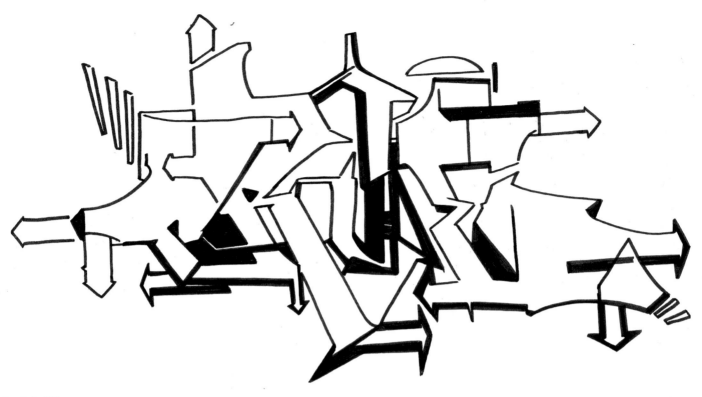

● **Try One** :: Berlin :: 2002

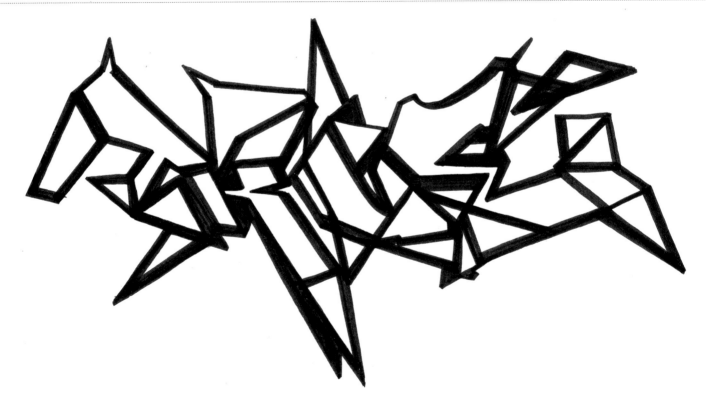

● **Try One** :: Berlin :: 2002

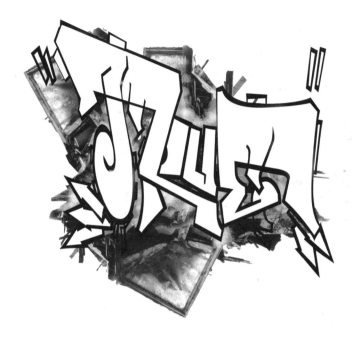

● **Dez 78** :: Berlin :: 2003

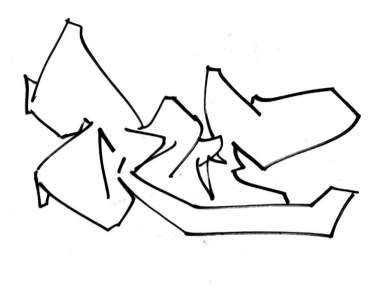

● **Year** :: Berlin :: 2003

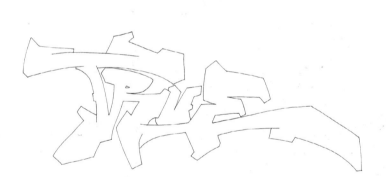

● **Flash** :: Berlin :: 2002

● **Akim** :: Berlin :: 2003

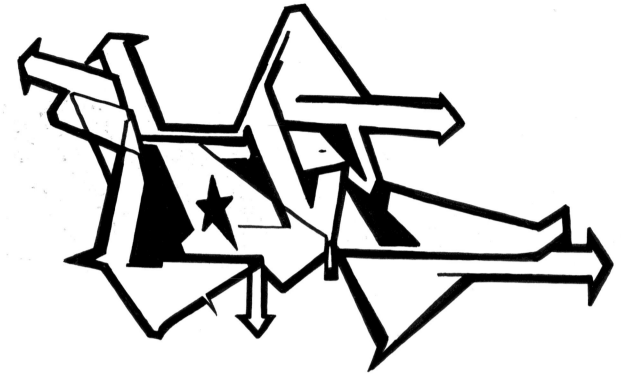

● **Try One** :: Berlin :: 2002

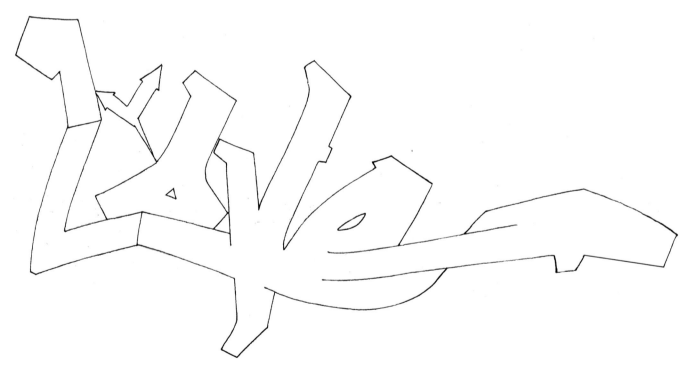

● **Flash** :: Berlin :: 2002

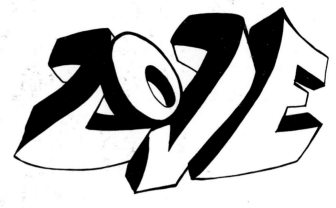

Zasd :: Berlin :: 2002

Milk :: Berlin :: 2003

Dez 78 :: Berlin :: 2003

Akim :: Berlin :: 2003

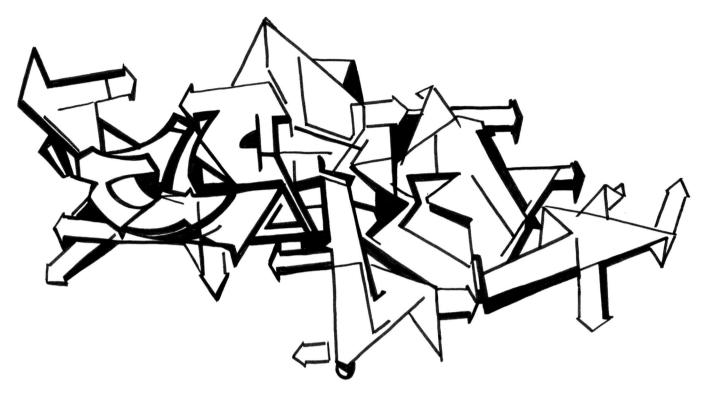

● **Try One** :: Berlin :: 2003

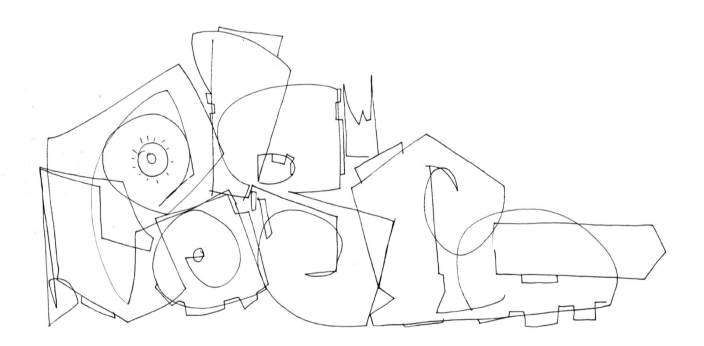

● **Dez 78** :: Berlin :: 2003

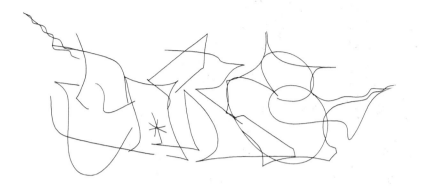

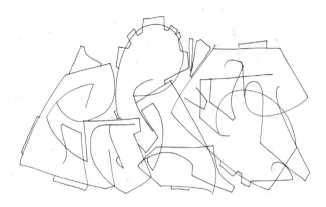

● **Akim** :: Berlin :: 2003

● **Dez 78** :: Berlin :: 2003

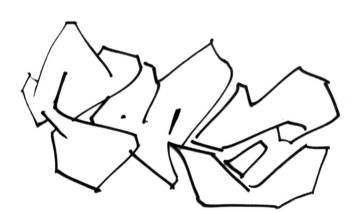

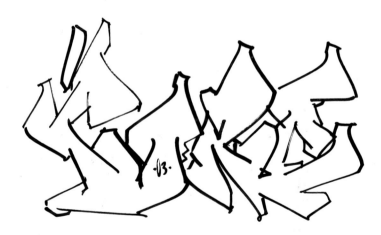

● **Year** :: Berlin :: 2003

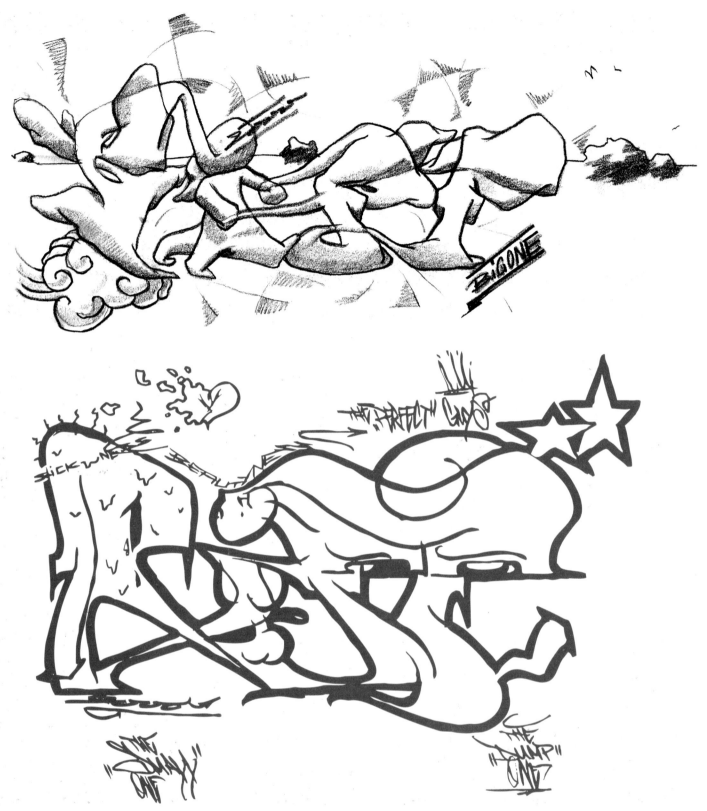

● **Tagnoe** :: Berlin :: 2000

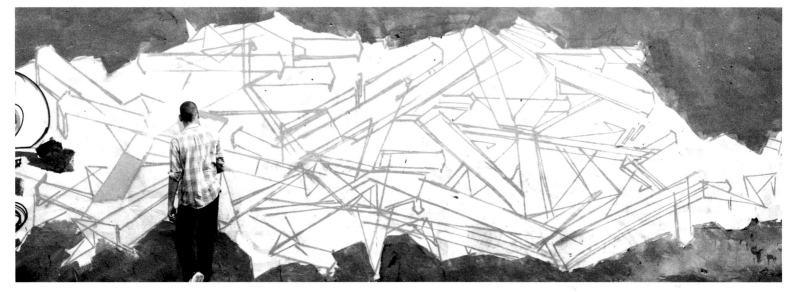

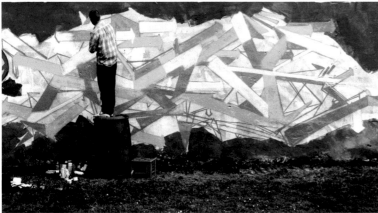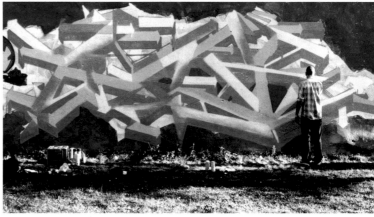

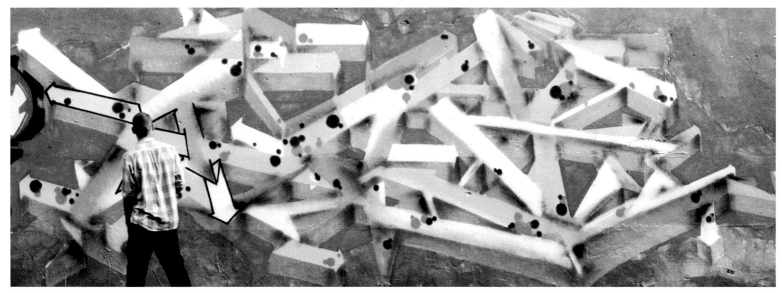

● **Try One** :: Berlin :: 2002

ANALOGY

The city is the culture of Writing's most important source of inspiration, serving as both medium and stage. Writers appropriate the forms, elements and symbols of the city and integrate them into their work. The city influences the architecture of Writing, and concepts found in Writing meanwhile also have an impact on architecture.

The Writer's thematic or expressive organisation of surfaces, for example, can clearly be found in the deconstructive drafts of a Daniel Libeskind or a Zaha Hadid. In addition to architecture, natural forms also inspire many Writers. This is especially true of the way nature structures spaces and energy. These insights flow into bionics, a style that excludes almost all right angles.

● Berlin

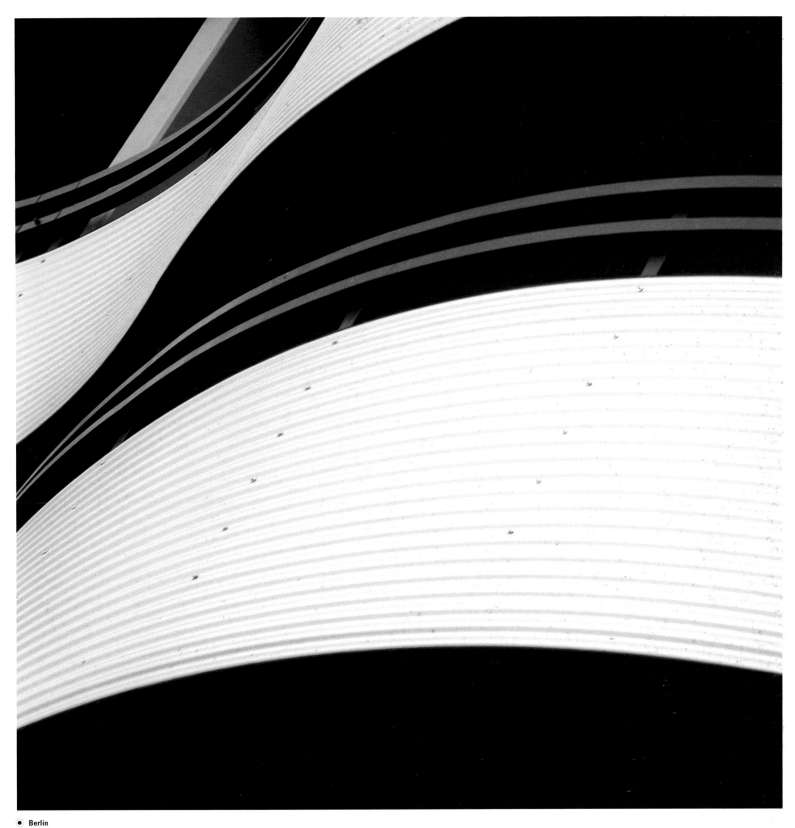

● Berlin

● Paris

● Paris

● Berlin

● Berlin

● Berlin

● Berlin

● Paris

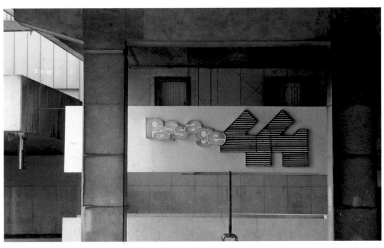

● Brussels

● Berlin

● Berlin

● **Emile Soupply** :: Brussels :: 1978

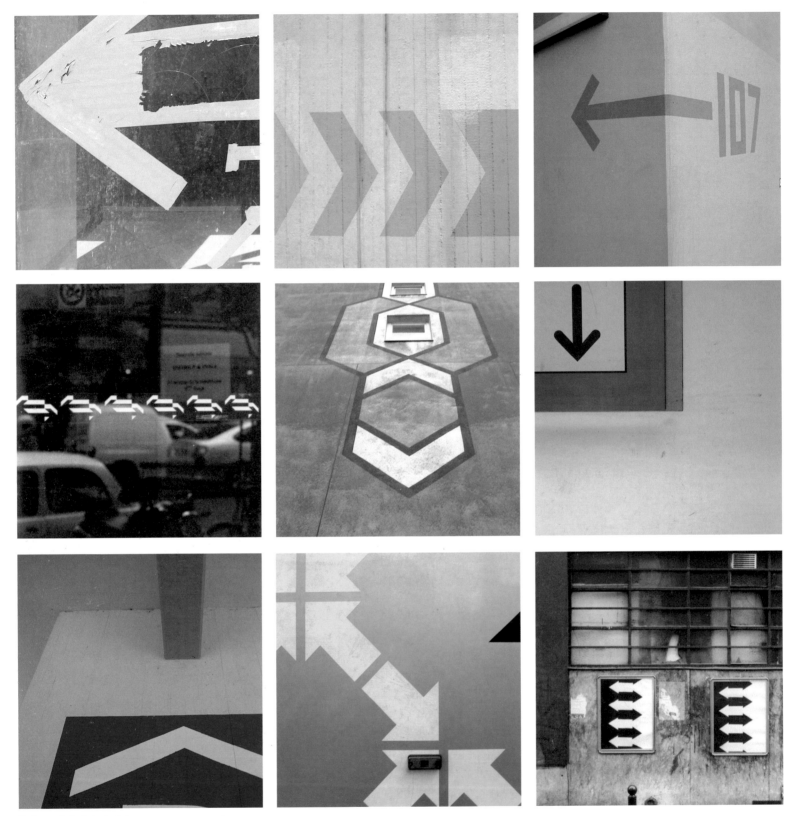

● **Arrows** :: Berlin :: Paris :: Amsterdam ::

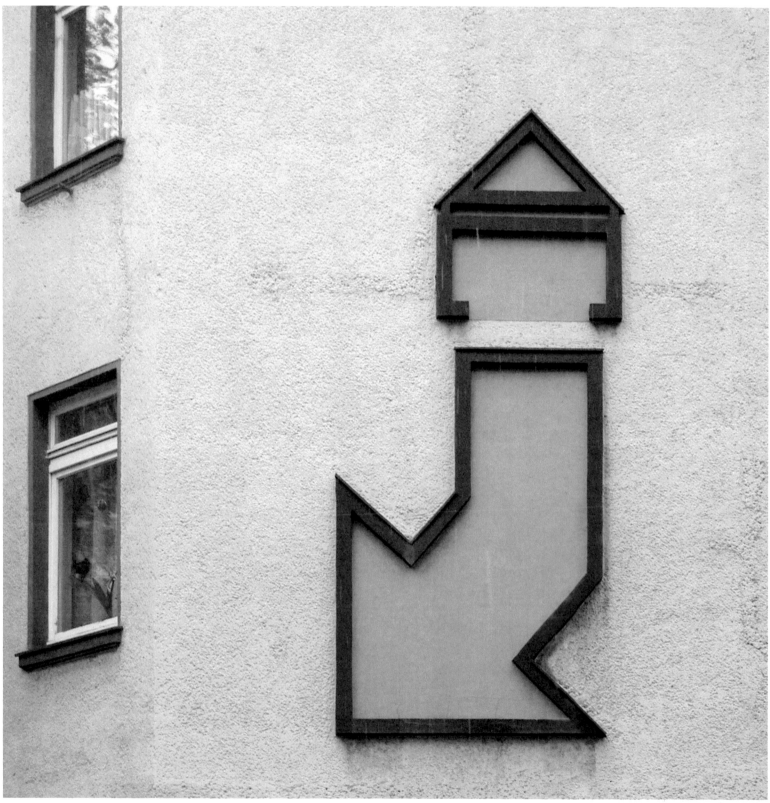

● Berlin

AKIM
IN WRITING THE EMPEROR'S NEW CLOTHES DON'T WORK

For you, the term "Writing" encompasses many ramifications. You employ a variety of materials and approaches, which sometimes differ wildly from traditional means.

Nevertheless, the name and the letter remain central to my Writing. But in my work and approach, shape and content are essential. In this context, the name is the content regardless of whether I make it into in a tag or a throw-up. The translated content, the name, becomes the shape and this shape carries character and personality. This is what its visual appearance really stands for. With practise, the shape gains more and more flow. And when you give it a conscious try, character and personality can transport a mood into the shape, too. What the character consists of differs according to personality. To really explain the way I work, I need to expand a little. When I first got obsessed with Writing, there already were a lot of styles and personalities with different levels of skill out there. The letters and styles, the pseudonyms were mostly self-centred. They proclaimed, "I am the content, the shape is an agent to shout my name." Visually speaking, the shape is my platform, a space to play and display myself, reflecting my world and my surroundings. Shape is meant to convey personality and character, the lettering acting as a stand-in for its creator. This is the traditional approach and visual language that I grew into. It would therefore be wrong to say that I or the Writers who came before me adopted the New York styles indiscriminately because even back then this language was our own. Even then we had started to shape our own ideas.

So, really, your approach is a natural by-product of the evolution of Writing?

Aside from the structure of the scene or the aspects of fame, the phenomenon of being carried away and doing it, of living the Writing without calculating fame credits or thinking of one's rank within the scene, seems far more important. It's the enthusiasm, feeling good with it, the challenge of growing with a conscious decision and living your life consciously. This explains my approach. In a way it is similar to being in a relationship. Unfortunately, many people can't bear it and put an end to it. Writing allowed me to go out into the world, pick up knowledge and develop an automatism to make decisions and carry them out no matter what.

You place a lot of emphasis on your approach...

This relationship between me and actually doing it was like an odyssey in which I experienced all kinds of human hardship. Like in any relationship a lot went wrong because I wouldn't admit to myself early enough that my perception was flawed. I was eager to amass more and more knowledge, which in hindsight only furthered my technical abilities. At some point I discovered that I had moved away from my ideals and my actual life. This was in 1998. Then I decided to approach it all differently. I was determined to BECOME the Writing. I wanted to go beyond the standard repertoire of traditional Writing that I had at my disposal.

Hardship?

By hardship I mean success, defeat, doubt, finding, searching... The new relationship turned into a union and pure identification with the essence of Writing. Nowadays, all I really care about is expediting and serving this idea, this projection surface, this phenomenon, which really is an inner funk, a rhythm that is with me at all times. The decision to identify with Writing has made me more self-assured and open. I couldn't confine Writing to the standard means of expression anymore. My Writing was the word and its condensed form. All of a sudden I could express this philosophy through a much wider variety of means.

What about traditional tools and materials?

Anyone good at his or her trade should be able to draw on the character of any medium. Sure, I use traditional means often and happily, frequently just to exploit their unique dimensions or strengths. But who is to say that only spray cans and markers constitute Writing? When we talk about the content of my work, the macrocosm is my style, my name. The microcosm is the structure, the form. In addition, the environment already supplies me with a given repertoire of shapes that I have assimilated as much as the given structures of Writing culture. I use everything I see to embellish and emphasise my funk. But the embellishment only starts when the solid scaffolding is in place, the stage for my art.

The concept of the Emperor's New Clothes doesn't work in Writing. Shapes and elements taken from nature, on the other hand, are already perfect and proffer incredible diversity and inspiration. It is important to show a neutral form, not an impression of the pain or joy in my life. That's why I am more likely to draw on the abstract repertoire of natural shapes. To me, attributes like density or flow are very important. As an Asian, my background has obviously shaped my aesthetics. Alone I am weak, it's only as part of a crowd that I become strong. This philosophy has left its mark on my work. Up close, the tiny elements are almost fragile and lose themselves in the structure. From afar, my structures become bulky and stable.

In the past, a letter was often considered a purely constructed entity. Nevertheless, it remained two-dimensional. Your writing bursts into three-dimensional space and becomes tangible from all sides.

The aim of Writing is to go beyond the surface. So when I move in space, I also want to discover and visualise my Writing in this space. I examine strategies in the two-dimensional plane to harness and investigate shapes as in, for example, the system of cycloids. This results in abstract styles, which again lead to three-dimensional constructions. The form has to evolve; it needs to grow. The same applies to nature in the three-dimensional realm. But even two-dimensional Writing requires the letter to be constructed in space because it, too, is a body in relation. Dancing is an example of a body in space. Where do I move, how do I move. My movement is the measure. The body is the measure - in the same way that the letter is understood in two or three dimensions. A word can be felt. A word can also be danced. The shape of a movement can, for example, be drawn with a spray can. This allows it to be reconstructed in space. In a way, a Writer is an architect. The only difference to a traditional architect is that he doesn't draw, but write. It is only once the letter has been written and built that you get a little closer to the anatomy of your creation.

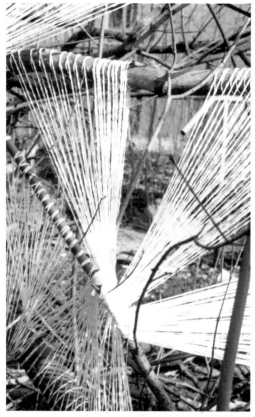
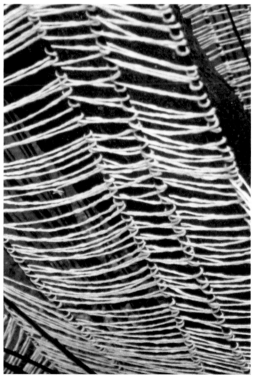
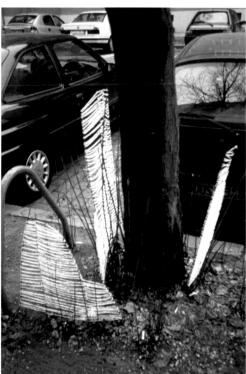
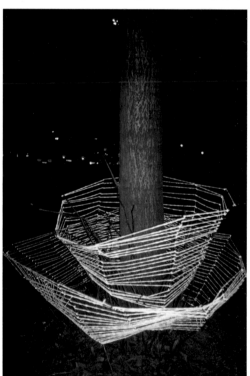

Akim :: Berlin :: 2003

● **Akim** :: Berlin :: 2002

● **Akim** :: Berlin :: 2002

● **Akim** :: **Wind** :: Berlin :: 2003

● **Akim** :: **Icestorm** :: Berlin :: 2003

Everything I perceive is structured.

Every shape has developed out of necessity. A shape is the vestige, the appearance and the materialisation of an energy flow. It is a grown medium for the energy of flowing exchange.

Structure. I perceive structures and move within them.

I myself am a structure – my body, my mind, everything right down to the smallest detail.

When I realise that everything fulfils a function, I see style with different eyes. How did it come about? Which function should my style fulfil? What influence do I have? What conditions should it meet?

I begin to fantasise. I start to philosophise, finding myself within a sphere of the unknown.

Thus far, script has been used to convey agreed upon content between people. Writers do the same, but they also deviate from it. They use the pure shapes of characters to create emotions. To communicate themselves, they develop their own representative aesthetic of letters.

To find these shapes, I get inspired by structures.

A tangle of branches in winter, or in the summer, a stone, fire, a child's drawing, the flight of a formation of birds above the city, a moving train, hair wafting in the wind, the sea, the cityscape, but also a melody of birdsong, a rattling sound in a subway station, the silence of a place.

I recognise the perceived structure and permeate it without scientific analyses. I just let the film roll.

How does a tree grow? How does a style grow? How does a praying mantis move? How does a style move? How does it attack? Should it attack at all? Maybe it could flow like a river. What sound does my style make? What shape results from that? What situation am I in?

I recognise style as part of nature. The letters are my way to achieve order, their shapes are repeated in nature all the time. That allows me to have faith.

Here I am. My duty is to write.

What U see is what U get.

Let's say I go into the woods and look around. If all that I see is a standard tree, that's all I will get. When I forget what something is called and how I normally know it, that's when I begin to see. Then the style flies to me. Maybe like an eagle or a butterfly, or like two triangles, or three, or twelve. Or like a triangle with five corners or seven or like a sphere within another, towing a ball of energy to free up the channels of my perception. BANG!

Where are you?

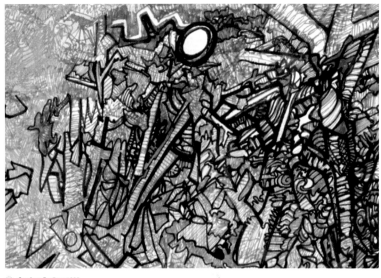

● **Sonic** :: Berlin :: 1988

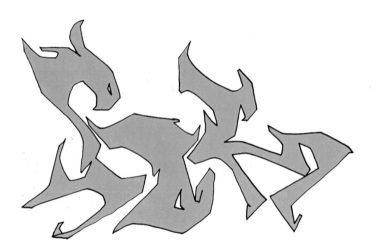
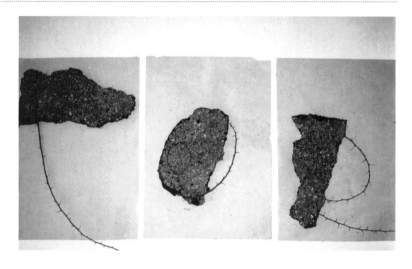

● **Poe** :: Berlin :: 2002

● **Zasd** :: **G** :: Berlin :: 2003

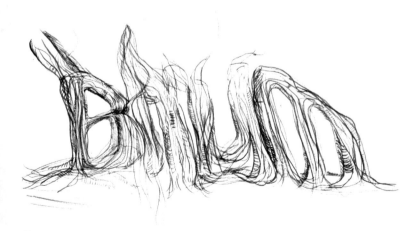

● **Zasd** :: **Baum (Tree)** :: Berlin :: 2003

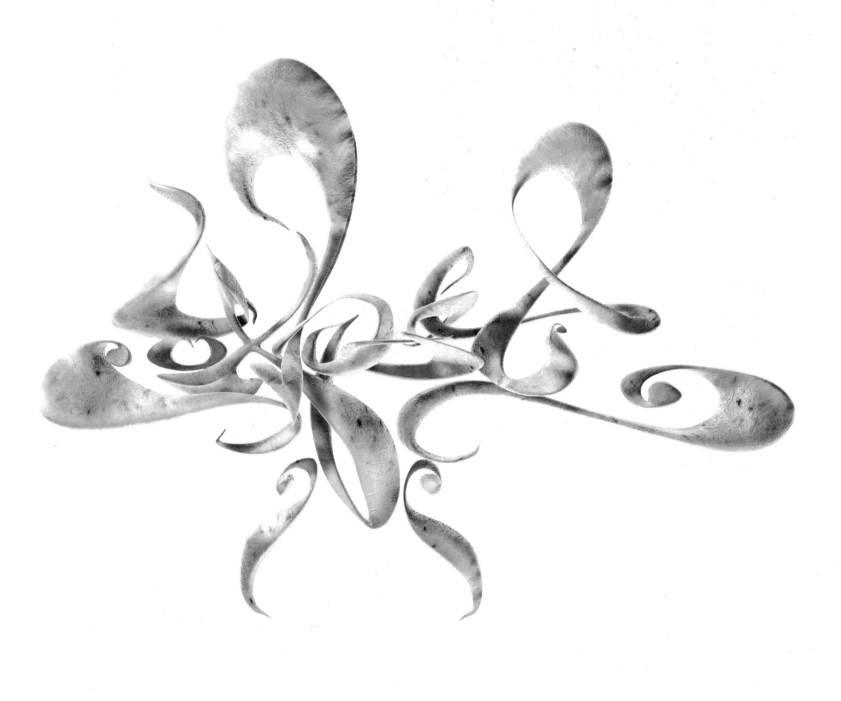

● **Oxboe** :: **Flow.Flower.Flowest** :: Berlin :: 2003

2D - 3D

Because Writing seeks to take possession of a space, Writers must concern themselves with the dimension of forms. Writers can, for example, choose to move beyond two dimensions in order to attempt to make their Writing appear more spatial. Complicated constructs of perspective are often necessary to make a 3D effect possible.

Because helpful guidelines cannot be included on a wall, these are first practiced in a sketchbook. The originality of the draft, practice and skill are then decisive to the quality of the final work. As with all objects drawn in 3D, a dynamic is created between the choice of an interesting perspective and its exact execution. This dynamic determines the overall spatial impression that an object makes.

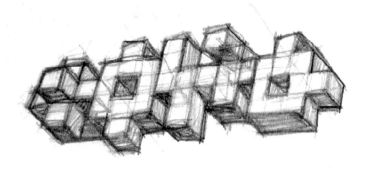 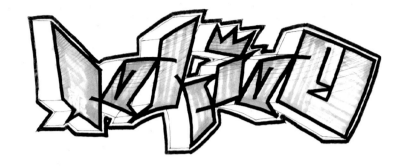

● **Tokioe** :: Berlin :: 2001

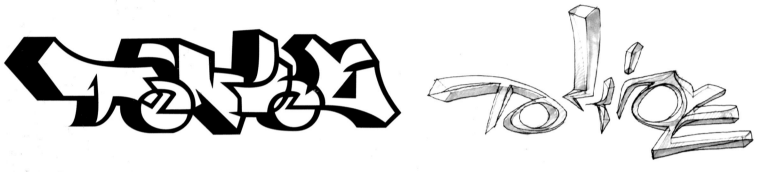

● **Tokioe** :: Berlin :: 2001

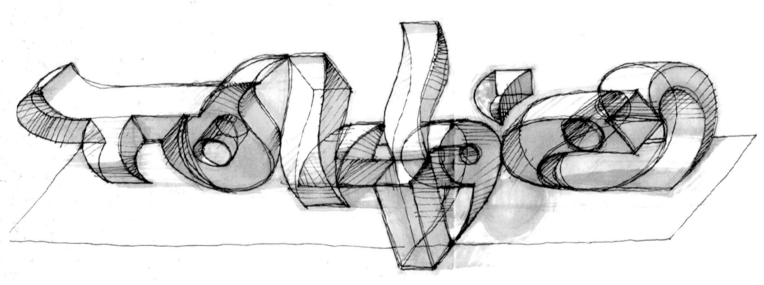

● **Tokioe** :: Berlin :: 2001

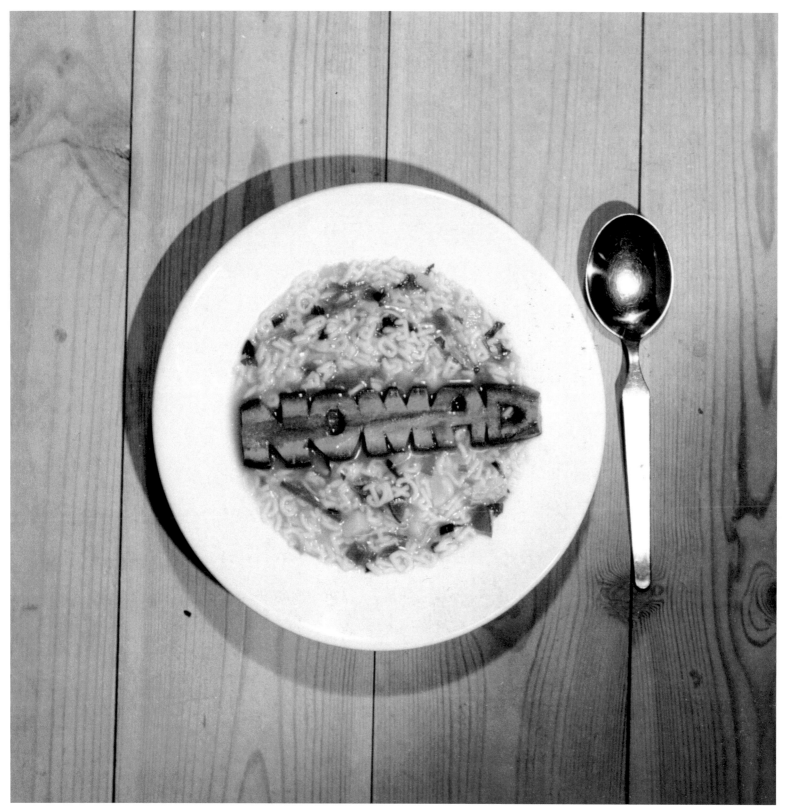

● **Nomad** :: Berlin :: 2002

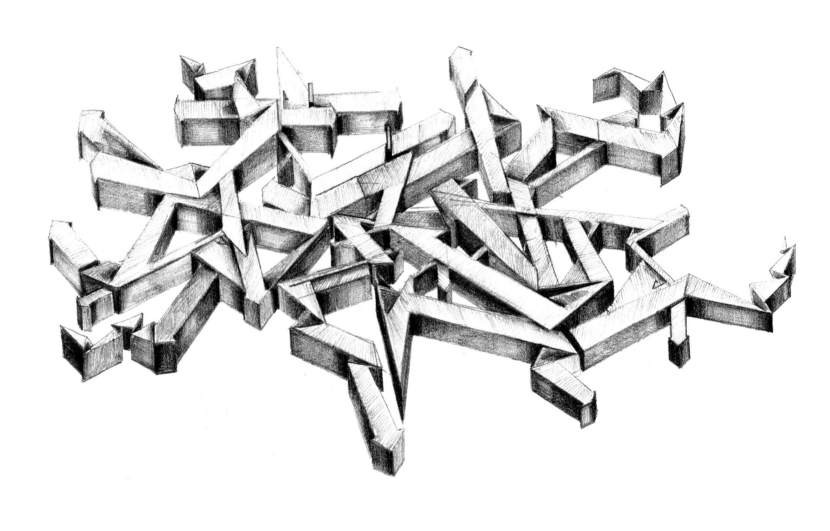

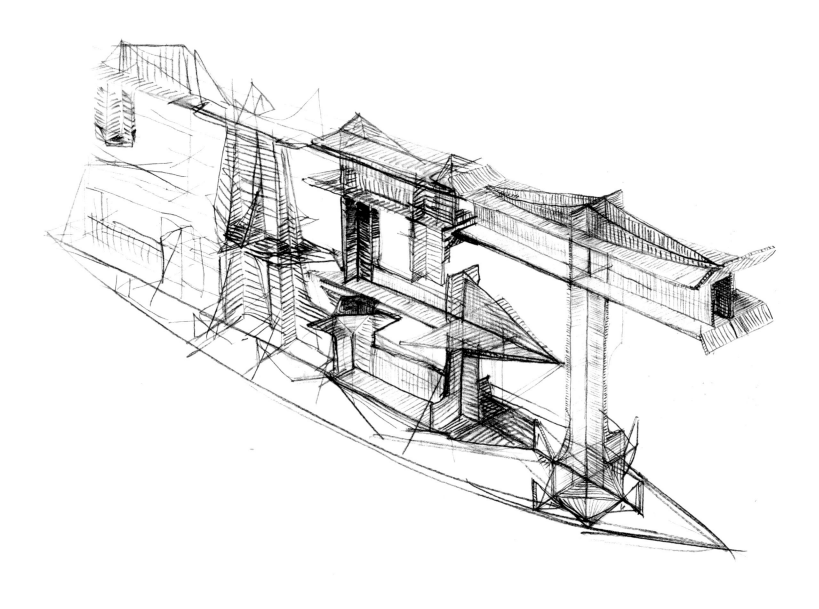

● **Zasd** :: **Vision Of A Huge Steelconstruction** :: Berlin :: 2003

● **Oxboe** :: Berlin :: 2001

OXBOE
AESTHETICS ARE A PRODUCT OF BALANCE

Your works show that you have changed your medium and tools. The mouse has taken over the place of the spray can. At the same time, you are still using traditional forms of Writing. Your changes are conceptual constructions. Do you see yourself more as a Writer or an architect?

That really doesn't matter much to me. I don't want to limit myself with rules of conduct or definitions. I'm continually trying to communicate with the elements instead. That means that I'm always trying to explore the objects that I design in a wholly new and fresh way. It takes time, but is really fun to explore all of the possibilities. I don't want to force my design upon the objects, but interpret each material's individual needs. For example, while I once faced a wall with all of the sketches and colours that I had worked out, completely different aspects caught my eye. I think it's one of the most important things in art to be able to let things go and not to love your own creation too much. Otherwise I would allow my work to have much too much power over me. Of course, that doesn't mean that I give up immediately when problems occur. Sometimes it's a hell of a struggle when I have a clear goal in mind but the realization just won't work out. It's times like that when a flexible approach is a real advantage. The objects' environment is pretty much as important to me as each single element in the composition as a whole. It's important to me to make a mural fit into its environment.

Does this concept only apply to your outdoor work in cities?

The eye might distinguish between what is real and virtual, but the rules of aesthetics always remain the same. That's why, as a matter of principle, I aim to establish the balance of the overall picture.

Is "design of space" an accurate description of your artwork?

I think of "space" in an extended sense. Designing space means sculpting the environment. Even my use of architectural methods and elements can't keep me from using different means of style. Organic life, for example, is not always constructible because its focus is on flow. It's essential to cross countless borders. As a rule, I'd say that none of my methods could be separated from the others. By taking photos, I developed an eye for camera shots in virtual spaces. Spraying and painting influenced my sense of texture. And, needless to say, these doors swing both ways. So when I use different media or mix them, I'm doing it to take advantage of the strengths of each technique and also not to get bored too quickly. It's a great way for me to question standards and develop something new. Since everything has already been done before, I am convinced that progress lies in mixing and finding new combinations. When I combine architectural elements with Writing's flow, both forms of art grow into something new. They benefit from each other to build a powerful symbiosis.

You are connecting areas, combining them in a natural manner... Is this how projects will be done in the future? Is your artwork more playful or concrete?

I'd say it's a mix of both because my hobby has become my job - a real double-edged sword. What about creating housing with roots in Writing? Most interesting, but I doubt that design is the priority of such a project. But time will tell...

Aesthetics... How important is it for you that people like one of your final products?

It's pretty important because my aim in most cases is to enrich our trivial world. Sometimes it's the atmosphere that motivates me while sometimes it's the forms. New aspects often emerge in the process of creation. The most interesting facets, however, become clear in conversations with friends. They know my abilities, but not the limitations of the tools that I work with. The fact that they project their desires onto a future project often provides me with new points of view that are pleasing to a wider range of people. The same applies to aesthetics. When, for example, I met with classmates from my elementary school a couple of weeks ago, one of them had brought a book in which I had once written. Pretty weird to see that in fourth grade I had wanted to become a craftsman. Later on I decided to become an artist because I had never really wanted to work. These days, 14-hour workdays without any free weekends are totally normal - and all of that's just because of the urge to push limits and a constantly developing sense for anatomy and composition. Constructions differ from surfaces. If the anatomy of a construction is just wrong, even the most optimally designed surfaces will be unable to hide it. To me, aesthetics are a well-kept balance between all the parts in and around the artwork, allowing it to become more than the sum of its parts.

You let yourself be inspired by your work. It pushes you... to new horizons?

People who attempt to improve themselves through failure are past their prime. That's a rule of time. The further I go, the more possibilities I have. 3D was my weapon of choice because it offers more or less unlimited possibilities, and my brain just works that way. But what I do is just a temporary expression, just a visualized idea. Energies flow in multi-layered dimensions.

● **Oxboe** :: **Oxboe 4D** :: Berlin :: 2003

MAKING OF **OXBOE 4D**

The fundament is found in normal 2-dimensional shapes, designed by following the rules of common writing. That means starting sketching on a piece of paper and working out the characteristics of each letter. Though my aim was to build a piece in which just a single letter was visible or readable from a particular point of view, I didn't have to care about the composition of the lettering as a whole like I usually do. So by scribbling around single letters, I recognised a mirrored similarity between the "B" and the "E". Indeed, these are my dominant letters (or the ones easier to play with) and I begin a lot of my pieces from the back or the middle. Maybe it's a lack of imagina-

tion, but as I see it "O"s have to be closed circles and "X"s have to look like crossed bones. That's no rule of thumb of course, but they had better come close to that picture for recognition purposes. Now having the "B" and the "E" as basis, the next step required bridging the gaps. In this case, both of the letters have a round belly, and for the first time ever this was an advantage. All I had to do now was to screw them up so that the upper half would break up and leave just the belly in the lower parts. That was the point where I had to leave pen and paper and head for the 3rd dimension. I just needed to see how far I could push it. After building, twisting, pushing and pulling, there was a rough model in front of me containing "O BOE" read-

able in an anti-clockwise rotation or, translated into 2-dimensional terms, from left to right. By the way, the 4th dimension is time and the rotation is the glue forming my tag out of five single letters built out of five single parts. Well, the "X" was still missing and I could not slice the belly in two... so I decided if it won't fit in, it has to take the weight! No need to mention that this construction follows static rules from outer space, but my aim was to come up with a style that I hadn't done yet and to involve the 4th dimension. The realisation was one hell of a ride and fun as hell too. But that's where I find my heaven and be sure there's more to come!

● **Oxboe** :: **DB-OCB** :: Berlin :: 2003

Bek :: Caracas Venezuela :: 2002

● **Zedz** :: Leiden :: 2002

● **Zedz** :: Leiden :: 2002

● **MUA & Zedz** :: Leiden :: 2002

● **Zedz** :: Leiden :: 2002

Maurer United Architects (MUA) & Zedz :: Eindhoven :: 2003 ▶▶

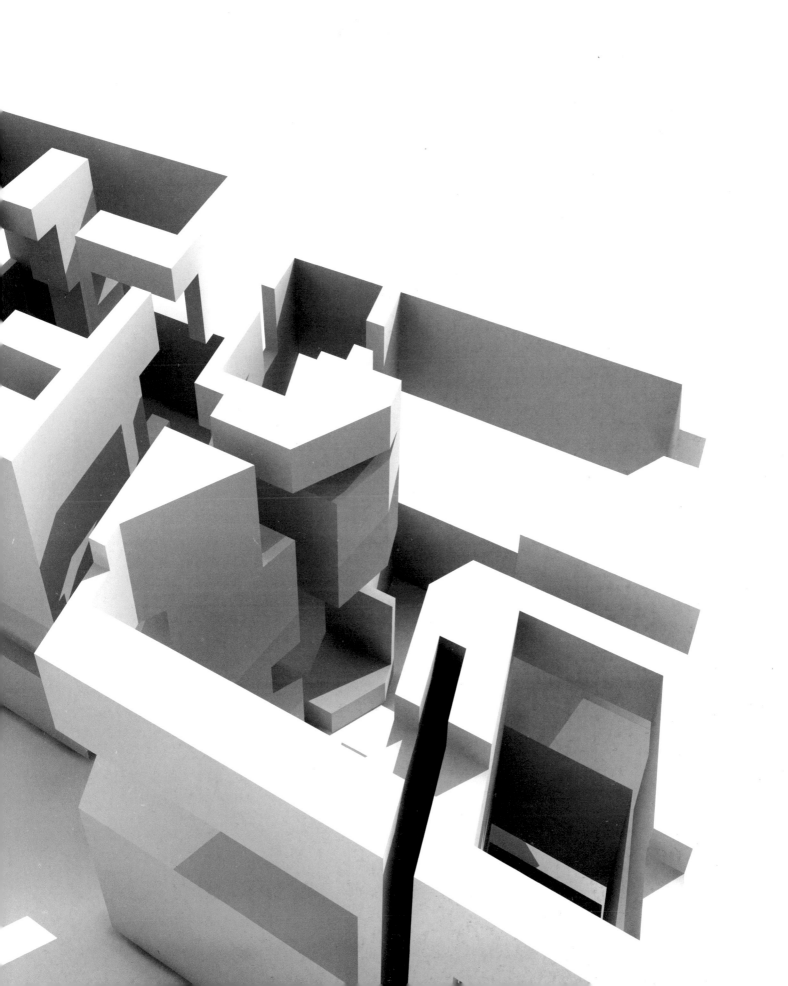

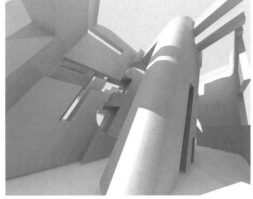

● **MUA & Zedz** :: **ZEDZBETON 3.0** :: Eindhoven :: 2002

INTRODUCING :: **ZEDZBETON 3.0**

At the behest of the Eindhoven University of Technology Art Foundation, Maurer United Architects (MUA) has developed the design of an urban furniture in cooperation with graffiti artist ZEDZ. The futuristic project, entitled zedzbeton 3.0, was designed for a location in front of the main building on the university campus. At the Eindhoven University of Technology, all students are given the opportunity to buy a partly subsidised laptop computer when they start their education at the institution. This way, the students can use these laptops to log onto an intra-/internet service in all campus buildings. In the public space outside the university, however, there are as yet no such possibilities. Also, in spite of its geographical location near the city centre, the campus hardly takes any part in the local, urban life of the city. The university board aims to transform the functional, businesslike and highbrow campus into attractive, approachable and open accommodations for students and non-stu-

dents alike, which are accessible both day and night. These facts gave rise to the idea of designing public, urban furniture that can fulfil these demands.

The MAURER UNITED ARCHITECTS (MUA) studio focuses on architectural design and relies on a close collaboration of two individual designers, Marc Maurer and Nicole Maurer. Social changes are translated into their design concepts, which consequently represent a sharply defined and "zeitgeist"-related statement in architecture that moves toward the level of the detail. In multi-disciplinary teams, MUA collaborates with graphic designers, graffiti artists, skateboarders, vj's and web designers to generate designs with cultural authenticity. Thanks to the immense progress in information technology, it is now possible to make crossovers between design fields more than ever before.

Graffiti artist ZEDZ is well known for his three-dimensional style. ZEDZ and colleague DELTA have pushed graffiti art to a higher level

of three-dimensional typography. His meticulously designed, often spectacular graphics and spatial artworks have an advanced technological and futuristic appearance.

The ZEDZBETON 3.0 design is based on the alias name of this graffiti artist. In a collaborative team, a design strategy was determined. The follow-up process led to the definition of a tactile design. The transformation of typographics into a three-dimensional architectural design involving the play of colour, shadow and light was the central theme in this process. The two-dimensional fonts were extruded to three-dimensional variations in order to subtract them from each other in a next step. This resulted in four objects: Z-E-D-Z. In every object there are two three-dimensional variations of the same character to be explored. The objects are meant to be built in concrete. Each of them measures about five metres in width, fifteen metres in length and four and a half meters in height. This scale makes it possible to access the objects and sit on them in different ways.

● **MUA** :: Eindhoven :: 2001

● **nginco** :: **Mitbususho** :: New York :: 2003

OBJECT

Writers have always concerned themselves with the third dimension as an extension of surface, and this topic is constantly being explored even further. In the beginning, tags and pieces became belt buckles or simple constructions made of wood. Today, the letter, which serves as the foundation for defining surfaces and partitioning spaces, is now materialising into complex objects.

As objects, letters can and must work from all directions. The viewer is thus actively included in the sculpture's development. At the same time, the attempt is being made to create new connections between the object and the viewer and to clarify dominant lines. In the definition of objects out of surfaces and lines, for example string, one can recognize an affinity to early constructivists including Naum Gabo. Computers, which serve as readily available tools, also influence objects' definition.

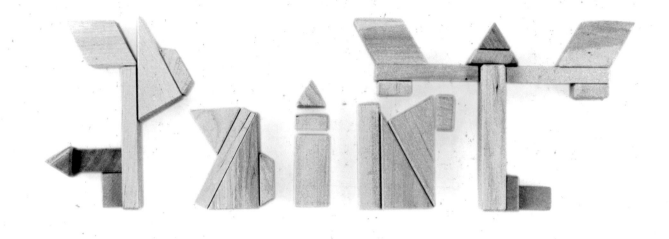

● **Zasd** :: **For Point** :: Berlin :: 2001

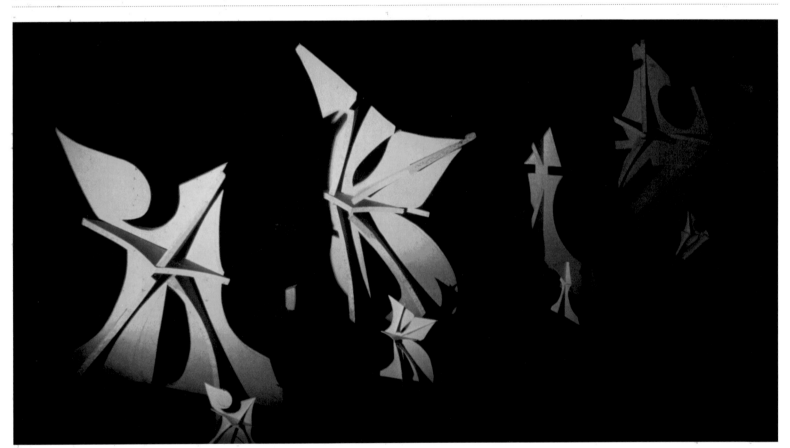

● **Akim** :: Berlin :: 2002

Zasd :: Swan S :: Berlin :: 2001

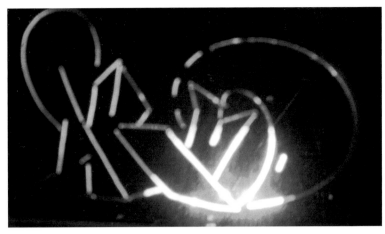

● **Akud** :: Jazzstyle Corner at Glaswerk :: Berlin :: 2002

● **Akim** :: Jazzstyle Corner at Glaswerk :: Berlin :: 2002

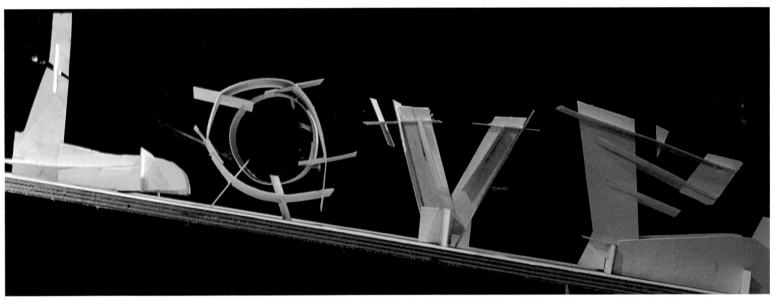

● **Zasd** :: Jazzstyle Corner at Glaswerk :: Berlin :: 2002

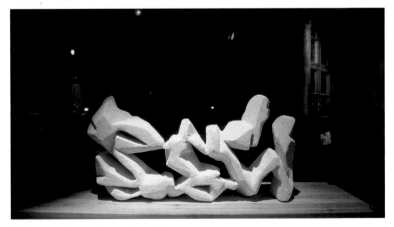

● **Poe** :: Jazzstyle Corner at Glaswerk :: Berlin :: 2002

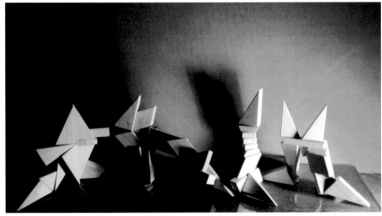

● **Akim** :: Jazzstyle Corner at Glaswerk :: Berlin :: 2002

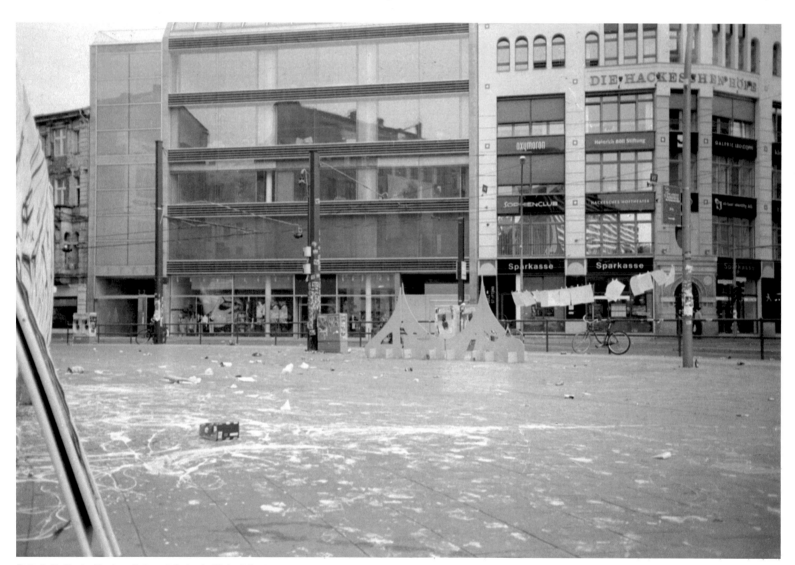

● **Zasd :: The Morning After Jazzstyle Corner At Hackescher Markt** :: Berlin :: 2001

The way you work, your entire attitude towards your work differs very much from other crews who, for example, only joined forces because they were friends or just work together…

Zasd: That's true. Jazzstyle Corner is not a crew in the traditional sense and therefore does not necessarily display the characteristics of traditional crews. We have a floating number of members. Jazzstyle Corner is more of an approach. The people who identify with this idea, this concept and then collaborate with each other are in a way all members of Jazzstyle Corner. But at the same time they only represent themselves, and they are responsible for their own work. There is no territory to be defended; there's only that, the Writing, which concerns all of us.

…so everyone who gets actively involved becomes a member…

… that's key. To actively participate in further development! Of course, there's also a human side to it, but essentially Jazzstyle Corner is based on the work we do together, which in turn often helps to bring us closer than if we were just hanging out… It all started with an idea that Akim and I had while he was watching me drawing sketches. I had long before stopped using an eraser and simply drew according to my current mood. To me, it was very important not to be interrupted. The drawing was meant to stand for and express that particular moment. To Akim, this was a totally new idea and we decided to use the same approach on walls. And we repeated it countless times. Instead of first sketching out our drafts, we drew the outlines straight away, writing the style.

And this was the basic idea behind founding Jazzstyle Corner?

At the time we were definitely very much aware that we had to question our own work and Writing in general a lot more intensively and extensively than we had done before. Until that point, this was in 1998, it wasn't especially common to question your own work or critique that of others. Criticism was generally not considered very constructive. In any case, this intense new way of working gave us a completely new perspective. All of a sudden other pieces could be judged by the same criteria. We also worked on a lot of public squares and walls, and we started a discussion with a lot of Writers in Berlin and elsewhere.

You exchanged the previously self-centred approach for joint discussions…

The grand idea behind it was this: when many people share their knowledge and experience, you can acquire far more knowledge in a much shorter space of time. That's what makes for real movement. People exchange ideas constantly. In Berlin it has become pretty normal to discuss how your own work can be improved. To recognise your own boundaries and then to cross them – to me that's the most important aspect. You still need to be able to rock the knowledge that you've acquired on your own and on the street, though. Before you cross a boundary in your head, you have to actually do something! You have to put it into practice! Because we're all masters in our own minds – especially in Berlin, hahaha.

So you think a lot more about the way you work and you often work in groups…

In the beginning the term Jazzstyle only described this special way of painting. You just stand there, unprepared, and give free reign to your perception. You just paint and translate this whole atmosphere, these feelings into your own style. Whenever you spend a lot of time beforehand thinking about which shapes create which inner sound etc., that a triangle is a very sharp form or that a circle is very round and soft, then after a while this knowledge automatically flows into your work. You shouldn't think about your style, but improvise. In the early years, when you start to spray, you get to know your instrument. Jazzstyle became our turning point when we moved beyond straightforward techniques and started to improvise on our instruments. We didn't want to just repeat the established New York melody, but to invent our own compositions instead. That's what the term Jazzstyle initially stood for. Jazzstyle Corner was a concrete result of the event at Hackescher Markt. Over time we have tried different ways of getting people involved and convincing them of our ideas. In doing so, we could find out if people were ready to change their views or how far we would be willing to change ourselves. In this way, a circle of friends and colleagues began to form, and, with it, the urge to organise real happenings. Up to that point whatever we did had always been spontaneous. There was never any money involved, no sponsors. It was just Akim and me who concocted a basic framework and then told the rest of the pack so that everyone was connected in a special way. Obviously it only meant that each and every one was given a neutral surface to present themselves, to entertain others and transport their own messages.

So, are these events mainly about entertainment? If that's the case, why don't you organise exhibitions or, for example, specialise in college lectures?

It is always about keeping an element of improvisation – in every sense. All events are organised in this spirit. When, for example, we've held an exhibition, the actual pieces are only built or painted a few days in advance. Whatever results from them is also improvised. The exhibit itself is not the most important aspect, but the fact that people come together. After all, it would be boring if XY has an exhibition and everyone just dropped by in quiet reverence. When we did an exhibition in the Glaswerk-Berlin, anyone was welcome to actively participate in the proceeding. Videos of all the tags, throw-ups or whatever were projected onto a screen, allowing you to watch someone spontaneously downloading his or her style in under a minute. If breakers and rappers have battles in front of an audience, why should Writers paint their fancy walls in slow motion if they could also have sessions showing a lot more of their real talents: flow, power, originality, the skill to act immediately, to react immediately… These exhibitions were kind of like jam sessions, events where everyone is an active participant. On the other hand, there are obviously guests who, in most cases, have very little knowledge of Writing, music or dance. These are the real consumers. And they are the ones we would like to lure on board with such an event, to fire them up a little. It adds a certain kind of power and improvisation that simply cannot be planned. Fact is, when nobody has to pay, there are no expectations. In the end this means that any guest is as important in making the jam work as the initiator, but that's something the guest has to work out for himself.

JAZZSTYLE CORNER
EXPECTATIONS ARE NOT BEING FULLFILLED...

What is the message to be taken home?

Most of all, it is an unexpected experience. It is something very different from a normal gallery visit, which is usually soon forgotten. It should be a kind of shared ritual of which there are really very few in our society. It is simply right to have a number of people joining forces to stage events together. Because most of the time people are too self-conscious and would never sit down at a table with people they don't know. But an event like this can remove those limits.

Does this bring an unsuspecting visitor closer to the idea of Writing?

Fact is, the general media-shaped opinion ostracises Writers as antisocial. So when we do a session, visitors get the opportunity to see that we're good and not evil, that we are willing to take on responsibility for ourselves and our actions and that, really, we are quite decent guys and girls. The core message of most of our events is that you have to create your own environment. Writing is only one aspect of this, if a central one. It is a simple message, which includes the element of Writing. On the other hand, there are also events solely dedicated to Writing.

The idea behind Jazzstyle Corner seems very loosely defined – you only provide the framework. It is neither clear where the individual events are heading, nor where you are heading as their organisers...

There are many ideas and approaches. These events are only one part of Jazzstyle Corner, which offer a public platform. Watch it!

Talking about approaches. You have revived the tradition of one-liners.

The intrinsic meaning of the word Writing is to write. So when I do a tag, I write it in one draught like a signature. In most cases I do this without even thinking about it. It is an automated process, a routine. It was my aim to bring the same automation to Writing. To write, in the truest sense of the word, style. Styles can be tagged! When you don't break the line, for example, it often happens that the end result simply surprises you. That's because something unexpected has entered the style, a unique moment that will never recur. And if you fuck up the first time round, at least you know where you are, where you stand.

In a way, this is the true concept of your events. You never know what might happen along the way or what the result might turn out to be...

It is only through many experiences and studies that you can improvise. Otherwise stay away from it when you start out. To me, one-liners are magic moments. You go somewhere, switch off and simply begin to draw. You don't even think because the line moves faster than your thoughts. Your body just has to do it; your movement needs to be coordinated. This adds a great assuredness to your movement. The result tells the truth about your abilities. But this is a question of intensity. To me, it's a process of evolution, but, because it's a continuation of the philosophy of throw-ups, it's not something really new.

You place a lot of emphasis on the line.

Well, that's the true strength of a drawing. The line on the wall is itself a drawing. But the strength of a drawing is also an illusion. Not an illusion of copying nature in a realistic way, but an illusion of sounds. There are many critics who don't consider the final product, i.e. the raw style, to be very innovative. But, viewed objectively, the outline contains the same information as the finished piece. It is simply the reduced form and thereby does not allow you to hide the actual form behind its elaboration or to hush it up. There are no beauty ops.

If shapes are sounds, the sounds are shapes and music becomes a drawing.

Yes, there are many ways of dealing with this. You can draw to the rhythm of music and translate this visually. When a jazz or funk track, for example, has a certain beat, you can adjust your movements to that. That's the easiest way. So if the sounds have shapes, what is their rhythm? You get a huge variety of combinations. And it is beautiful to look at. When you watch someone drawing to music, the style flies to him or her straight from the universe. And when that person reaches a certain flow it is very impressive.

This is all very raw and, in most cases, the product is raw, too.

Writing is raw! A cruel beauty. Sure, the craft of painting is something you should have mastered, but that's not the end all, be all. Craft alone won't create a good style if it hasn't been planned out well. It can only help lend the style some character. The blueprint is the essence; the actual letters are what it's all about. And that is why you can differentiate. But differentiation is only the starting point for becoming aware of the multitude of talents and tools, which are only ever used subconsciously and tend to go unmentioned in Writing. Then all other elements join one by one. But this time employed consciously. I think we really have to grapple hard with colours. We're still at the beginning. But we have moved far from the traditional views. A spray-painted train, of course, still stands for the euphoria that kicked it all off, but nevertheless the essence of Writing means handling letters to spread your name. No matter what colours or materials you use, at which location and in what style. It's your eyes, ears and perception that are important, how everything comes into focus and how you win over the hearts of others. It's not about adhering to dogmas. Keep moving!

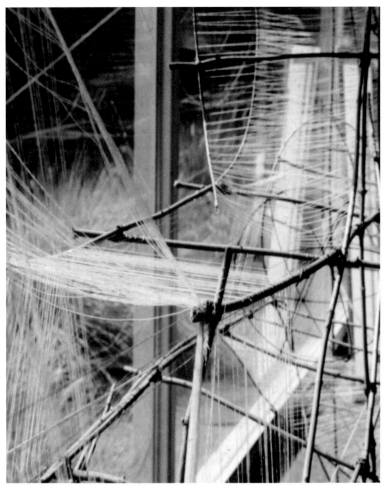
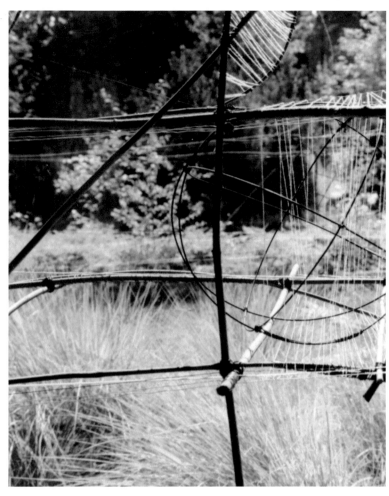
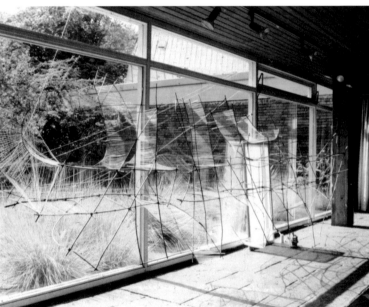
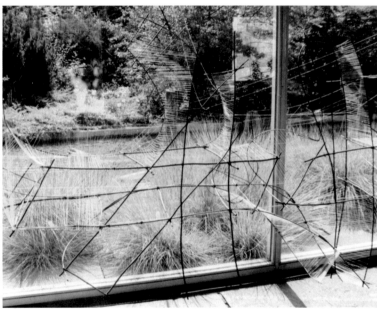

● **Akim** :: **At The Academy Of Arts** :: Berlin :: 2000

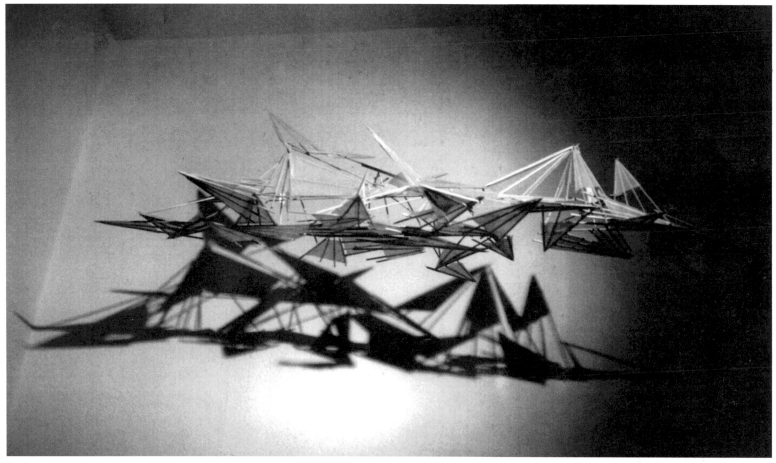

● **Try One** :: Berlin :: 2002

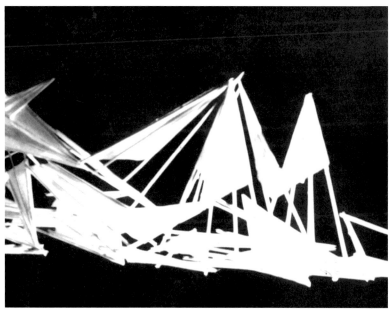

● **Try One** :: Berlin :: 2002

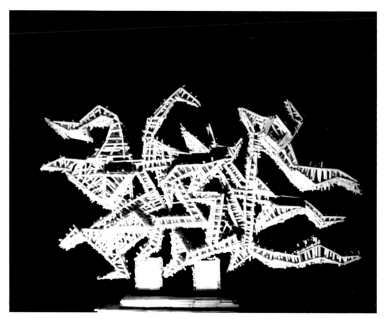

● **Try One** :: Berlin :: 2002

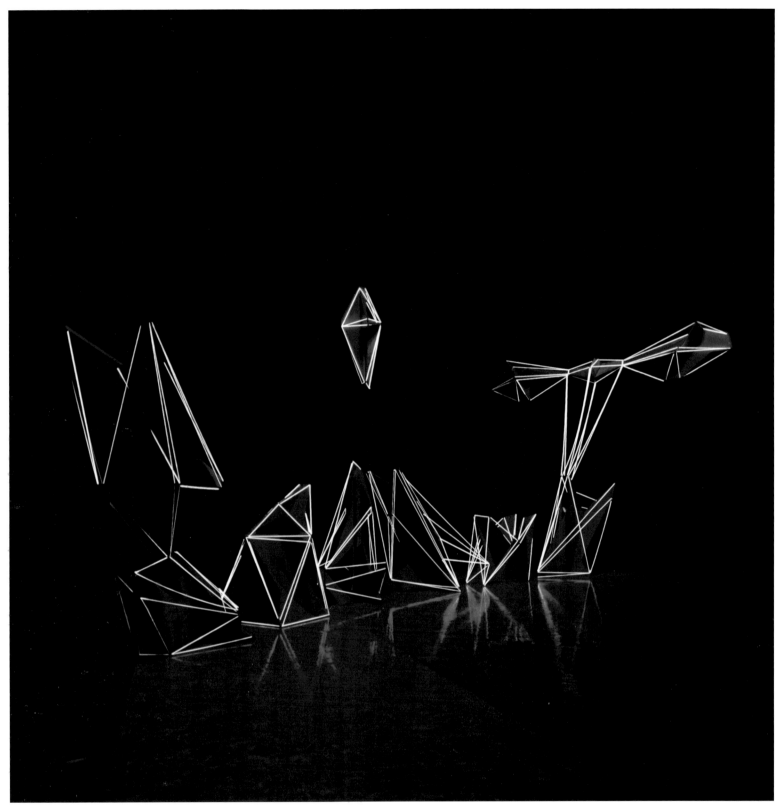

● **Point** :: Prague :: 2002

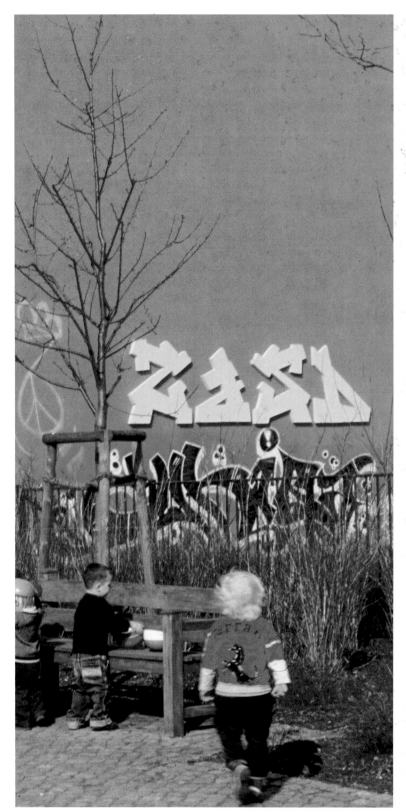

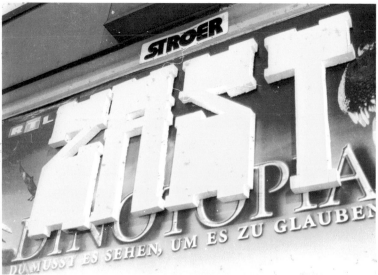

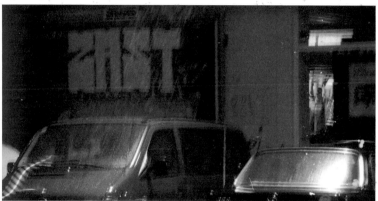

● **Zast** :: **Styropor-Styles** :: Berlin :: 2003

● **Point** :: Prague :: 2002

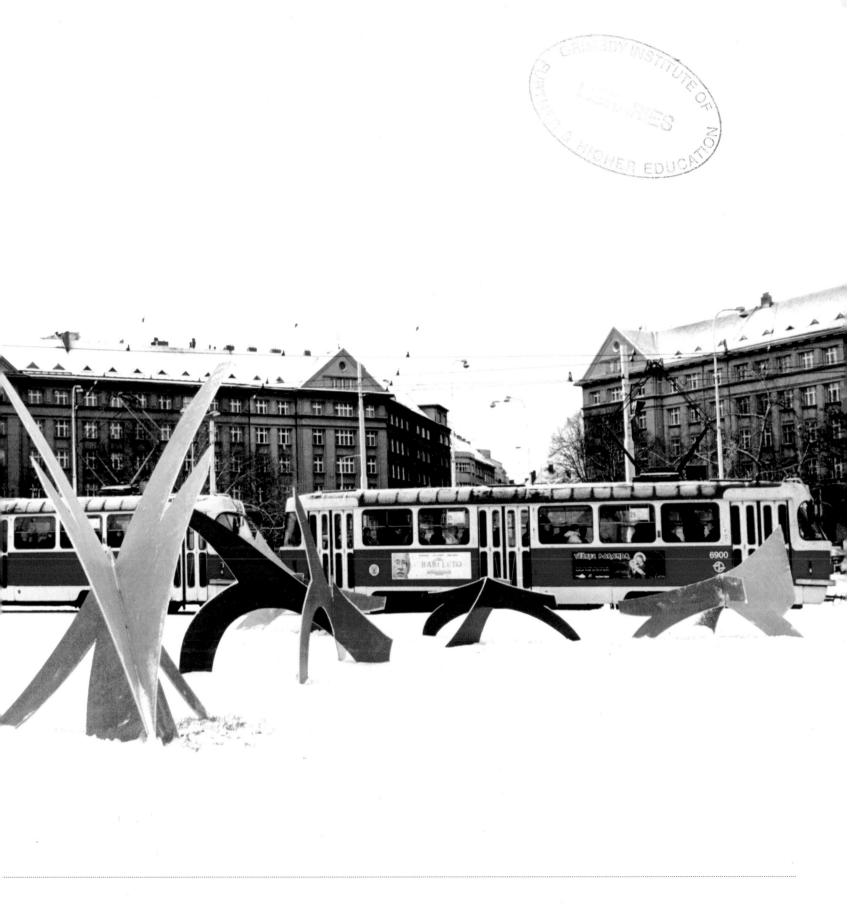

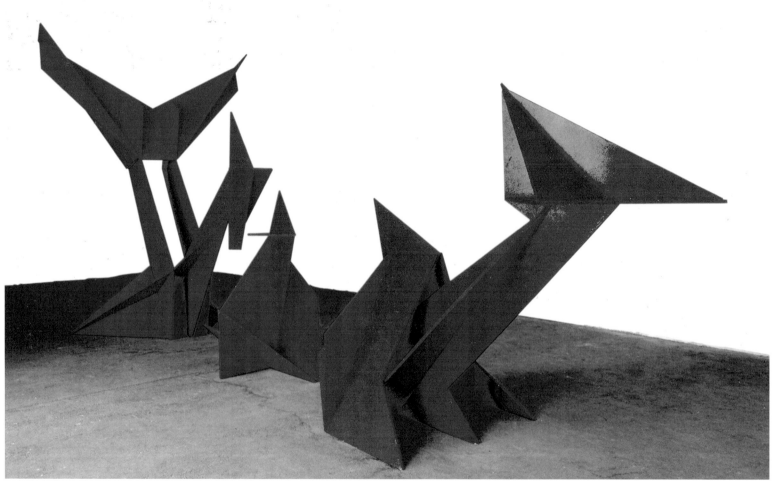

● **Point** :: Prague :: 2002

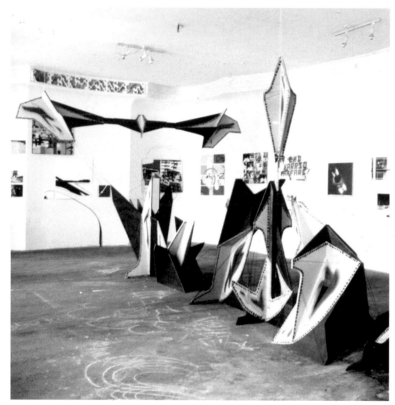
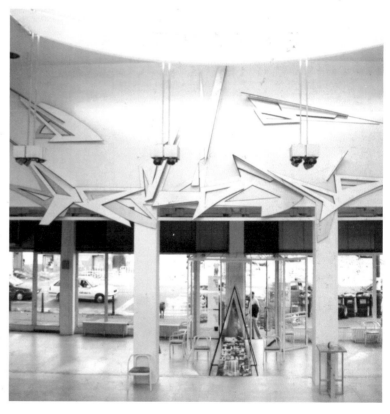

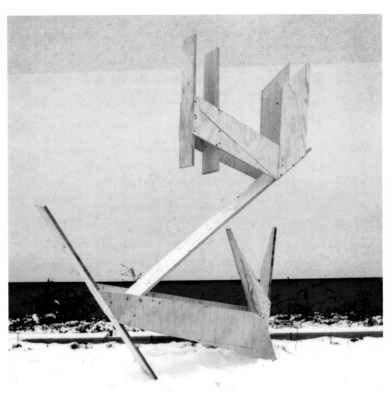
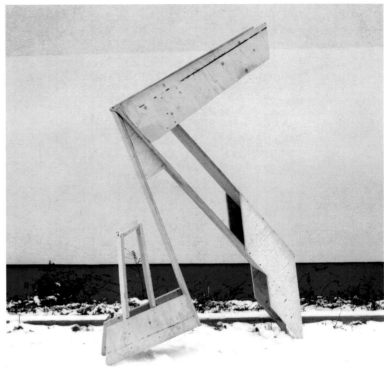

● **Zasd** :: Berlin :: 2002

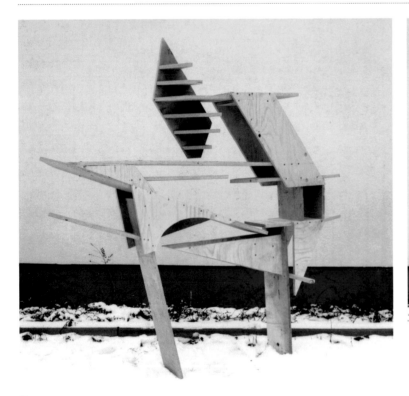
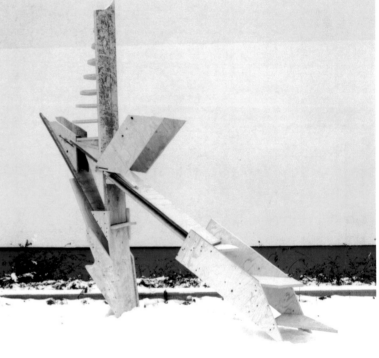

● **Akim** :: Berlin :: 2002

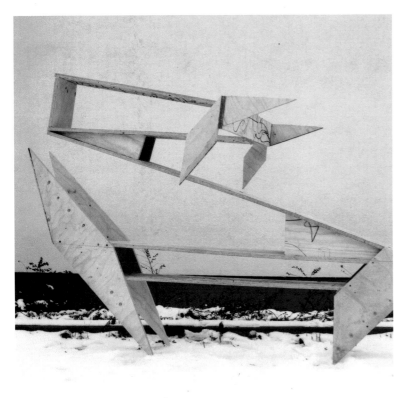
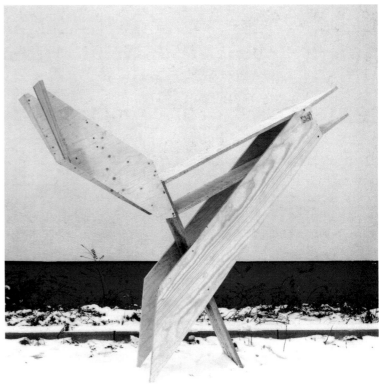

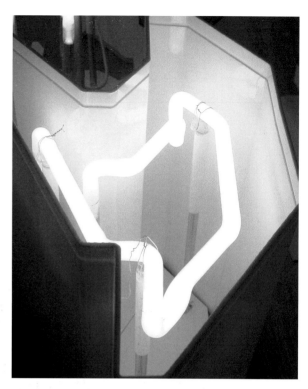
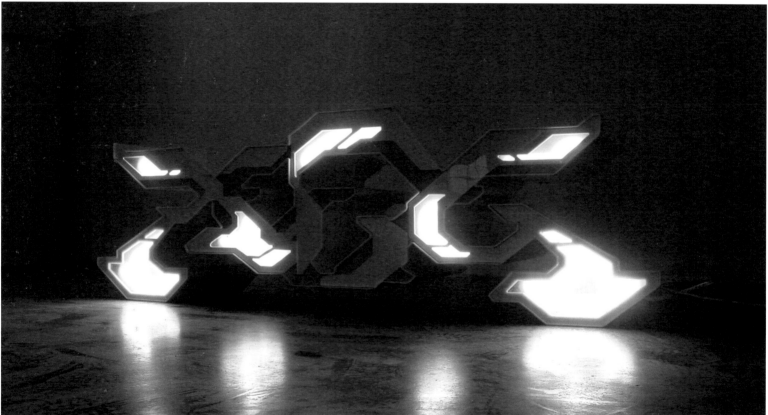

● **Recto** :: Belgium :: 2002

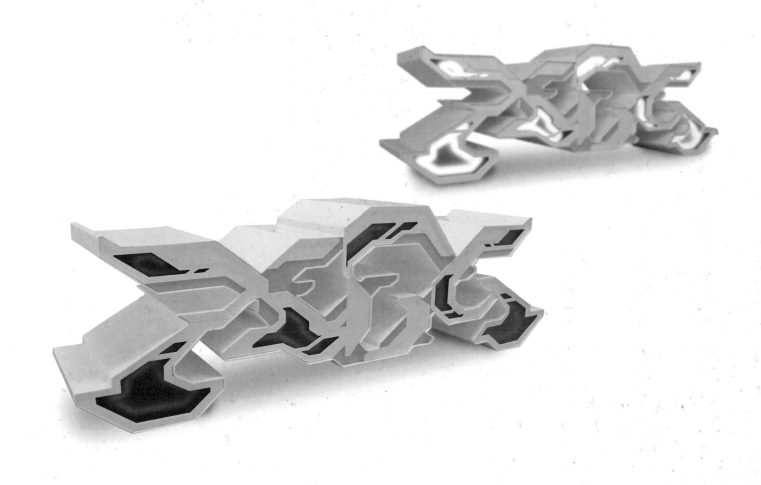

 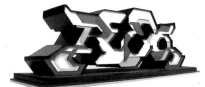 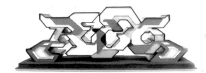 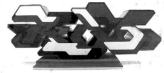

- **Recto** :: Typoflex Models :: Belgium :: 2002

 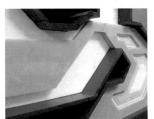 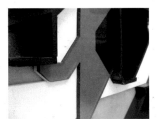 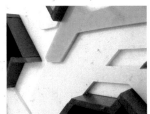

- **Recto** :: Typoflex Detail View :: Belgium :: 2002

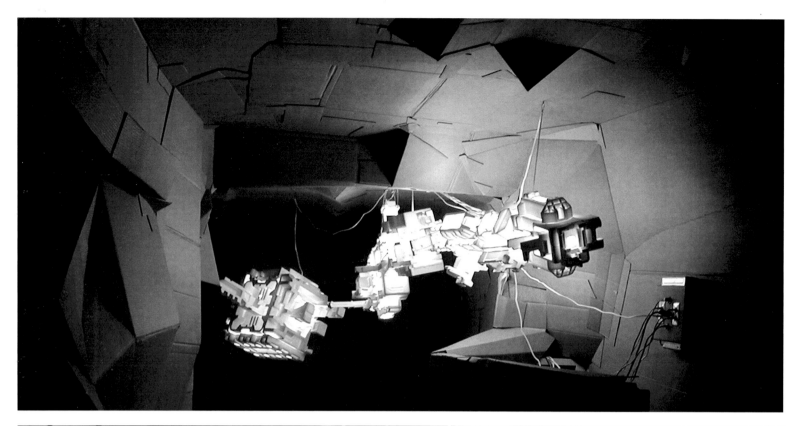

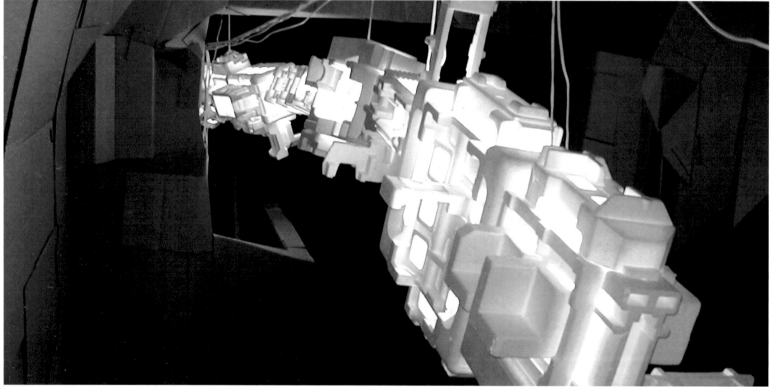

● **Jason Rogenes** :: Los Angeles :: 2001

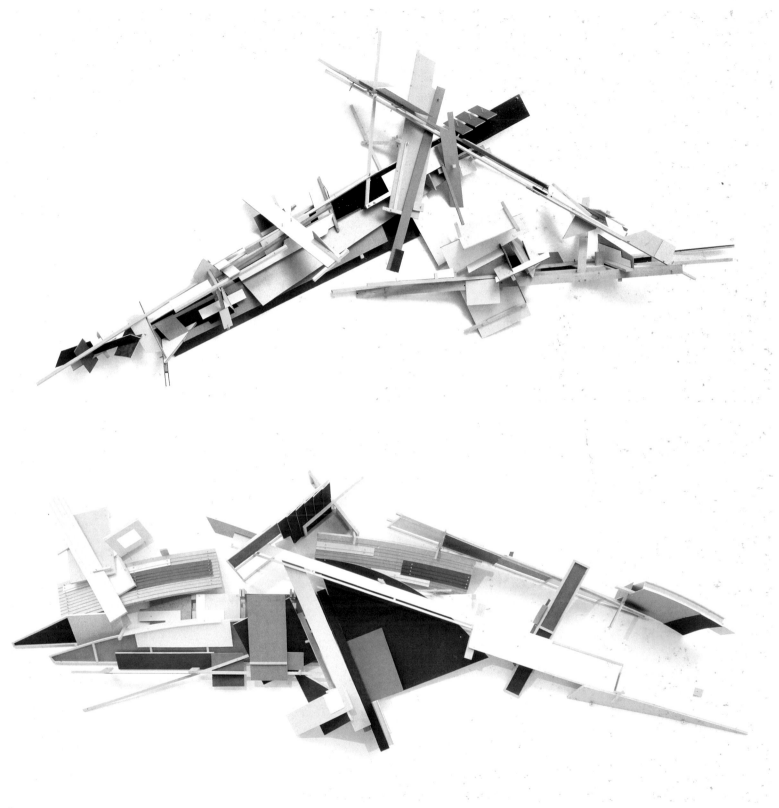

● **Colin Ardley** :: **Above And Below Horizon** (top, 1994) :: **Ariel Strategies** (2000) :: Dresden

GRAPHICS

By the early 1990s, computers as well as desktop publishing and layout applications had become affordable. It wasn't long before Writers began to use the computer in addition to paper to develop their illustrations and plan their alphabets. Styles used in Writing quickly began to influence graphic design. Hip-hop bands and labels as well as fashion companies were the first to use elements borrowed from Writing in their logos in order to signalise a connection to the street. Computers introduced possibilities that have proven to broaden the styles used in Writing. Vector graphics are created according to principles similar to those that a Writer works with to create his or her tags.

This chapter presents the mutual influences between Writing and graphic design. On the one hand, you can see that graphic designers have been influenced by the development of the approaches that we have shown in previous chapters. On the other hand, it will become clear that many Writers feel a connection to deconstructive typography. The typographical approaches that have been developed in modern graphic design and the views on the expressive interaction with surface that are held by Writers offer many points of intersection. Vector illustrations or the use of outlines have, for example, been strongly influenced by graffiti. The works that we show here cannot represent the full scope of all approaches, but they should serve to give you an impression of how strongly the culture of Writing and modern graphic design influence each other.

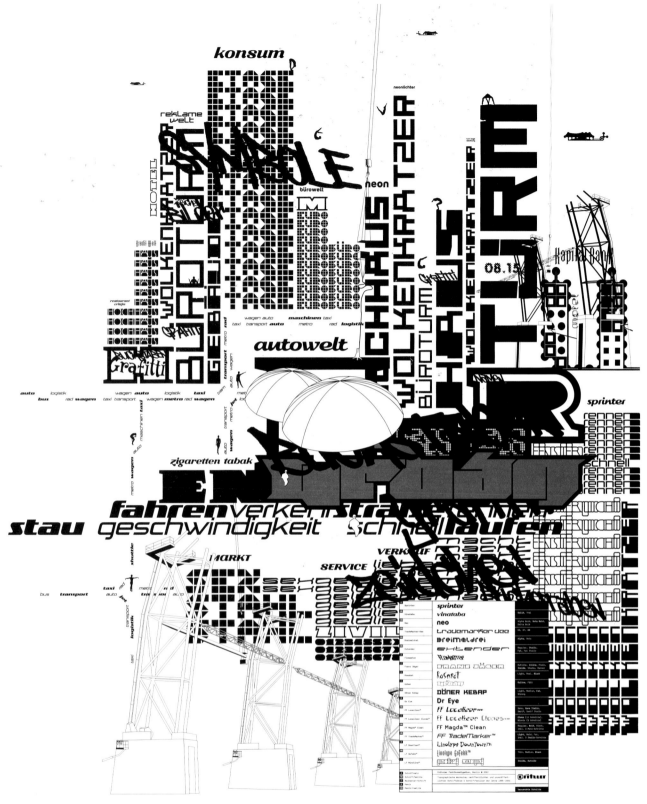

● **Critzla** (Pfadfinderei.com) :: Berlin :: 2002 P. 153 :: **Harsh Patel** :: Los Angeles :: 2002 ▶▶ P. **154 - 155** :: **Matthias Gephart** :: Dortmund :: 2002 ▶▶

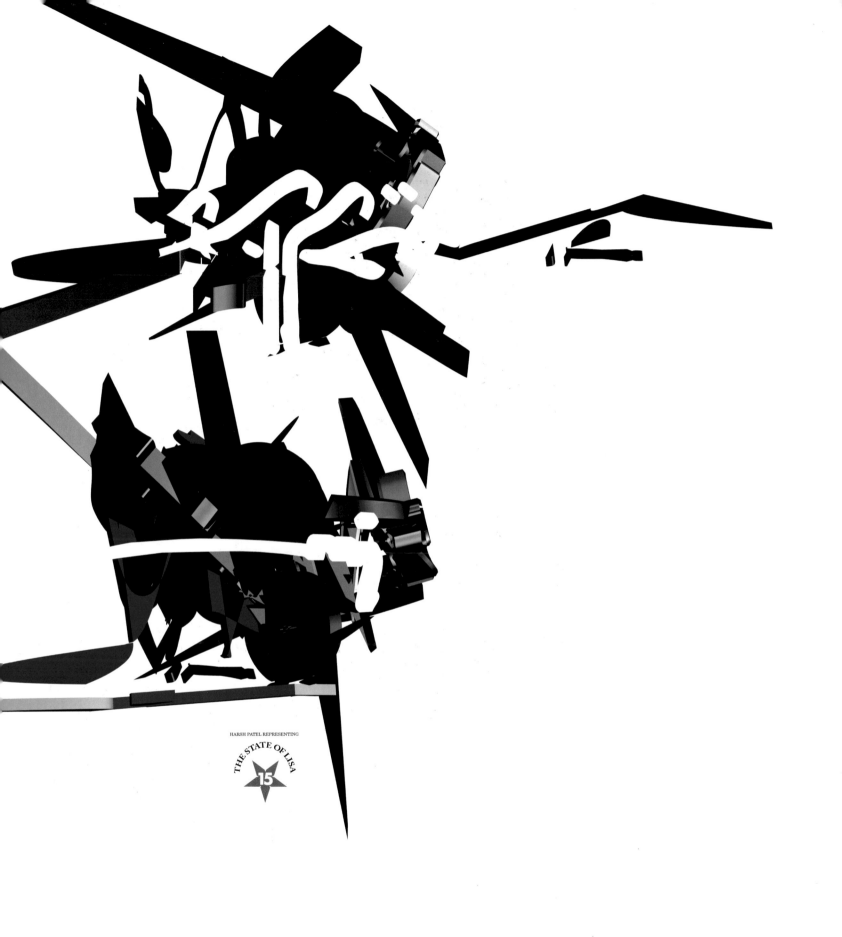

HARSH PATEL REPRESENTING

THE STATE OF LISA

15

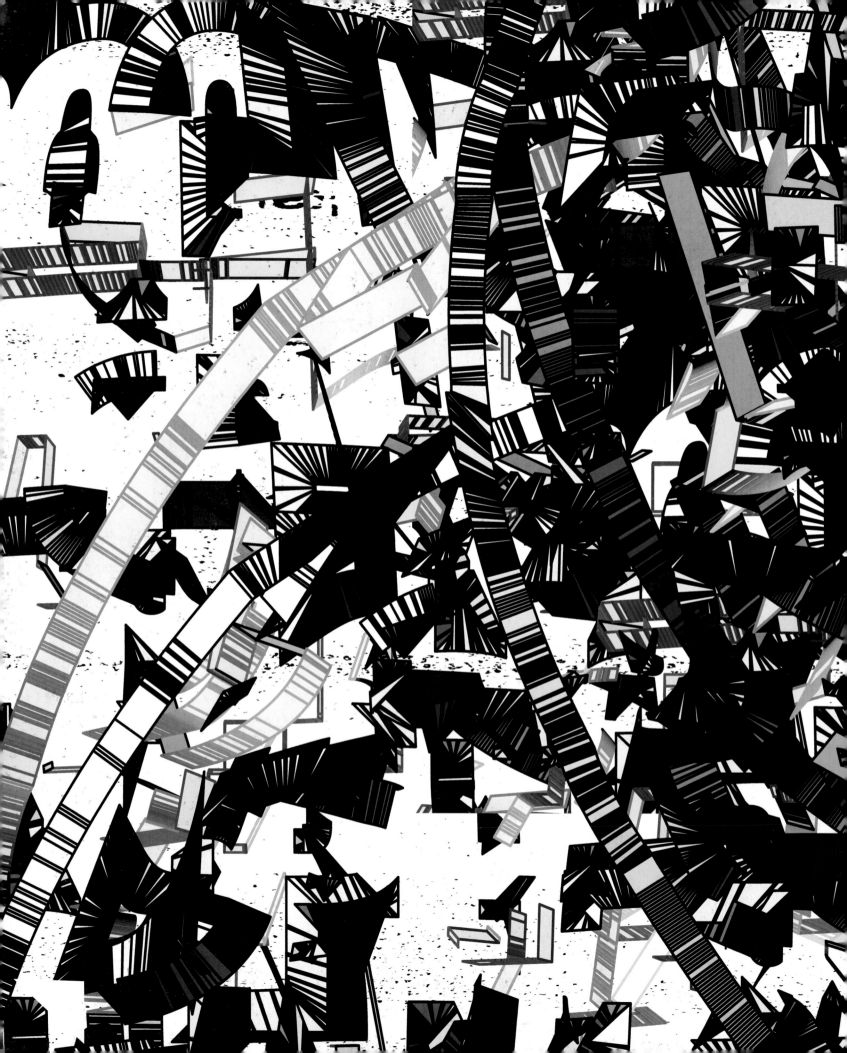

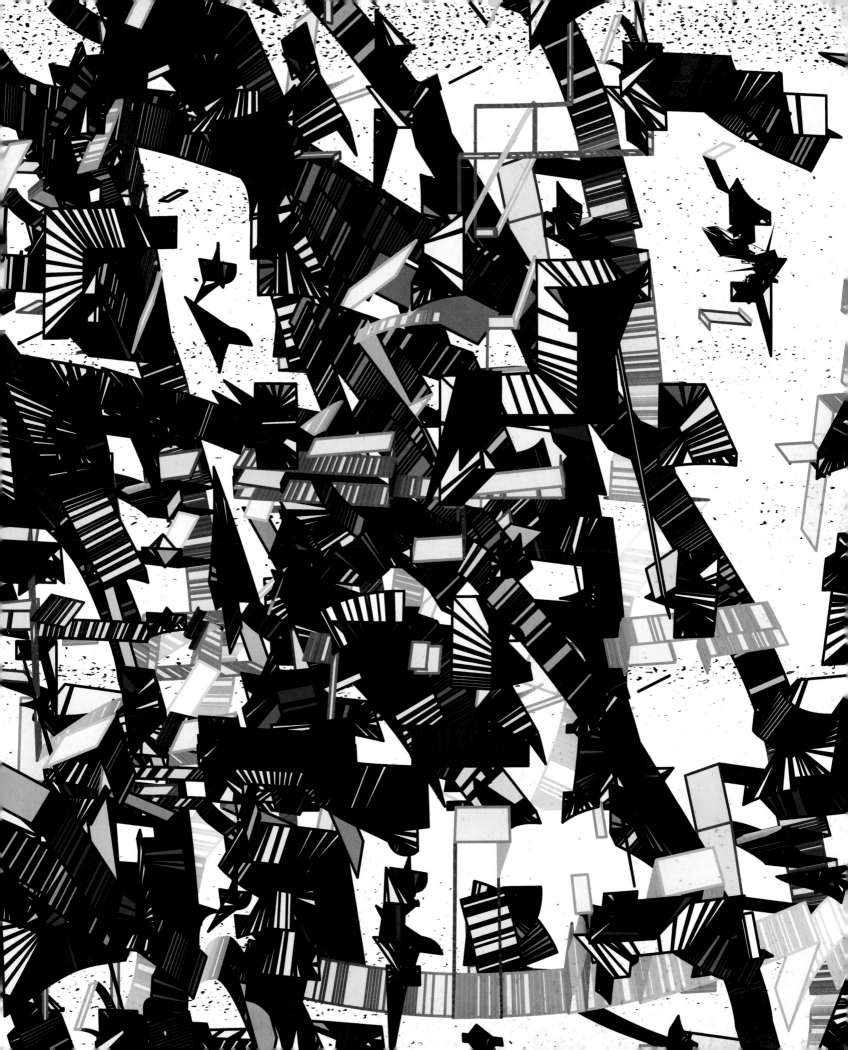

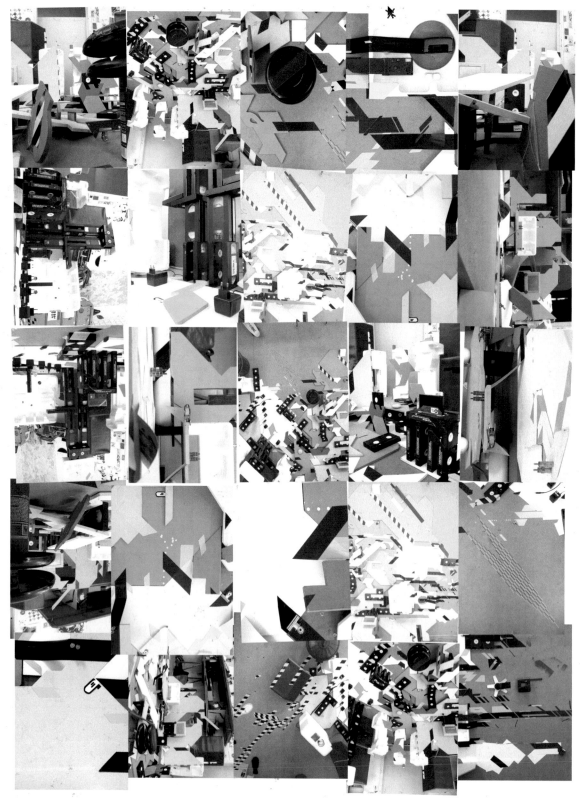

● **Pfadfinderei Allstars** :: **Working Without My Computer** (for Backjumps Magazine) :: Berlin :: 2002

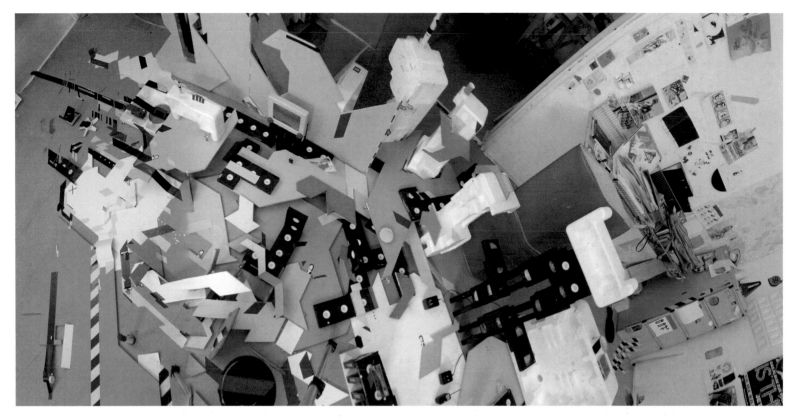

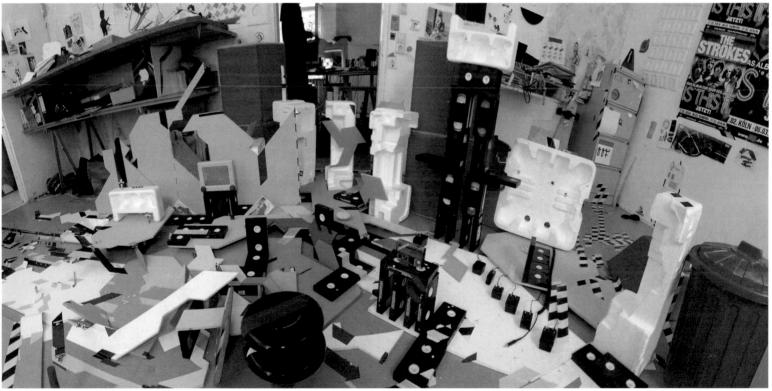

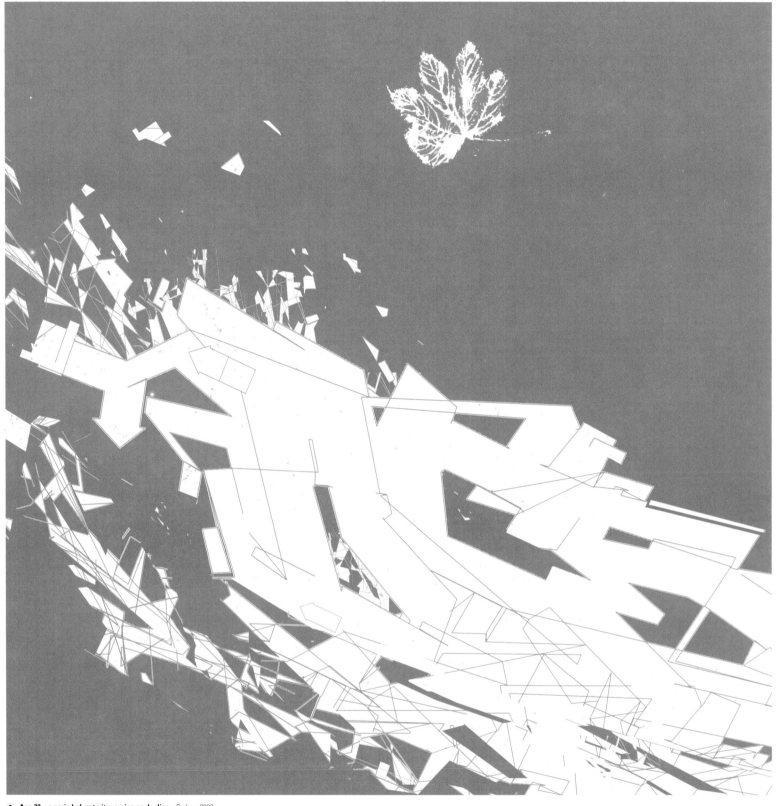

● **Ace 73** :: **a period of maturity verging on decline** :: Berlin :: 2002

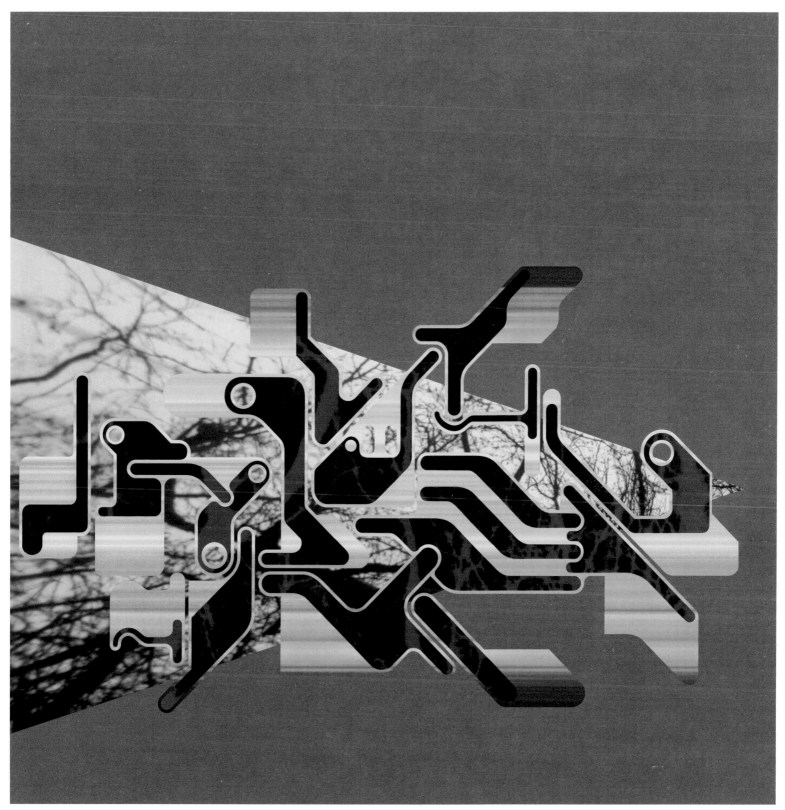

● **Ash** :: Paris :: 2003

● **Ash** :: Paris :: 2003

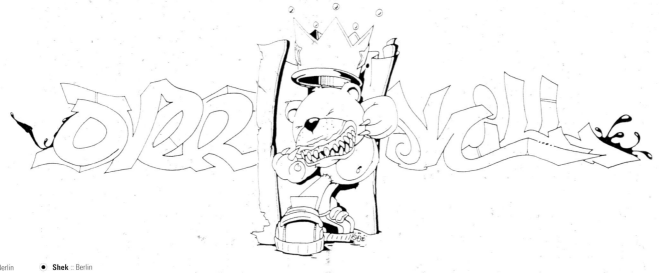

Odem :: Berlin ● Shek :: Berlin

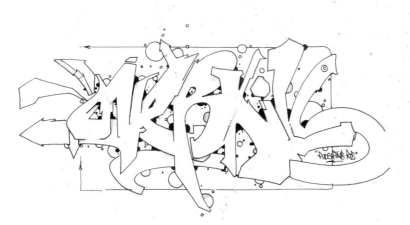

● Phos 4 :: Berlin

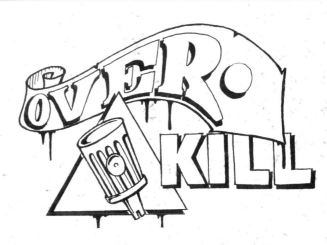

● Odem :: Berlin

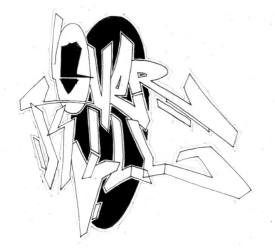

● Flash :: Berlin

● Amok :: Berlin

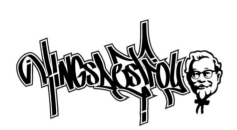

123 Klan :: France **Martin** (Pfadfinderei.com) :: Berlin **Kazik Prodüksiyon** :: Berlin

Typeholics :: Hamburg

123 Clan :: France

Kazik Prodüksiyon :: Berlin **Zedz** :: Leiden

● **Zedz** :: Leiden

● **123 Klan** :: France

● **Martin** (Pfadfinderei.com) :: Berlin

● **Mek 32** :: Berlin

● **Kazik Prodüksiyon** :: Berlin

● **123 Clan** :: France

● **Typeholics** :: Hamburg

● **Underground Productions** :: Sweden

● **123 Clan** :: France

● **123 Clan** :: France

● **123 Clan** :: France

● **Akroe** :: France

● **Masa** :: Caracas :: Venezuela

● **Hase** :: Caracas :: Venezuela

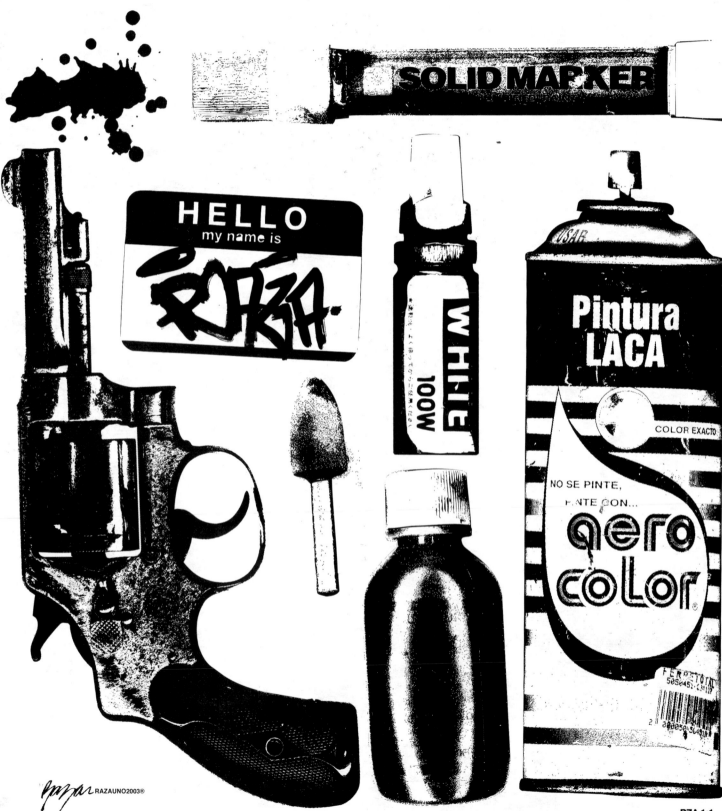

RAZAUNO2003®

RZA 1:1

Raza :: Caracas :: Venezuela :: 2002 ● **Masa** :: Caracas :: Venezuela :: 2002

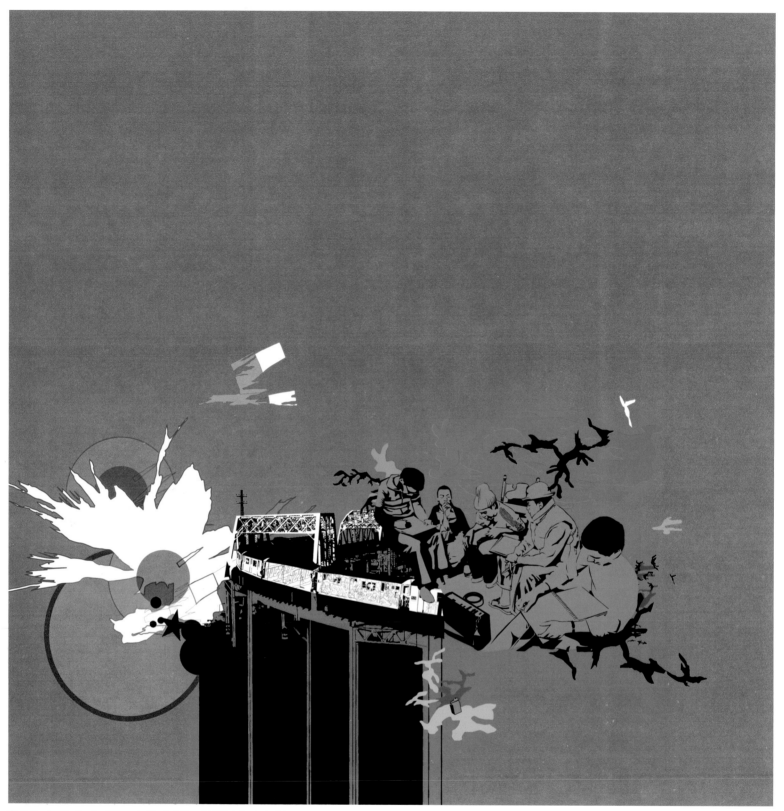

● **Battlecake :: The Complex Of Dream And Reality Is Never Definitively Resolved** :: Oslo :: 2003

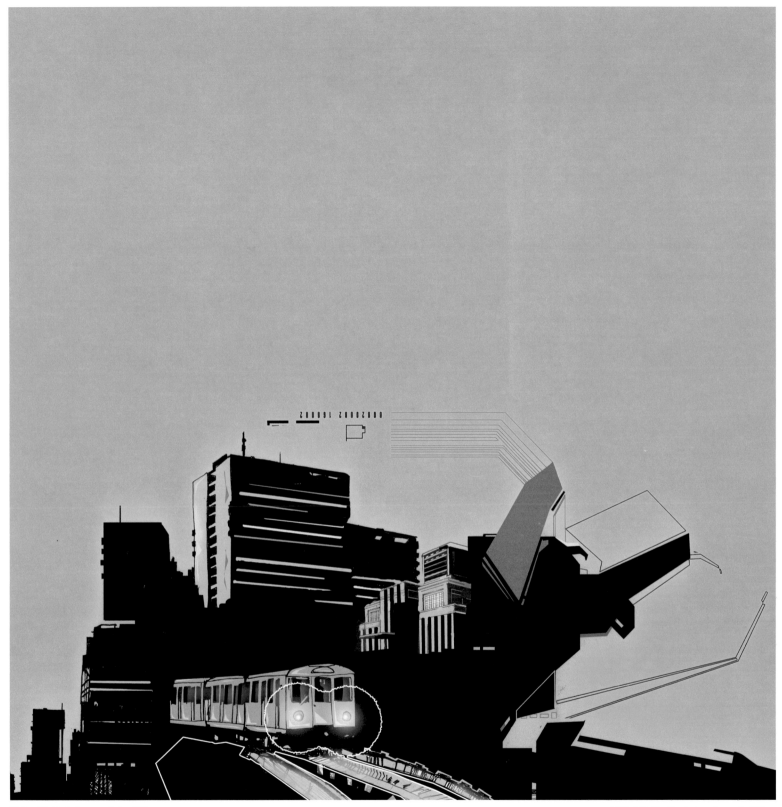

Bus 126 :: **Berlin Summer** :: Berlin :: 2002

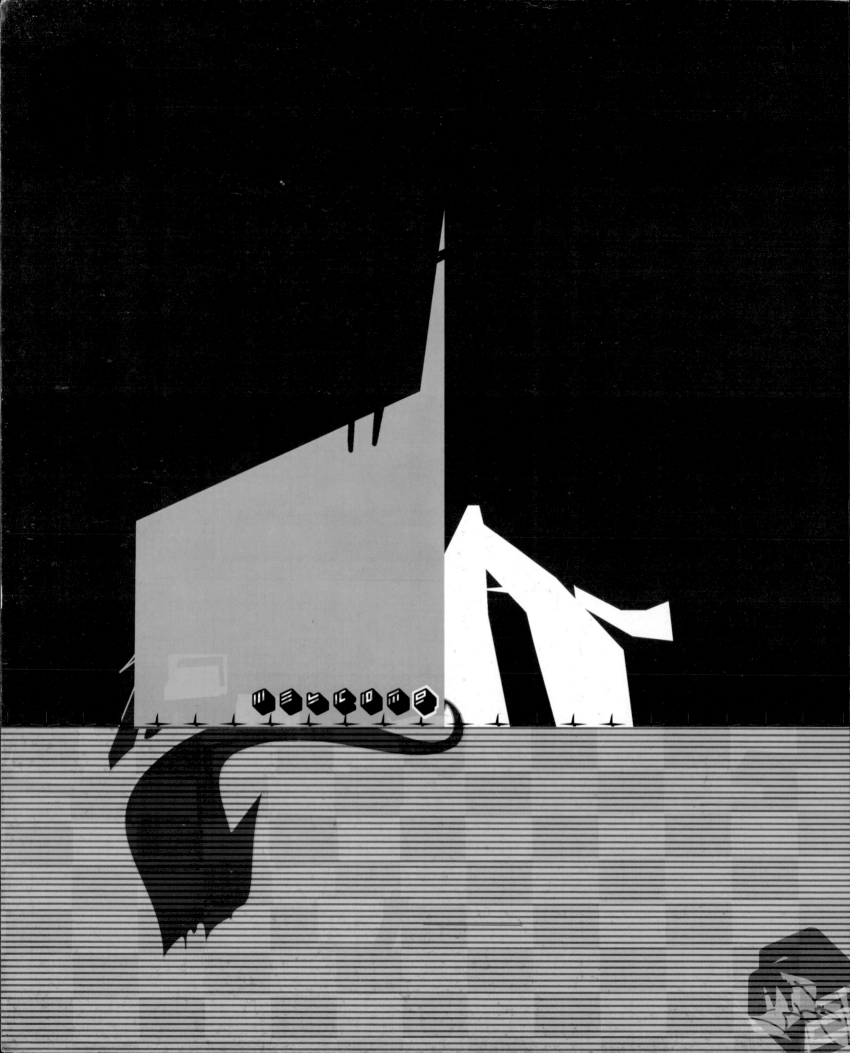

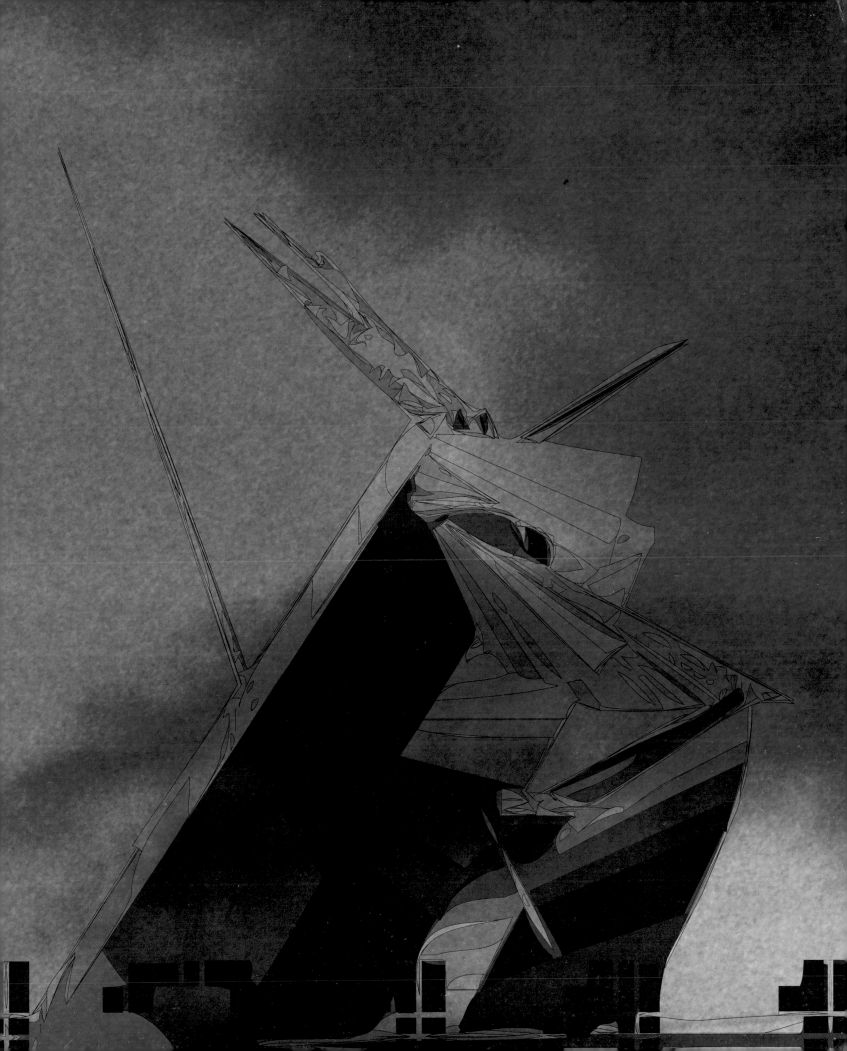

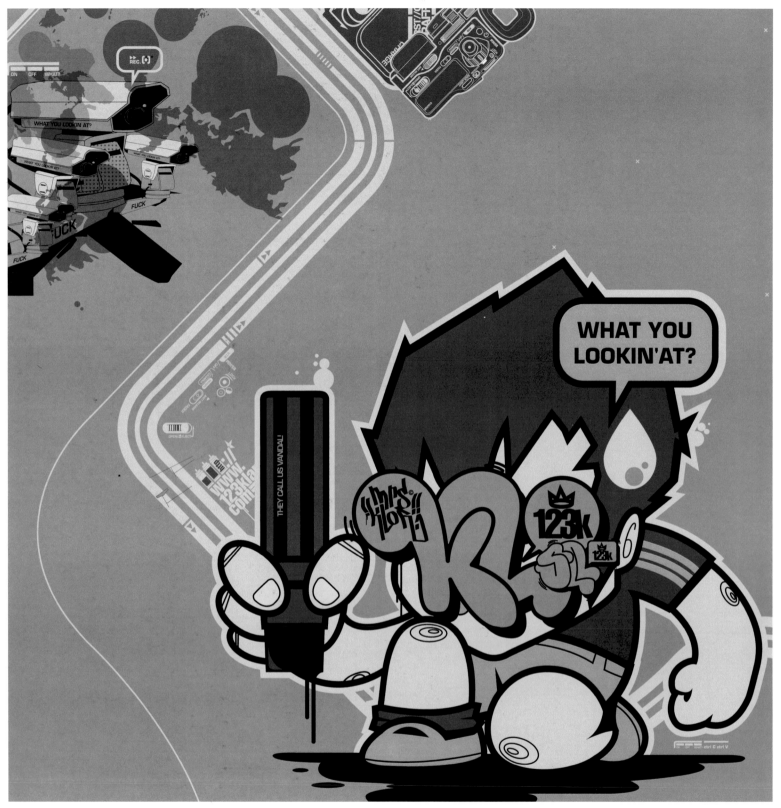

● **123 Klan** :: France :: 2002

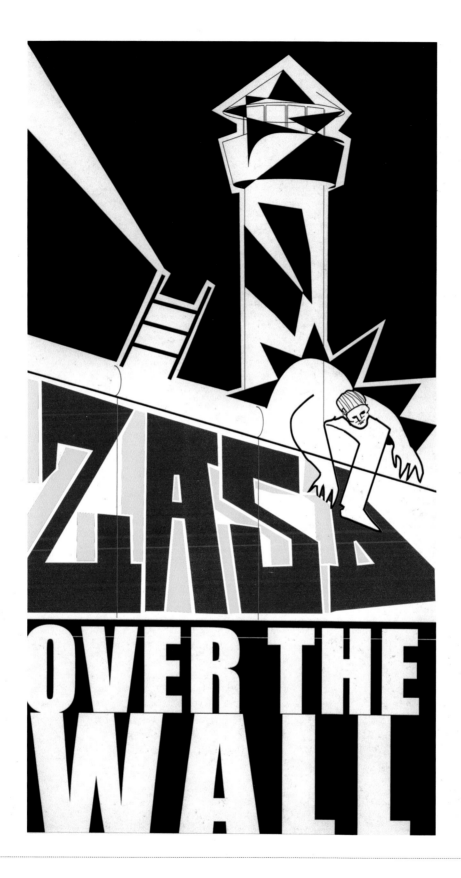

Zasd :: **Over the Wall** :: Berlin :: 1989

BATTLECAKE
WRITING - WORDS NOT NAMETAGS
(had to lye down with len to figure out the motion of math)

the other day i just happened to be kicking it with zaha up on 149th street, when a random stranger walked past us wearing camouflage trousers and some fly by night label architectural baby blue graff print tee. now zaha saw this and got real pissed. (for real.) she laid it down like:

'yo, i'm hip to the po'mo lomo snap happy generation of tellyfed tubbyheads and whatnot - but the grand con of this of course - is that those shark styled aerosholes have got my shit about as right as them green pants would look sneaking up into the frames of fritz' metropolis. you know what i'm saying? and that's in black and white, fo' real honey!'

to which i responded:
'say word?'

she said:
'for damn straight, even pre technicolour those laura ashley aestheticists had no piece all up in the urban dystopian take on it all. self-preservation my mule, you know those suckers never read lofty to get wise man, but still they try to get over. real chameleons use shifting lights to alternate their blend in ambiguous spaces, thus fluctuating most fluidly within their own fluxus if you will.'

and despite the fact that miss hadid's perception on this matter may have kept her from being amongst the most built of her ilk in this era, i replied:

'word zee, that's why i've done opted for particles of an altogether higher frequency, cause radiance burns reflection, and when you radiate, you can still reflect, so i guess it's a shift to the best of both words. word.

or:

somewhere along the way i lost interest in the constrictive aspects of repetitive ornamental addition and rearrangement within the confinement of a chosen pseudonym. not only that, but the hours were wack and my lungs didn't get on too well with particles and fumes.

sometimes i still get writer's block though.

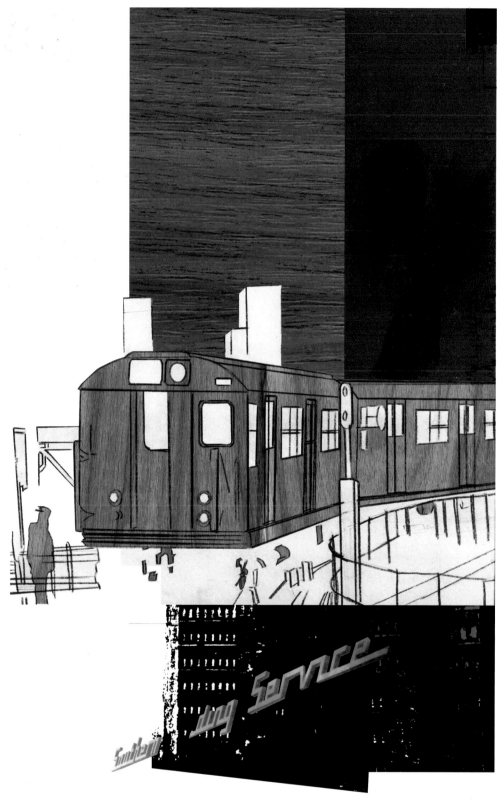

Writing My Name in Graffiti on the Wall

MCurry 2003
www.ninjacruise.com

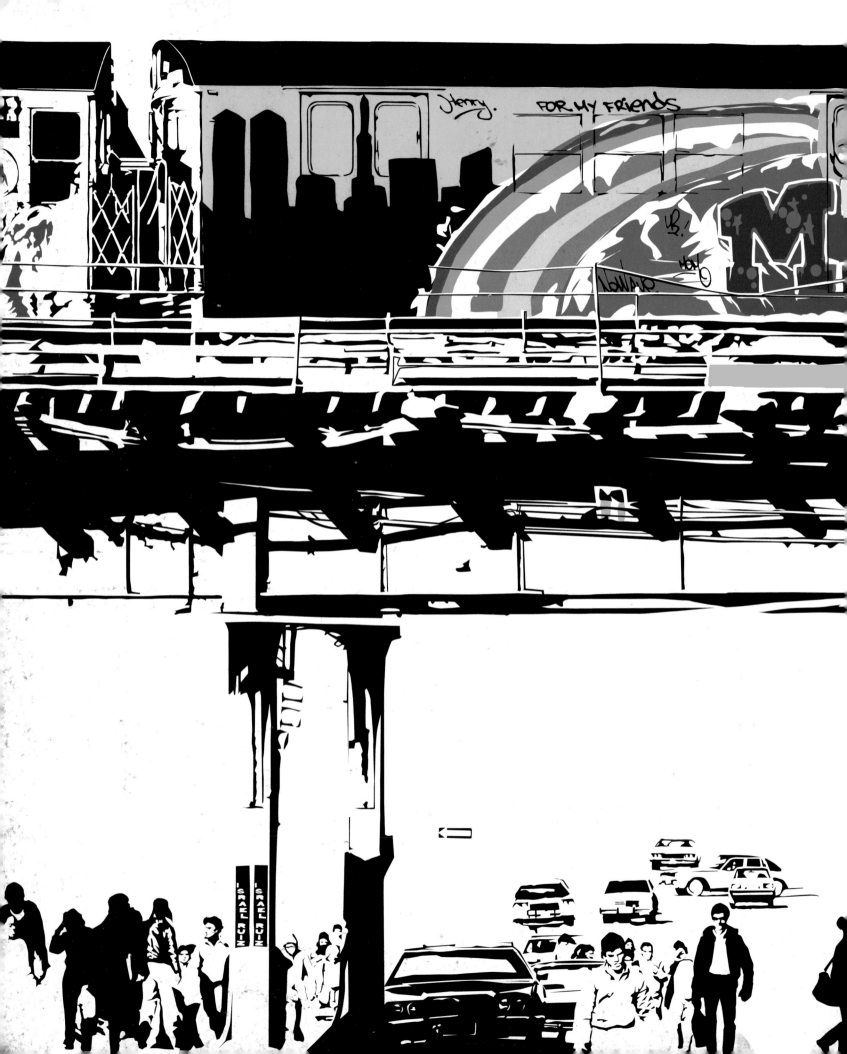

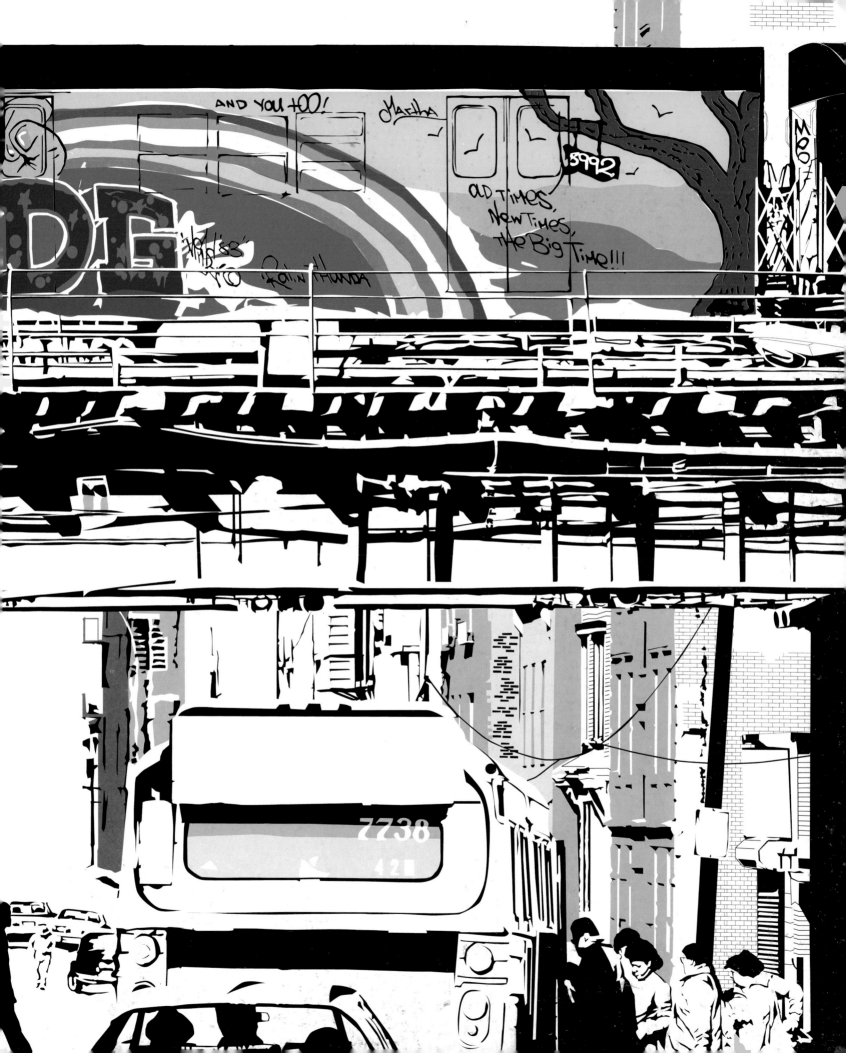

URBAN :: ART :: ACTIVISM

This chapter contains various approaches, which take Writing beyond the boundaries defined by the previous chapters. Through advancements in technique, these approaches also facilitate the exchange of new messages.

As previously mentioned, Writing's ubiquity has resulted in its dilemma. When a wall is completely filled with tags, an individual tag no longer stands out

The creators of so-called urban art now avail themselves of the methods developed by Writers. They infiltrate a (public) space, leave a message there and then withdraw themselves quickly without being recognised. Let's call their methods "urban tactics". At the same time, the work of Writers as well as artists inspired by Writers is also appearing in the context of the established art market more and more often. In addition to traditional markers and spray paint, stencils, posters and stickers are now being used.

All of these newer media allow artists to put up their images and messages very quickly. Because the images created in these media are easily recognisable, they also serve to convey identities. These media continue to emphasise the importance of a succinct style and originality, which were once only communicated through letters. Posters mimic advertisements and play with the irritation of viewers, who search in vain for concrete information about a product or event. Artists are even going a step further of late. Instead of putting up a message, they are changing or removing familiar slogans or elements from public spaces. They thereby create new messages, which are often political or socially critical. The American activists of the Adbusters movement, for example, have used these methods as a source of irritation time and again. The Frenchman Zevs goes even further by removing messages from the huge billboards that have been appearing lately on facades and scaffolding in almost all large cities. He "kidnaps" commercial advertising slogans and holds them hostage. His changed, partially emptied slogans get more attention than the originals.

● **Kazik Prodüksion** :: Berlin :: 2002

● **Kripoe** :: Berlin :: 2003

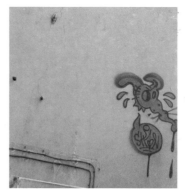

● **Shin** :: Berlin :: 2002

● **Mad Real** :: Toronto :: 2003

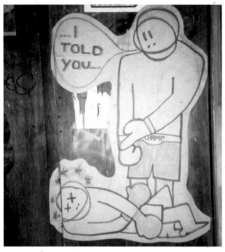

● **Nomad** :: Berlin :: 2003

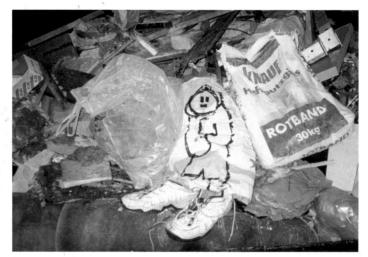

● **Nomad** :: Berlin :: 2003

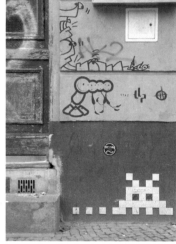

● **Space Invader** :: Berlin :: 2002

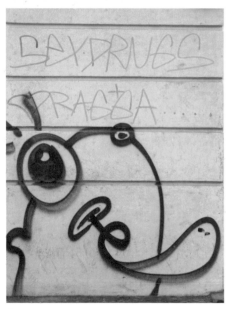

● **Shin** :: Berlin :: 2002

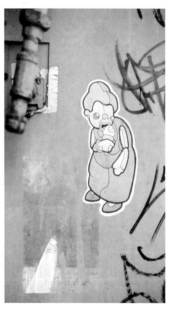

● **Mad Real** :: Toronto :: 2003

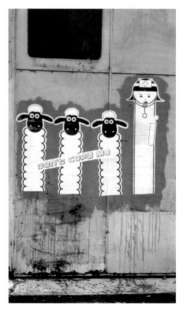

● **Eko** :: France :: 2003

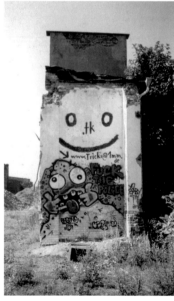

● **Ehs One** :: Berlin :: 2003

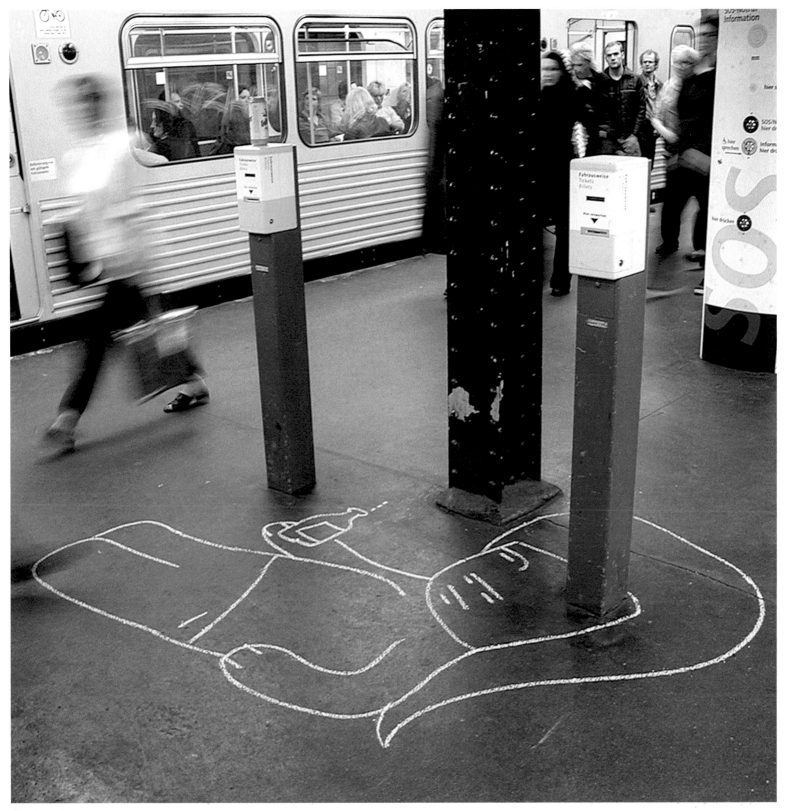

Boris Hoppek :: Berlin :: 2002

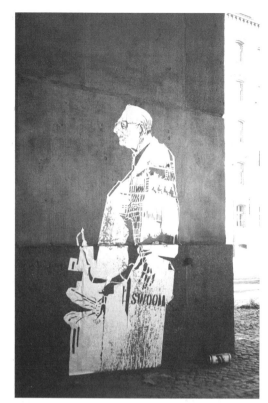
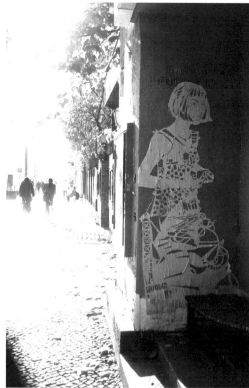
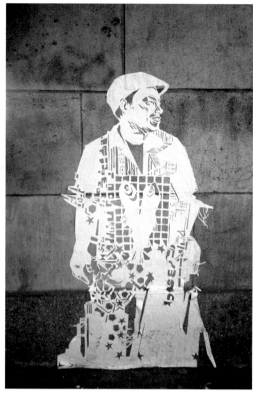

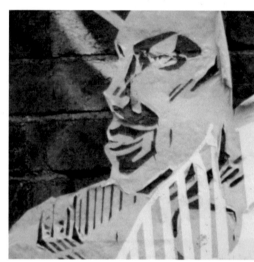

● **Swoon** :: Berlin / New York :: 2003

SWOON

We belong to the endless signs of life in our cities, which are so often designed without wasting any thought on their residents. Stories of stone and pavement attempt to construct an image of stable austerity until we come along with our dirty fingerprints, the traces of our dirty thoughts, our spray paint scrawls and our clumpy, peeling wheat pastes. We are drawing a living map of our cities, turning the inside out. We are everywhere and as contagious as a virus. With every action, I am trying to create a personal presence. I am teasing and whispering, "you can do this too." In some utopian fantasies that I feel we are directly on the edge of fulfilling, I imagine cities so full of life that every surface bears its mark. All detritus becomes art. All space becomes public, open for the democratic, dog-eat-dog flow of information and communication. Right now is the first time in human history that a majority of people live in urban environments. We are thirsting for wilderness. I believe that, in seeking it, our generation creates wilderness for itself. Our walls become screeching jungles; rapacious conversations, life, death, birth and decay are written aloud all around us. These portraits are x-rays of my city plastered back upon its surface. Through the hundreds of holes that I cut into them, I am trying to interact with the walls beneath them. I am trying to create a record of events, which may or may not have happened here, which could have happened anywhere.
Enjoy.

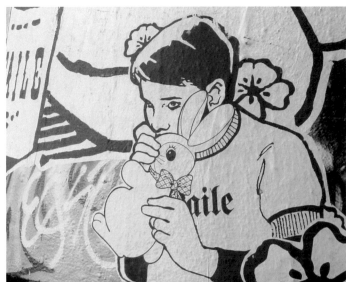
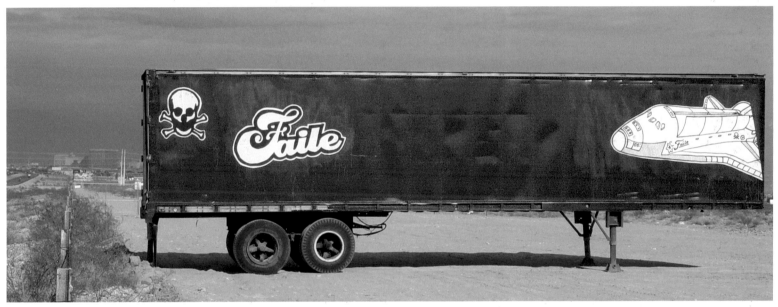
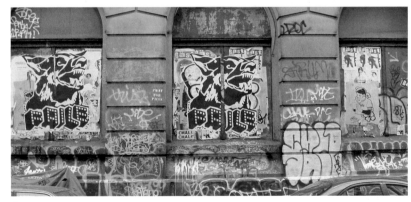

● **Faile** :: New York :: 2002

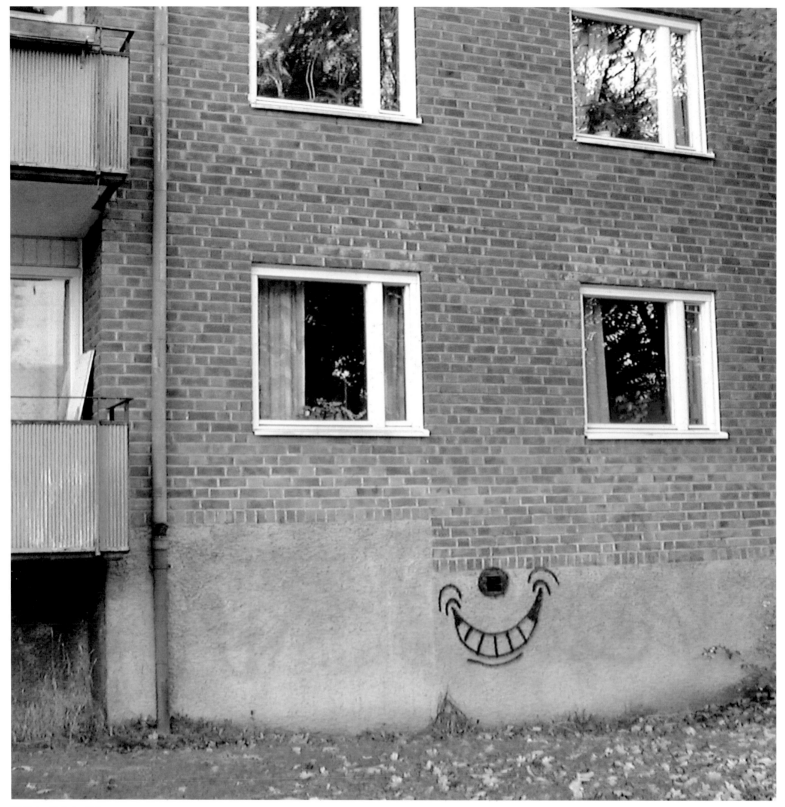

● **Finsta** :: Stockholm :: 2002

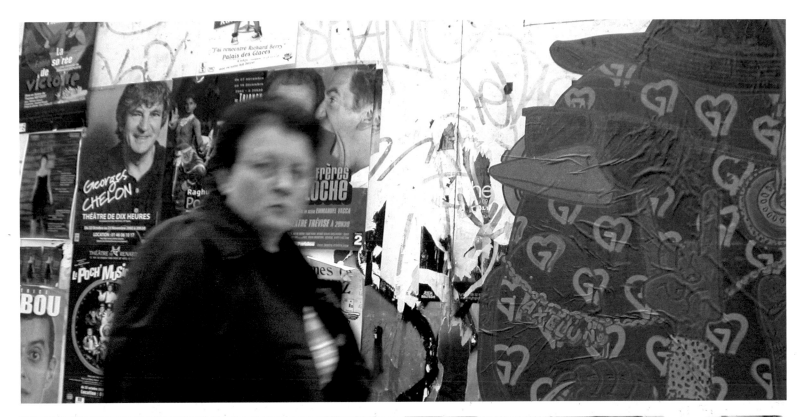

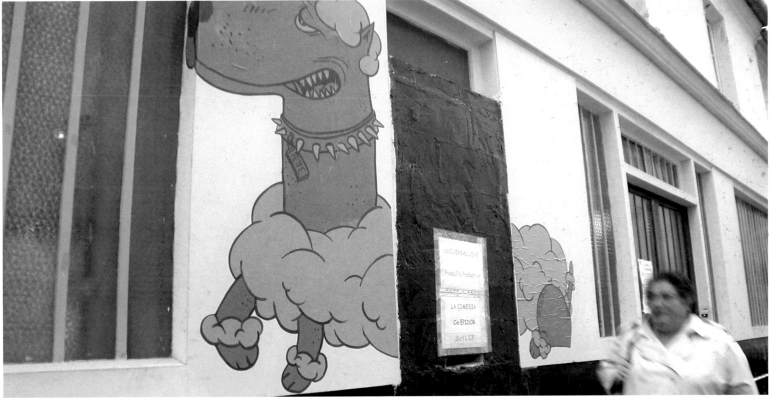

● **Alex One** :: Paris :: 2002

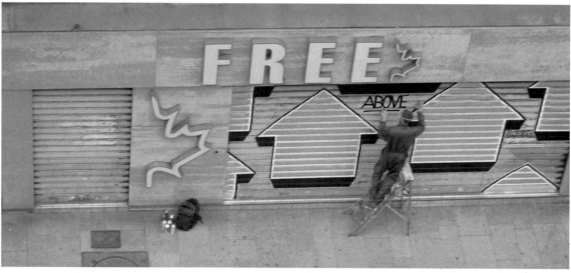
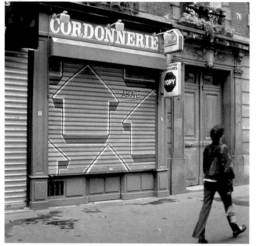
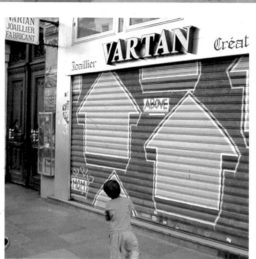
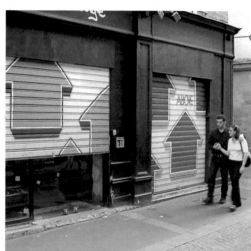

● **Above** :: Paris :: 2002

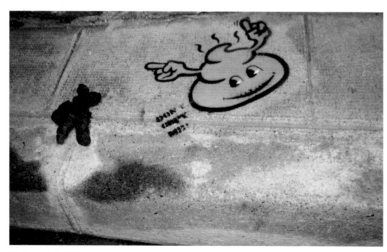
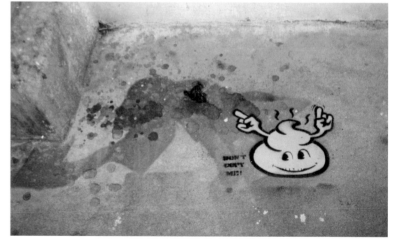

● **Etron** :: Paris :: 2002

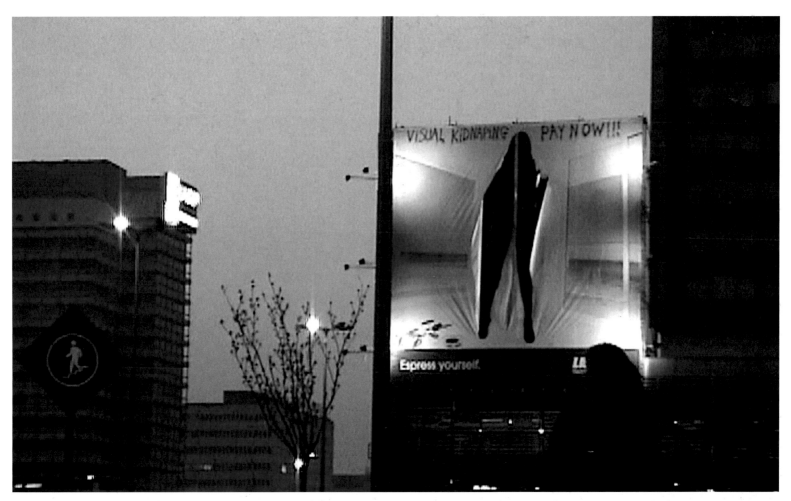

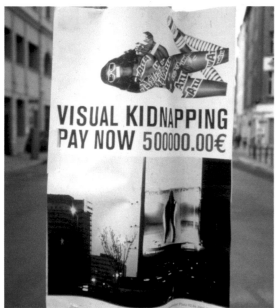

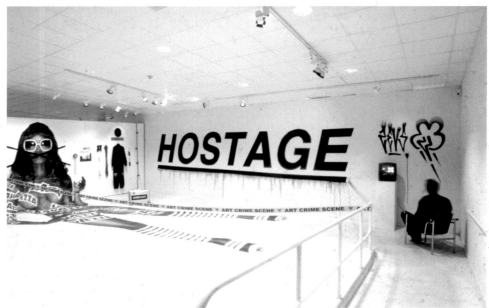

● **Zevs** :: Visual Kidnapping Berlin - Paris :: 2003

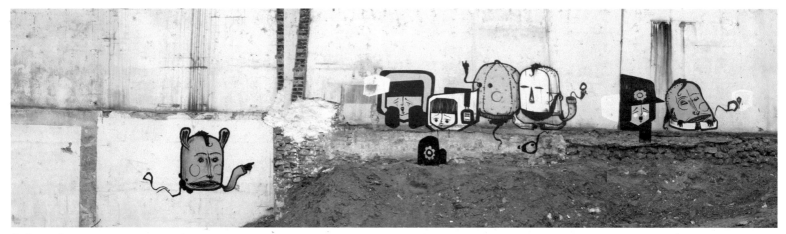

● **Akroe & KRSN** :: Paris :: 2003

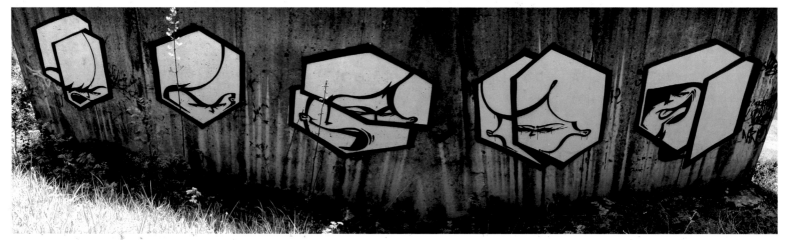

● **Akroe** :: Pannessière :: 2002

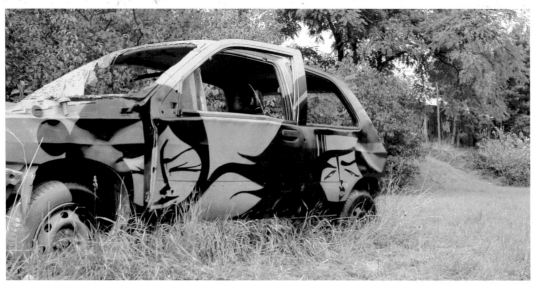

● **Akroe** :: Paris :: 2002

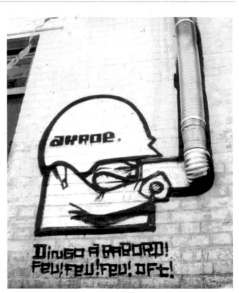

● **Akroe** :: Paris :: 1999

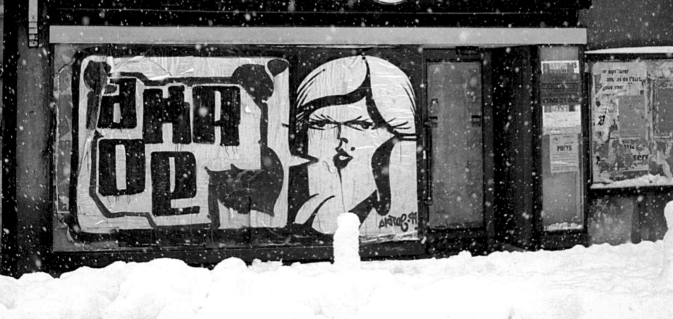

J'AI ENTREPRIS L'OEUVRE DU CO...
DANS L'INTÉRÊT DE ...LISATION
ET POUR LE BIEN DE LA B... ...LISATION
1835 LEO... ...09

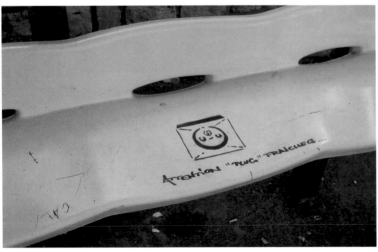

Attention "PLUG" FRAICHE...

● **The Plug In Propaganda** :: Belgium :: 2002

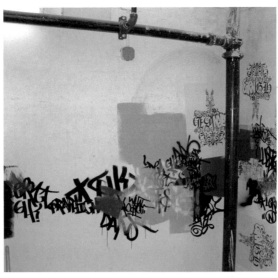
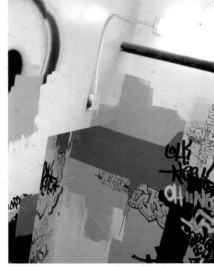
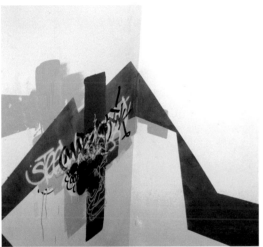
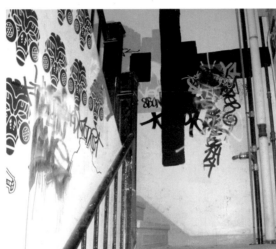
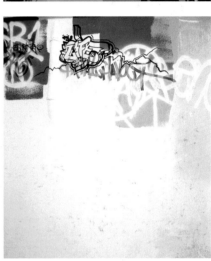

● **Derek Lerner** :: New York :: 2003

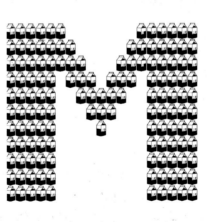

● **Milk** :: Hamburg :: 2002

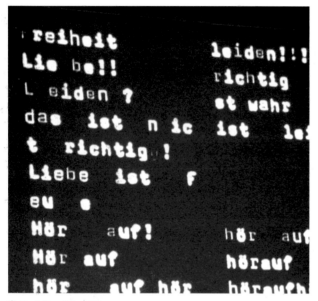

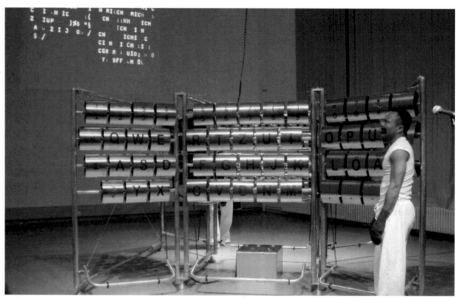

● **Typefighter** :: Berlin :: 2001

INTRODUCING :: **TYPEFIGHTER**

TYPEFIGHTER tackles the subject of interaction between man and machine via "interhuman communication". The concept comprises an experiment in which two users are able to communicate with each other via a specially designed interface. TYPEFIGHTER visualises the "immediacy" of the voice through the insertion of an interface, enabling scenarios for communication with physical and performance elements. The participants are conversation partners, co-players and adversaries simultaneously, using their entire bodies to communicate thoughts, words and emotions. TYPEFIGHTER involves an interaction of reading and writing within the scenario of a conversation - writing instead of speaking, reading instead of listening. The two parties to the conversation communicate on gigantic mechanical keyboards positioned back-to-back, their words being displayed via a special interface. The keyboards are velocity-sensitive. They respond to the intensity and speed of the physical input, making them formally comparable to a classic typewriter. The characters vary in brightness and shape depending on whether the user types on, pushes, bangs or kicks the keys. This lends the communication process a new, different corporeality that is absent in both oral conversation and written correspondence. TYPEFIGHTER consciously contravenes economic and ergonomic rules. Writing under its conditions requires extensive physical activity, the ultimate aim being for users to illustrate their emotional condition through the intensity of their physical input. Writing on the TYPEFIGHTER as such also means leaving a trail on a virtual screen that is usually governed by standardised rules. Although the body joins the conversation and correspondence, the medium of communication is manifestly "bodyless", i.e. virtual. TYPEFIGHTER integrates bodily expression into the medium of writing - the letter not solely being a neutral conveyor of "disembodied" information, but also communicating a visual expression of the physical activities of the opposite person. From this perspective, the voice gives the writing back a part of its "materiality".

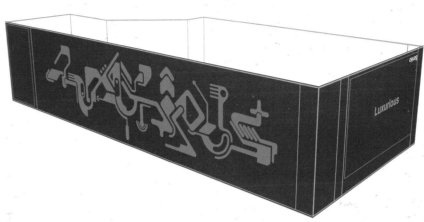

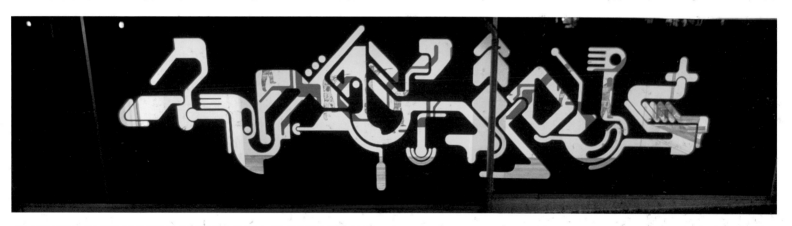

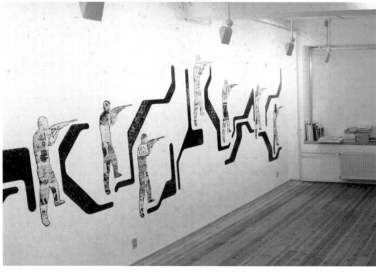

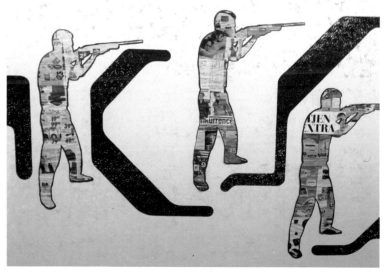

● **Ash** :: Paris :: 2002

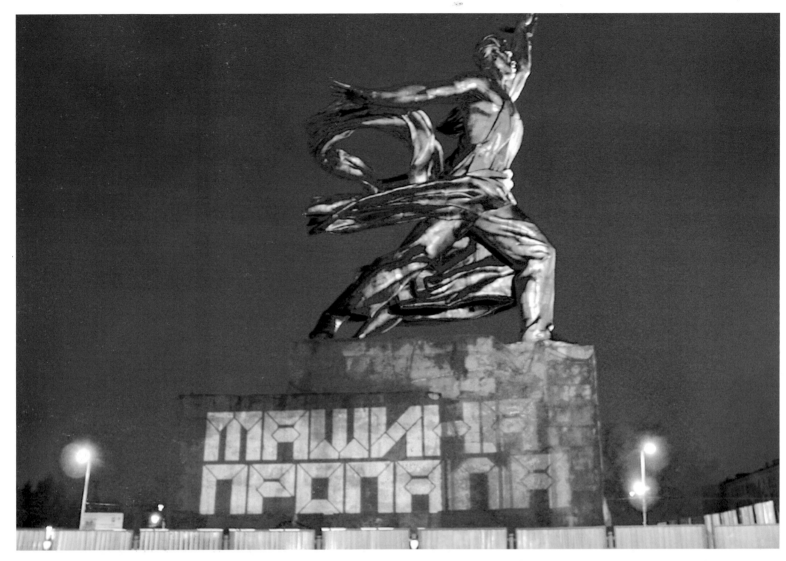

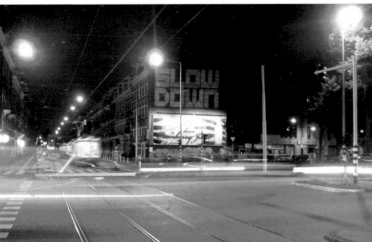

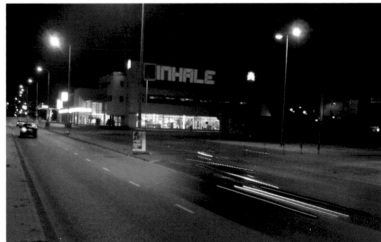

● **Machine** :: Germany :: 2002

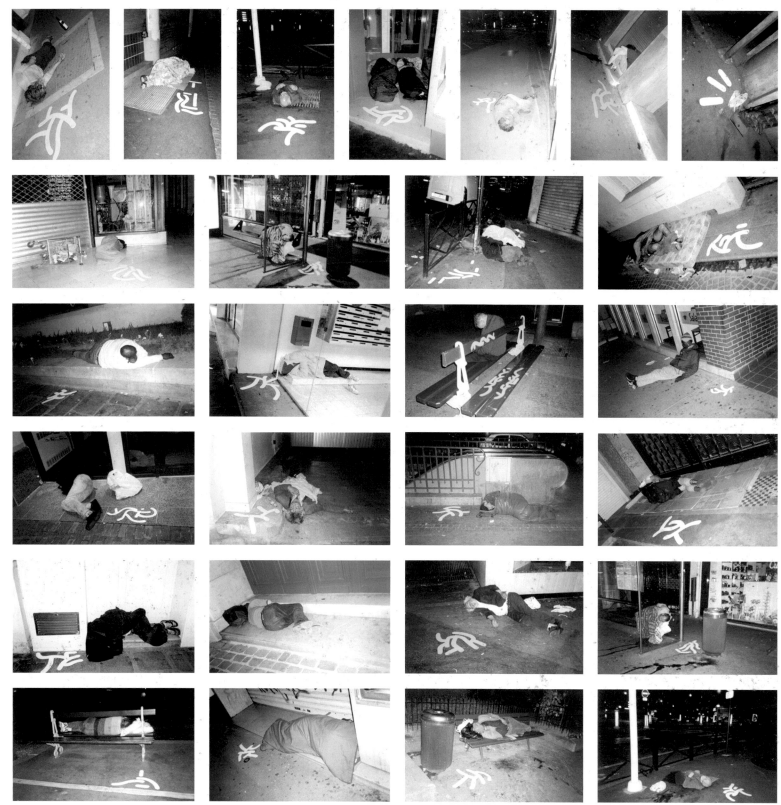

● **Crust** :: France :: 2002

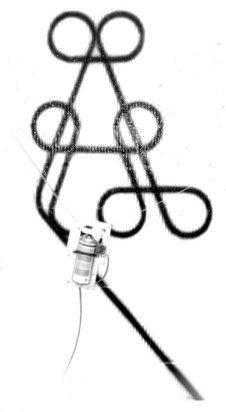

● **Hektor** :: Work Set & First Tests :: 2002

INTRODUCING :: **HEKTOR**

Hektor was realised as a collaboration between Jürg Lehni and Uli Franke, an electronic engineer from Zurich. It is a portable wall-spraying machine, a graffiti printer. Hektor basically consists of a suitcase, which contains two motors, a spray-can holder, toothed belts, cables, a strong battery and a circuit board that is connected to a laptop and controls the machine. The motors, which are placed onto the wall by a rapid mounting mechanism, suspend the can holder through the toothed belts and define its position by changing the length of these belts. Hektor is controlled directly from within Adobe Illustrator™, the spray-can follows vector graphic paths and sprays them.

The idea behind Hektor was to create a tool with new and different aesthetics. It is intended as a reaction to a certain monoculture in design, caused by the use of computers and the same few applications and techniques - which are mostly based on vector graphics - that are used by the majority of designers all over the world. Therefore, Hektor was to be a machine that conveys the abstract geo-metrical information contained in these clean vector graphics in a different way than normal printers do. Hektor follows vector paths like the hand follows a line when drawing. Moreover, with the spray-can, Hektor uses a tool that was made for humans. Combined with the fragility of the installation, this aspect gives the machine a less precise but somehow poetic quality. Ambiguous on purpose, Hektor unifies technological and imprecise qualities.

● **Hektor** :: **Chè** :: Lausanne :: 2002

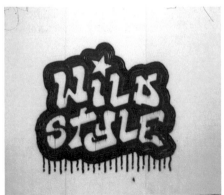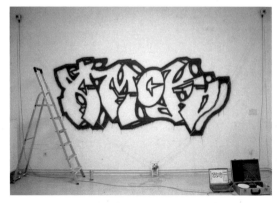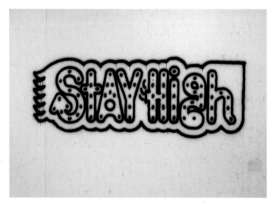

● **Hektor feat. Dondi, Amok, Stay High 149** :: Paris, Berlin :: 2002

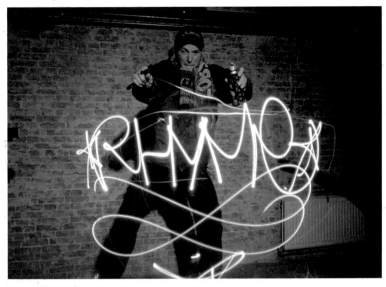

● **Crash** :: **Pipslab** :: Amsterdam :: 2002

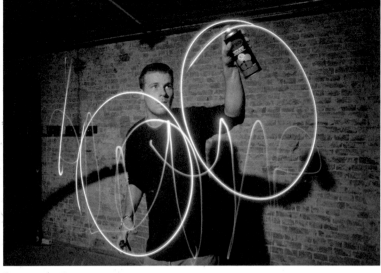

● **Sel One** :: **Pipslab** :: Amsterdam :: 2002

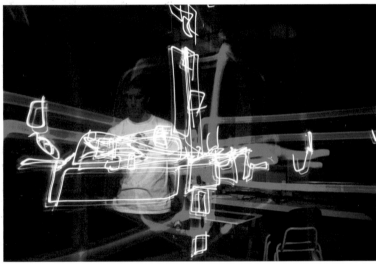

● **Delta** :: **Pipslab** :: Amsterdam :: 2002

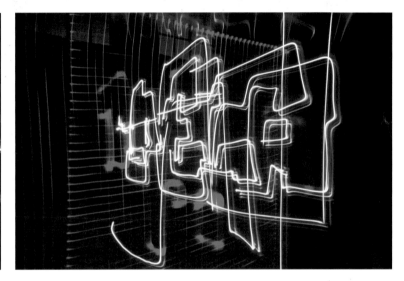

● **Kraze** :: **Pipslab** :: Amsterdam :: 2002

INTRODUCING :: **PIPSLAB**

Pipslab is a multi-disciplinary collective from Amsterdam. Content-wise, they prefer to collaborate with people, adjusting their interactive/photographic techniques to give their subjects an opportunity to show their skills.

With Lumasol light graffiti, they allow artists to do a piece in front of a multiple camera set-up with an empty spray can, which has a light bulb attached to it. Placed in a sequence, this light painting becomes a virtual three-dimensional object.

The hard part about Lumasol is that it is created in complete darkness so that neither pipslab nor the Writers can actually see what they are doing at the moment they are creating the piece. The result becomes visible afterwards and is then put online at http://www.pipslab.nl.

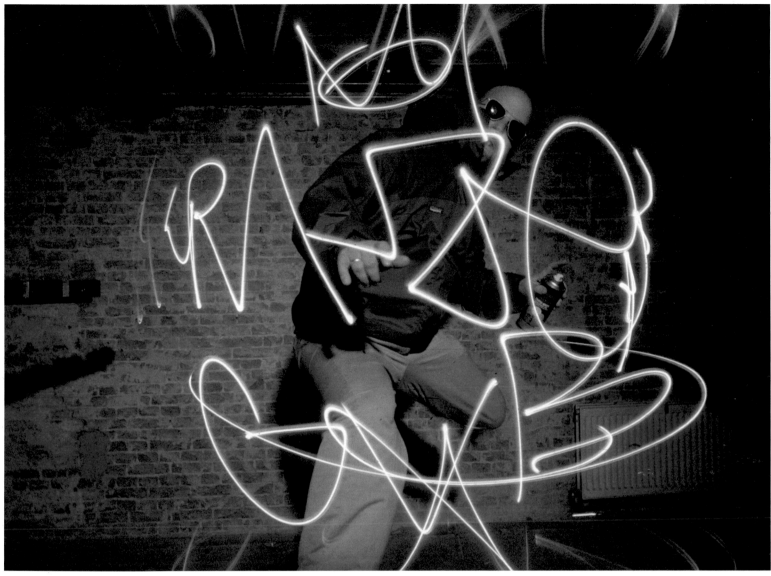

● **Kraze** :: **Pipslab** :: Amsterdam :: 2002

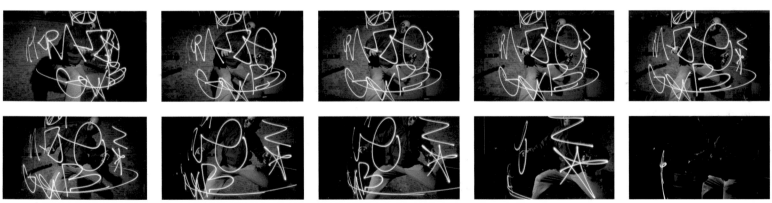

● **Kraze** :: **Pipslab** :: Amsterdam :: 2002

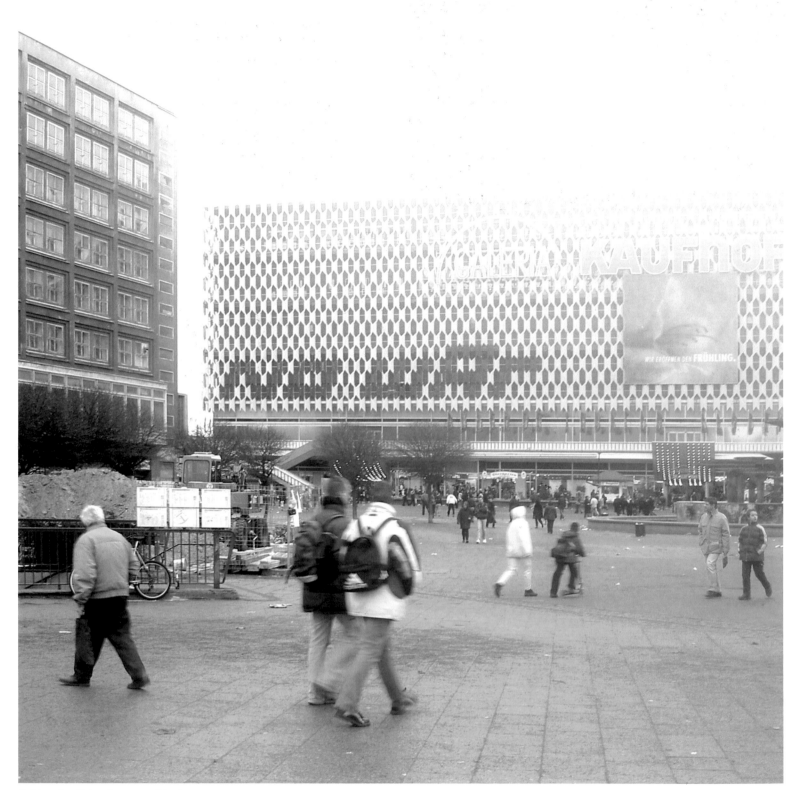

● **Kripoe :: Fao :: Monkey :: Broa :: Angst :: Cebo** :: Berlin :: 2003

● **Poet** :: Berlin :: 2002

● **Ehs One** :: Berlin :: 2002

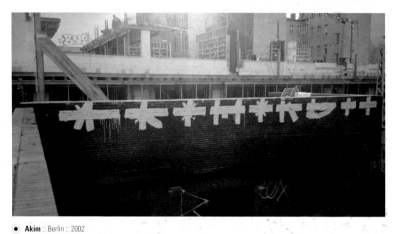

● **Akim** :: Berlin :: 2002

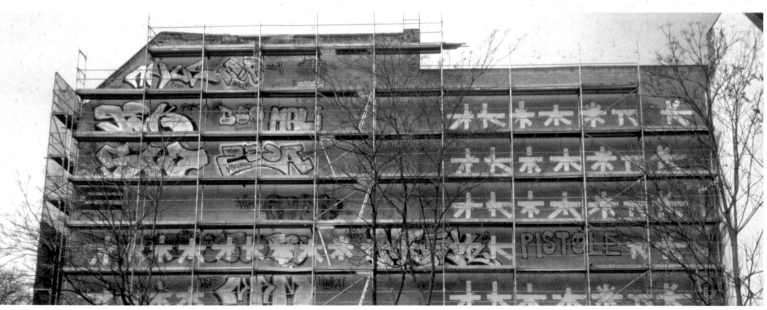

● **Akim** :: Berlin :: 2002

INDEX

Photo Credits :: ...

Akim
Hezht, Blaze, Acud (P. 037), Pistole, Boy, Nous,
Poe (P.130), Acud (P. 130)

Markus Mai
Brush, Flash, Zec Oner, Ruzd, Grace, Bojus, Neco,
Ass, Again, Zeus, Poet (P. 039, 079), Skee,
Acud (048), Broa, Try (P. 078),
Analogy (P. 090, 92, 93, 96-97), Emille Souply

Matthias Hübner
Analogy (P. 097), Kripoe (P. 202)

Thomas Bratzke
Analogy (P. 102, 103. 104, 105)

Alain Broders
Zevs in Paris (P. 189)

More links :: ...

www.artcrimes.org
www.at149st.com
www.berlingraffitisux.de
www.bladekingofgraf.com
www.defumo.org
www.dokument.org
www.dondiciakings.com
www.fatoe.com
www.frank151.com
www.imperialnation.org
www.klarkkent.de
www.metataggers.de
www.rollingstars.de
www.tatscru.com
www.terribletkid170.free.fr
www.thetrainyard.de
www.urban-art.info
www.zephyrgraffiti.com

Recommended Reading :: ...

Backjumps Sketch Book , Backjumps Magazine ::
Nabi, Adrian :: www.backjumps.net

Concerning The Spiritual In Art :: Kandinsky,
Wassily :: Dover Pubns, 1977 :: ISBN: 0486234118

**Dondi White Style Master General: The Life Of
Graffiti Artist Dondi White** :: Witten, Andrew ::
Regan Books, 2001 :: ISBN: 0060394277

Getting Up: Subway Graffiti in New York ::
Castleman, Craig ::
The Massachusetts Institute of Technology, 1982

Graffiti Amsterdam :: Marc Todt, Maurice Balt ::
Edition Aragon :: ISBN 3-89535-459-7

Hard 2 Burn Magazine :: www.hard2burn.de

New York 82/83 Subway Graffiti :: Thomas Christ ::
Edition Aragon :: ISBN 3 89535 421

Overkill Magazine :: www.overkill.de

Point and Line to Plane :: Kandinsky, Wassily ::
Dover Pubns :: ISBN: 0486238083

Style Writing From The Underground ::
(R)evolutions of Aerosol Linguistic :: Schmidlapp and
Phase 2 :: edt. Stampa Alternativa/Nuovi Equilibri
in association with IGTimes :: ISBN 88-7226-318-2

Spraycan Art :: Chalfant, Henry and James Prigoff ::
Thames & Hudson Inc. :: ISBN 0-500-27469-X

Subway Art :: Chalfant, Henry and Cooper, Martha ::
Henry Holt & Co, :: ISBN 0-8050-0678-8

**Subway graffiti: an aesthetic study of graffiti on
the subway system of New York City, 1970-1978**
Stewart, Jack ::
Ph. D Thesis, New York University, 1989

The Art Of Getting Over :: Powers, Stephen ::
St. Martin's Press :: ISBN: 0312206305

Theorie des Style
Die Befreiung des Alphabets
Scum, Cheech H. & Techno 169 :: www.styleonly.com

The Faith of Graffiti :: Mailer, Norman ::
Greenwood Publishing Group Inc :: ASIN: 0275716104

Writing - Urban Calligraphy and Beyond

by Markus Mai

Edited by Robert Klanten

Layout & Design: Matthias Hübner :: bordfunk.de

Organisation DGV: Hendrik Hellige

Foreword and Chapter Introductions by Robert Klanten with Markus Mai and Sven Ehmann

Translation: Sonja Commentz, Helga Beck

Proof Reading: Helga Beck

Production Management: Janni Milstrey

Production Consulting: Alice Goh, AVA Production, Singapore

Editorial Support: Hendrik Hellige, Eric Dalbin (France), MASA (South America)

Special thanks to MASA for organising the South American artists

and to Till Vanish and Fubbi Karlsson from Planfilm for their input!

Cover Image: Tagnoe

Chapter Intro Images: Chapter A : Acud | Chapter B : Phos 4 | Chapter C: Emille Soupply | Chapter D: Tokyoe | Chapter E: Zasd

Bibliographic information published by Die Deutsche Bibliothek

Die Deutsche Bibliothek lists this publication in the Deutsche Nationalbibliografie;

detailed bibliographic data is available in the Internet at http://dnb.ddb.de.

ISBN 3-89955-062-5

THANKS ::

Simon R. :: Matze :: Thomas B. :: Kim N. :: Tobias F. :: Dennis C. :: Michael L. :: Daniel W. :: Hans R. :: Markus B. :: Guiseppe C. :: Crille :: Samir Breakfastking :: Grischa :: Henni H. badmofuka :: Robert K. :: Veysel Ö. :: Adrian N. :: Danilo & Conrad :: Gretel :: Manfred & Marianne :: Prof. M. Gubig :: Bernd G. :: Mehmet :: Erkan S. :: Nece :: Jay One :: Mase The Hustler :: planfilmberlin.com :: ekosystem.org :: Sonja C. :: Helga B. :: Sven E. :: Laurence R. :: Wesp Whomademegraff :: Crime TDC :: Big Sexyland ::